RECORDING CONCEPTUAL ART

RECORDING CONCEPTUAL ART

EARLY INTERVIEWS WITH

Barry

Huebler

Kaltenbach

LeWitt

Morris

Oppenheim

Siegelaub

Smithson

Weiner

BY PATRICIA NORVELL

Edited by
ALEXANDER ALBERRO
and
PATRICIA NORVELL

UNIVERSITY OF CALIFORNIA PRESS
Berkeley Los Angeles London

University of California Press

Berkeley and Los Angeles, California

University of California Press, Ltd.

London, England

Library of Congress Cataloging-in-Publication Data

Recording conceptual art : early interviews with Barry, Huebler, Kaltenbach, LeWitt, Morris, Oppenheim, Siegelaub, Smithson, and Weiner by Patricia Norvell / edited by Alexander Alberro and Patricia Norvell.

 p. cm.

 Includes bibliographical references and index.

 ISBN 0-520-22010-2 (cloth : alk. paper)—

 ISBN 0-520-22011-0 (pbk. : alk. paper)

 1. Conceptual art—United States. 2. Artists—United States—Interviews. I. Barry, Robert, 1936– II. Alberro, Alexander. III. Norvell, Patsy.

 N6512.5.C64 R43 2001

 709'.04'075—dc21 00-032583

Manufactured in the United States of America

09 08 07 06 05 04 03 02 01 00

10 9 8 7 6 5 4 3 2 1

CONTENTS

Illustrations follow page 100.

9. Robert Morris, *Card File*, 1962. Photo courtesy of the Centre National d'Art et de Culture Georges Pompidou.

10. Robert Morris, *Untitled (Threadwaste)*, 1994 refabrication of 1968 original. Photo by David Heald © The Solomon R. Guggenheim Foundation, New York.

11. Robert Morris, *Untitled (Dirt)*, 1994 refabrication of 1968 original. Photo by David Heald © The Solomon R. Guggenheim Foundation, New York.

12. Stephen Kaltenbach, sketch for *Earthworks*, 1967. Photo courtesy of Stephen Kaltenbach.

13. Stephen Kaltenbach, *Canvas Piece*, ca. 1967–68. Photo courtesy of Stephen Kaltenbach.

14. Stephen Kaltenbach, *Time Capsule*, ca. 1968. Photo courtesy of Stephen Kaltenbach.

15. Stephen Kaltenbach, *Art Works*, 1968. Photo courtesy of Stephen Kaltenbach.

16. Robert Barry, *Telepathic Piece*, 1969. Photo courtesy of Robert Barry.

17. Robert Barry, gallery space occupied simultaneously by *88mc Carrier Wave, FM*, 1968; *1600kc Carrier Wave, AM*, 1968; *40khz Ultrasonic Soundwave Installation*, 1969. Photo courtesy of Robert Barry.

18. Robert Barry, *Inert Gas Series: Helium*, 1969. Photo courtesy of Robert Barry.

19. Robert Barry, *4 to 1*, 1968. Photo courtesy of Robert Barry.

20. Robert Barry, page from *Andre Barry Huebler Kosuth LeWitt Morris Weiner* (New York: Seth Siegelaub and Jack Wendler, 1968). Photo courtesy of Siegelaub Collection and Archives.

21. Lawrence Weiner, *A Rubber Ball Thrown at the Sea*, 1969. Photo courtesy of Siegelaub Collection and Archives.

22. Lawrence Weiner, page from *Andre Barry Huebler Kosuth LeWitt Morris Weiner* (New York: Seth Siegelaub and Jack Wendler, 1968). Photo courtesy of Siegelaub Collection and Archives.

23. Lawrence Weiner, *An Object Tossed from One Country to Another*, 1969. Photo courtesy of Siegelaub Collection and Archives.

24. Sol LeWitt, page from *Andre Barry Huebler Kosuth LeWitt Morris Weiner* (New York: Seth Siegelaub and Jack Wendler, 1968). Photo courtesy of Siegelaub Collection and Archives.

25. Sol LeWitt, *Wall Drawing #2, Drawing Series II (A)*, 1968. Photo courtesy of Sol LeWitt.

26. Sol LeWitt, *Wall Drawing #1, Drawing Series II 18 (A&B)*, 1968. Photo courtesy of Sol LeWitt.

We would like to express our gratitude to a number of people for their encouragement, comments, and support. First, we thank the seven artists and the one former art dealer and exhibition organizer who permitted their interviews to be published in this volume: Robert Barry, Douglas Huebler, Stephen Kaltenbach, Sol LeWitt, Robert Morris, Dennis Oppenheim, Seth Siegelaub, and Lawrence Weiner. Nancy Holt granted us permission to publish photographs by Robert Smithson and the interview with him; Darcy Huebler offered her assistance following the death of Douglas Huebler in the fall of 1997; and Duane Michals, Alice Zimmerman Weiner, and Kim Bush of the Solomon R. Guggenheim Museum archives all helped us obtain permission to reproduce illustrations for this project. Elizabeth Hess and Elizabeth Weatherford provided editorial support. Jessica May, Lora Rempel, and Alan Wright gave us invaluable assistance in preparing the manuscript, as did Ellie Hickerson of the University of California Press. We also profited a great deal from the anonymous readers who reviewed the manuscript for the Press. The College of Fine Arts at the University of Florida generously supported the initial work on this book. Finally, without the support and aid of our editors, Edward Dimendberg and Stephanie Fay, this book would not have been possible.

In the late sixties when Conceptual art rumored the death of sculpture and painting, I was a graduate student in sculpture at Hunter College in New York City preparing to write my master of arts thesis. Four years earlier, I had graduated from Bennington College in Vermont, where I had been immersed in formalist thought with the artists Lyman Kipp, Tony Smith, Anthony Caro, and David Smith, as well as the critics Hilton Kramer and Clement Greenberg. My own sculptural concerns were largely shaped by my interest in abstract mathematics, focusing on a defined or limited interior space rather than on monolithic objects. Although my work could be viewed as falling within the tenets of formalism, I was not invested in its basic philosophical principles.

Once in New York City, I was drawn to Conceptual art because of its intellectual rigor. But I was disturbed that many of the major Conceptual artists insisted on the elimination of the physical art object. I also saw problems in the presentation and subsequent interpretation of this new work. I decided to investigate it to discover how it related to its formalist art predecessor and to my own artwork. To this end, I proposed a process piece consisting of oral histories documenting artists' ideas and approaches to art, which became my thesis project. Robert Morris, my graduate advisor, helped compile a list of possible artists, including Carl

Andre, Robert Smithson, Rafael Ferrer, Robert Barry, Douglas Huebler, Dan Graham, Richard Serra, and Jack Burnham, the historian. This list changed as the project evolved and eventually included ten artists and one dealer, all of whom were men.

The roles of female interviewer and male interviewee reflected the sexual politics of the 1960s. Unfortunately, as was the norm prior to the women's movement, there were few *recognized* women artists, much less any renowned female Conceptual artists. While it is now clear that men dominated the Conceptual art movement, women were actively involved from the beginning. Yet no one suggested women artists for me to interview. At the time, I did not think it unusual that only a few women were on my list. Among those I considered interviewing were Eva Hesse, who was gaining recognition; Lucy Lippard, the primary critic writing about this work; and Trisha Brown, the dancer. Hesse was unavailable; Lippard and Brown declined. I remember seeing Nancy Holt in the next room while I was interviewing Robert Smithson and wondering who she was and what she did. Hanne Darboven, Lee Lozano, Christine Kozlov, Adrian Piper, Brenda Miller, Yvonne Rainer, and Simone Whitman all should have been considered for this project—I am sure there are dozens more.

While I was conducting the interviews, the civil rights movement and the anti–Vietnam War movement were taking hold, and the second wave of the women's movement was beginning. They would all be felt in the next decade. The women's movement became a liberating source for my work and that of many of my peers. In the seventies the antiformalism of the late sixties expanded beyond Conceptual art to embrace a pluralistic approach to art. In keeping with the technological developments of the time, art ideas were instantly appropriated and assimilated. Although the early Conceptualists stated their intent to make their works publicly accessible and available, they were openly indifferent to the actual public. Subsequently, a more interactive public art emerged, in which women artists played key roles.

In 1992 the art historian Alex Alberro contacted me, asking to hear the tapes that constitute my master's thesis for his own doctoral research. Because I consider this collection of tapes an important historical document, as well as a process piece, I maintained it in its audio form. Although I had been approached about transcribing the interviews, I was committed to the piece as oral history and to that point had allowed only a few excerpts to be transcribed for Lucy Lippard's *Six Years: The Dematerialization of the Art Object* (1973). Alex's certainty about the importance of these records and his commitment to their publication as both written and oral documents persuaded me that it was time to transcribe the tapes.

Listening to and transcribing the interviews after twenty-nine years proved surprisingly provocative. This book introduces the artists as they were generating the Conceptual art movement. Their questioning of the prevailing limits of art brought about the honing of formalism to a bare intellectual activity. Radical at the time, it remains fascinating. In the political climate of the late sixties and seventies, however, the art movements that followed were bound to question the restrictiveness of these male, Western art tenets. The need for a fresh examination of the 1970s and 1980s, focusing on art made by women and its relation to the art object, to art sources, and to concerns about social accountability and accessibility, particularly in public art, logically emerges from these interviews.

Patricia Norvell
New York, 2000

AT THE THRESHOLD OF
ART AS INFORMATION

ALEXANDER ALBERRO

The type of art that I'm involved with and con-
cerned about has to do less with materiality than
ideas and intangible considerations.
> SETH SIEGELAUB, APRIL 17, 1969

What is the least amount of presentation that I
can get away with?
> ROBERT BARRY, MAY 30, 1969

I don't sell the commodity. I sell the idea.
> SOL LeWITT, JUNE 12, 1969

Objects are about as real as angels are real.
> ROBERT SMITHSON, JUNE 20, 1969

Art is not necessarily a visual experience.
> DOUGLAS HUEBLER, JUNE 25, 1969

Among the many provocative ideas advanced by the eleven artists Patricia Norvell
interviewed in early 1969, one of the most problematic, though in retrospect
clearly prescient, is the only apparently humble reduction of the role of the artist to
that of a mere catalyst for processes of producing art. In particular Robert Morris,
under whose direction Norvell conducted the interviews for her master of arts the-
sis in studio arts at Hunter College, maintains this tenet.[1] Morris explains his gen-
eral philosophy or method of working in the late 1960s to Norvell as one where

"I'd initiate the whole thing and it goes on from there.... I would present a very general situation ... and let them [patrons or officials of the sponsoring gallery or museum] suggest what kind of materials might work best, or what way of fabricating might be best, so that I could use their imagination, and their knowledge.... They could come up with things, which I would approve of or reject. I was pretty much involved every step of the way but I didn't have to preconceive the whole thing."[2] Sol LeWitt evokes the same approach, explaining that his "art is about ... not making choices. It's in making an initial choice of, say, a system, and letting the system do the work." The results for Morris and LeWitt are similar: Morris gives instructions for works that will be fabricated anonymously, and LeWitt "designs" schemata for projects that others will bring to fruition.

The variety of forms this approach could take is highlighted by the working methods of Robert Barry and Stephen Kaltenbach, for whom the initial "system" or "concept" is never fully articulated or expressed, either verbally or visually, existing only as a subtle influence and suggestion or, to put it more precisely, telepathic communication. Barry conceives of himself as a transmitter of mental energy, similar to a radio ("Whether anybody picks it up or not is something else. ... I wouldn't say I'm communicating it; I'd say I'm transmitting it," he tells Norvell), whereas Kaltenbach labels his telepathic pieces "attempts to influence." Joseph Kosuth, in contrast, refers to the practice of art as a "game," and to his artist-run "Museum of Normal Art" (which by early 1969 "exists [only] as an idea") as "an art game. Some sort of game." But what exactly *is* this "art game"? Is it, as Carl Andre dismissively suggests (implicitly exempting himself from the charge), merely a lot of "con men in the art world who can talk a lot"? Or are there some more substantial issues at stake in the insubstantial and immaterial art production advanced by most of the artists Norvell interviewed?

All these instances share an allegiance to the idea of putting a system into place and allowing it to unfold and develop freely, both on its own and in interaction with various "others" who cooperate in the manufacture, exhibition, and dissemination of what had been, but is no longer, an ephemeral intention, concept, or intuition. Almost without exception, the artists Norvell interviewed do not offer their work (as an object) to the public for consumption or even interpretation, as artists have traditionally done. Rather, each in his (all those interviewed are males) own way relies on the public—indeed invites, urges, *expects* the public— to pursue the process he has started. What is more, he elicits the public's participation in all the stages through which the given artwork will wend: the initial concept, when it is accessible, along with that concept's first concrete manifestation; its recorded traces, if any; and the documents that, a posteriori, establish its past existence and offer commentary, interpretation, and matter for reflection, discussion, and new production.

What is striking about Norvell's *Eleven Interviews* is that they themselves can be understood as such a document, a "process piece," capturing a moment in the development of the Conceptual art movement and, though by no means exhaustively, illustrating the problematics of that moment.[3] This view rests above all on the special circumstances of its production. Initially the result of a collaboration between an astute thesis director, a diligent interviewer, and a number of more or less articulate artists, *Eleven Interviews,* published now three decades later as *Recording Conceptual Art,* defines the reader as a participant in a spatially and temporally open work of Conceptual art. Where do we find the initial sparks of this process piece?

Norvell's project originally consisted of eleven interviews, with ten artists and one art dealer. One of the artists was Morris. Yet he was not just another artist participant but Norvell's thesis director. He helped her both to conceive the project and, directly or indirectly, to arrange many of the interviews. But in particular it is the content of Morris's comments during Norvell's interview with him that allows us to think of *Eleven Interviews* itself as a work of Conceptual art. For instance, Morris on several occasions presents, indeed underscores, his methodology as an artist. Concerning a recently completed project, *Money,* which was to be displayed at the Whitney Museum of American Art within days of his interview with Norvell, Morris explains that he "just presented" it. And the administrators of the museum "could make visible whatever aspect of it that they wanted. What they seem to be doing now is to be collecting all the documents, and they'll show those—which is the record of the work."[4] And later on in the interview he reflects on a project he had recently submitted to an arts group in Houston: "I proposed that they … rent a section of land and contract a farmer to plant a crop, whichever one was making money, and harvest it. And I would get half of the profit from the crop, whatever it was…. And then that suggested other things. Like what other things exist where you could initiate something and have an already existing organization of energies or whatever to complete the thing."

In remarking on Morris's method of working, I mean in no way to diminish Norvell's role, for she is an extremely apt and successful interviewer, encouraging her interviewees to talk freely and providing us today with a rich document. But because the interviews conform in concept and format with an idea of art production that is locatable in Morris and is given further articulation in the "collaboration" with Norvell, the risk is that Norvell as interviewer will be overshadowed by Morris, with his greater stature. Indeed, when Norvell asks about the role of the participants in previous collaborative projects, Morris answers by insisting that authorship lies with the originator of the idea: "The artist is setting the situation up. I mean, he initiates it. It's his idea; it's his overall structure," even though "the particular outcome or form of it may be contingent upon other people's deci-

sions." Ultimately, however, Norvell triumphs by claiming the project as her own and preventing it (like one of Kaltenbach's "Time Capsules") from being published or made accessible to the public for some thirty years. And when she does finally open the project to the public, she does so under her name. Indeed, it is her project, her artwork, just as the project belongs to each participant and, ultimately, to the reader as well. In this broader sense, then, *Recording Conceptual Art* could be received as an art event.

Such a reception, however, like much about conceptualism, has risks, including idiosyncratic readings considerably removed from the authors' intentions and their (subjective) idea of which reading qualifies as an art form. Ultimately it is left up to the reader to choose, or not, to play the game of Conceptual art production, approaching the transcribed interviews as a late stage in that process. But more than thirty years have passed between the interviews and their transcription and publication. What are we to make of this gap—the conspicuous absence today, for example, of Kosuth's interview of April 10, 1969, and that of Andre, which took place on June 5, 1969. Both of these now-prominent artists declined to have their interviews published. The reader is thus left to fill in the gaps and complete the meaning, thereby making the absence and presence of particular interviews equally significant. For by not participating, Kosuth and Andre transform the very fabric of the project and thereby reactivate the work, making it an ongoing dynamic piece. At one point, Seth Siegelaub describes a similar situation. Several artists did not participate directly in one of the projects he had recently initiated because they "consider[ed] themselves to have participated just by keeping the page blank."[5] That is how we must interpret Kosuth's and Andre's intervention, for, as Walter Benjamin repeatedly reminds us, history is made up of fragments and absences—what is left out is as significant as what is included.[6]

The time lapse also imperils the reception of the printed interview. As if to protect their works through extended control (despite proclaiming a hands-off policy), several interviewees hint at how the reception game should be played, how a reading of *Eleven Interviews* in the future could yield the concepts that generated it. One notion that surfaces repeatedly is the importance of the context that led to and culminated in this project, one that in the form of documents, records, and archives will be of interest in the future. In his concluding remarks to Norvell, Siegelaub notes, "What you're doing, from a purely archival point of view, is very interesting.... I could see someone wanting this information at some point." Indeed Siegelaub and the artists who participated in *Eleven Interviews* have an acute historical awareness or self-consciousness—almost all of them see themselves as historical subjects and strive to insert themselves into a historical narrative. This awareness prompted many of them to participate in Norvell's project in the first place.

Siegelaub in particular, who defines himself as the one nonartist or "dealer" in the group, is conscious of this sense of "making history." To quote him again, "Time will tell in terms of value what our positions were in 1965 or in 1969. [In] 1970 or in 1980 we'll look back and say, oh, yes, he was doing these things when." As a dealer, Siegelaub had to have an eye on the market and on the future, and he is keenly aware of his role in the production process, regarding himself as a "catalyst" or, as Kosuth more cynically describes him, an "entrepreneur." Siegelaub continues: "The effect of what I'm doing, egotistically or not, you know, may not be felt until ten or twenty years [from now]." With this comment Siegelaub raises a question: what exactly *is* it that he is doing, and how? In this context how much does his role differ from Morris's? Is he not crossing the fine line and becoming an artist himself? Certainly that is how Kaltenbach and Norvell viewed him at the time: "He's becoming an artist," Kaltenbach states, though "he won't admit it." And do we now relegate Siegelaub to the role of dealer precisely because we see through the historical lens that he gave up the possibility of becoming an artist, whereas others continued to pursue their artistic careers? Or is it that the tenuous definition of "being an artist" that would have allowed Siegelaub to be seen as one in the late 1960s no longer holds sway? The answer, in any event, remains unclear, as does Siegelaub's specific role during the early months of 1969.

Any discussion of history is inevitably linked to the attendant problems of documenting, recording, fabricating, and shaping it for the future. Historical validation, indeed, is inextricably related to documentation, which is implicitly an effort to make sure that evidence remains to attest to what existed or occurred. As I have already suggested, we cannot underestimate the conscious strategies of the artists Norvell interviewed, all of them acutely aware of history, to ensure that some trace will remain. That many of the artworks produced by these artists are without a concrete or material base only lends greater force to my suggestion. It comes as no surprise that one of Norvell's key questions in the interviews is the role and nature of documentation in Conceptual art.[7] Even if we follow Morris, for whom *all* art has a brief life span and period of relevance before it becomes a footnote in history—"I feel like it's true of all art. You know, fifty years, a hundred years old, you just have the record. It's not alive anymore; it's completely dead as far as I'm concerned. And it becomes a record. Like art history's a record"—the question remains how artists conceive a legitimate residual "record." The divergent answers to Norvell's query represent some of the greatest insights of the interviews in this book, not only about each individual artist's conception of his art at the time, but also about the broader relationship of art to document, history, and photography.

For some of the artists Norvell interviewed, history itself becomes the subject and matter of the production. Kaltenbach is a case in point. His "Time Capsules,"

in which he claims to seal "evidence" for varying periods of time, are about history generally and about his specific role as artist in that temporal continuum. He made one of these capsules for the art critic Barbara Rose, specifying that the contents be sealed until such time as Rose believes Kaltenbach has "attained national prominence as an artist." He designed another for the Museum of Modern Art in New York, designating that it be opened upon his death. In this instance, both the subject and the form of Kaltenbach's work are purely archival or documentary.[8]

But not all the artists featured in *Eleven Interviews* so directly link their artistic output to history. For Kosuth and Weiner, for example, the process of documentation takes place with the help of the very language that both is and accompanies their work. According to Weiner, language replaces the need to document: "Documentation can be distracting, which is why I prefer for the work originally to be seen just in language.... I don't take photographs." But a language-based art still needs a record. For although Weiner will never show the photographs of his work in a gallery, they do exist—precisely for the purpose of visual documentation in an exhibition catalogue.[9] To what extent, one might then legitimately ask, is such a catalogue freestanding, as in some of Siegelaub's exhibitions, and to what extent is it merely an archival record of something that once took place?[10] Catalogues also record ownership and property rights. As Weiner notes, "In 1969 anyone can copy anything that they want, exactly," so that "complete proof of receivership" is located only in the "title." Indeed the establishment of ownership is prominent, even conspicuous, in exhibition catalogues of the late 1960s and 1970s that feature Weiner's work: following the title and date of each work, the catalogues make a point of indicating the collection to which it belongs. *Eleven Interviews* thus invokes complex issues of where something identified as "art" begins and ends. The project also obliquely addresses the boundaries of a Conceptual artwork and the appropriate way to view all the closely related accompanying information: legal documents, catalogues, artist statements, preliminary models, schemata, photographs, sketches, maps, and the like. Is this, one might legitimately ask, the acting out of the late-1960s Derridian maxim that "there is nothing outside of the text [there is no outside-text; il n'y a pas de hors-texte]"?[11]

Kosuth, at one point during his interview with Norvell, openly reads a passage from an essay that he wrote so that his thoughts as she would record them would be articulate as well as coherent on that particular day in early April 1969 and, perhaps more important, in sync with what he had already said and was about to begin publishing in international art magazines. Thus he quotes himself. Similarly, a vital part of Smithson's, Morris's, and LeWitt's art practice was the dissemination of their thoughts about art in the form of magazine articles. Kaltenbach,

by comparison, would take out self-promotional advertisements in *Artforum*, whereas Barry, Weiner, Kosuth, and Douglas Huebler occasionally publicized their work in 1969 through interviews that, unbeknownst to readers, each artist wrote entirely by himself. All these printed or published forms function as a record. The printed text or essay as an element of artistic production is central to the British Art and Language group and constitutes an indispensable portion of the work of Conceptual artists such as Dan Graham, Yvonne Rainer, Daniel Buren, and many others around the world. The self-promotional advertisement, postcard, or faux review make up an important strand of Conceptual art by artists working in the Northern Hemisphere (On Kawara, Lee Lozano, and Marcel Broodthaers) as well as the Southern Hemisphere (Eduardo Costa, Roberto Jacoby, and Raúl Escari, all from Argentina).[12]

I want to insist, however, that records not only validate and affirm but also fix or freeze meaning. Indeed, that particular characteristic more than any other may lead Oppenheim to observe that the documentation of his recent work "is the weakest part of the aesthetic," for as he goes on to explain, the work is concerned with how "a particular medi[um] move[s] in time and place. And to solidify this through a photographic abstraction is ripping a thing that's going with a certain force out and throwing it back to the dormancy of a rigid form of communication." At the same time, Oppenheim acknowledges the popularity of the photograph and believes that to resist this trend, an artist should allow a "piece to live only in its own location. If others want to document it, I suppose you can't do much about it." Like Weiner, then, Oppenheim declines to be involved in any form of documentation. Barry is similarly dismissive: "Documentation sort of gets in the way of the art," he tells Norvell as a segue to his claim that he will no longer provide photographs to supplement magazine articles that feature his work. Moreover, he insists that even he has made photographs of his installations in the past only to "prove the point that there was nothing to photograph." This refusal to record creates a conundrum for the exhibition director, curator, dealer, or gallery. Here, for instance, is Siegelaub on the greater difficulty of showing Barry's work in comparison with that of Kosuth and Huebler: "In the case of Kosuth you have a newspaper. Even though it's not in fact the art, it's a record of the art—a public record of the art. Huebler has photographs.... But Barry is quite a bit different. There's absolutely nothing." Thus the challenge is how to make something out of nothing.

In sharp contrast to Barry, however, others embrace the inevitability of documentation and, indeed, the necessity to record the existence of their work for the future. Some of the artists incorporate documentation into the initial process of production, preferring to have an active hand in determining what record will remain. Huebler, for instance, states that "it's the documents that carry the idea.

And documents have to exist." Likewise LeWitt tries "to show everything.... Plus all of the working drawings.... Afterwards, there were the finished drawings, which I did after the show, and then photographs.... I wasn't showing a formal sculpture. I was showing a thought process." Note, though, that for LeWitt documentation not only functions as a record but also, like a musical score, elaborates further on the work.[13] Documentation in the form of maps and photographs is also integral to Smithson's work. At one point during his interview with Norvell he describes an upcoming project as follows: "The documentation will be two maps: a map showing the points of removal on the cement company site, and then there'll be a map of the museum grounds.... I'll probably document that through photographs." Smithson continues, "The photograph is in a sense a trace of the site. It's a way of focusing on the site. For instance, if you take a trip to the site, then the photograph gives you a clue to what you look for." Photography here serves as a scientific tool, one that aids surveillance and helps implement vision—making visible what is naturally invisible. The photograph becomes an accessory to the event, singling out "instances or moments in time and present[ing] those along with other deposits." Touching on what Fredric Jameson in "Periodizing the Sixties" sums up as the shift toward "a culture of the simulacrum," a society in which representation supplants what was previously known as reality, Smithson posits an inversion: we now see "the world through photographs and not the other way around."[14] I do not want to belabor the parallel, which is meant only to be suggestive. But it should come as no great surprise that Smithson, an amateur archaeologist and amateur geologist, emphasizes the scientific aspects of photography and the necessity for documentation in the form of charts, traces, and mappings.

What makes the situation still more complex, however, is the anxiety several of the interviewees expressed about the relationship between the process of documentation, of material record, and the original art object. For if the document is linked inextricably to the initial thought process or idea, as in the case of LeWitt, Weiner, and Huebler, then it should logically be granted full status as an artwork. Surely this is what Barry refers to when he remarks, "I really don't like most of the documentation that is done, anyway. Some of the documentation has to be so involved that it just becomes like a little art object itself." This passage is revealing on several counts. First, it relies on a set definition or conception of art as pure and separate and ultimately exclusive. Second, it acknowledges the proliferation of documentation accompanying works of art. Finally, it sums up the apprehension expressed by several of the interviewees about confusing the boundaries between artworks and documents, between art and information about art. The paradox is that it was precisely the limited definition of art Barry's statement implies that so many other artists at the time were questioning.

Morris too is quick to draw a distinction between art and document, or art and information. Though he does not dismiss the necessity for documentation, as Barry does, for Morris the status of documentation is secondary to that of the original piece: "Documentation is like a residue or sediment.... but it's like one edge of the piece. And it has a sentimental value more than anything else. You can't locate the work in terms of its record. It's like a series of snapshots or something." Morris clearly predicates such comments on his worry that the public may unwittingly mistake the record for the art and in so doing miss the artwork altogether.[15] I want to emphasize that in expressing concern here with the initial integrity of each of his works, Morris contradicts his earlier claims to equanimity about the fate of any particular piece. What I find both unexpected and suggestive, however, is Morris's use of the term "sentimental," resonant with allusions to mass culture or kitsch. His use of this term parallels Huebler's characterization of some of the photographs accompanying his work as "ornamentation," though for Huebler in other cases the photographs function as "absolute documents when they are what the piece is about." The terms "sentimental" and "ornament," when uttered by male artists, are especially problematic, for in the modern period both have often been culturally codified as feminine, inherently superficial, linked to mass culture, and thereby denigrated.[16] And here we might recall that Weiner disparagingly refers to making photographs as "touristitis." Such references to photography's documentary function betray a clear contempt for the medium's use in Conceptual art.

The fear of misinterpretation is another manifestation of the tension between the "real" and the "sign" in an era increasingly dominated by simulacra. The photograph, or whatever form of documentation is used, functions as a substitute or a sign that, as Siegelaub says in reference to the work of Huebler, "something has been *done*." But the documents themselves are neither the central event nor the referent. As in the theories of a "society of the spectacle" in the 1960s, with signs replacing their referents and gaining ascendancy and primacy as sites of value, the documents accompanying the work of most of the artists Norvell interviewed challenge the purity and self-sufficiency of the work of art and upset the hierarchical relation between what Siegelaub referred to as "primary" and "secondary" information.[17] As Huebler, who uses maps as documentation, observes, "The map is only a chart, you know. It isn't [a] real thing, and yet we begin to assume it is a real thing." The "real thing" to which Huebler refers is presumably the ephemeral art event—though some, like Weiner, maintain that an "event can never be art." But as Huebler seems well aware, if the ephemeral art event is documented, then nothing prevents the documentation from metonymically standing in for the discrete art object. Indeed, much of the contemporary development of early video art can be tracked precisely as the documentation of events or per-

formances. The performance that transpired is now available in a format that can be replayed and, perhaps more important, distributed for sale. Whether this constitutes art, however, remains unclear. Siegelaub recalls shows that include photographs of different artists' work: "In some cases the artist takes [the photograph], but in other cases they don't.... [T]his work of art was here even before these photographs were made.... Because all this is a record of the work of art, which is right behind it all, in a way. It's not the work of art." But as we have begun to see, sometimes, as in Huebler's work, the artist carefully differentiates between the photograph as an accompanying document, or "ornament"—an accessory to the piece—and the photograph, and more generally the process or procedure of documentation, as the subject matter, with the piece existing in and of itself as photograph. In fact, at one point Huebler explains to Norvell that photographs he recently took of various sites in New York City functioned as both the artwork and the record, with the boundaries between the two completely effaced.

At stake is a process of redefinition, not just of the discrete status of the artwork and its immediate limits (nothing new here), but also of its extended record and legacy. A number of questions arise in the interviews: Do the works under consideration function as discrete material objects or as entire thought processes? If they are entire thought processes, then what are their concrete manifestations? And shouldn't these be traced and recorded as well? And if they should, is it possible to fragment and separate out the constitutive elements of what is actually an entire process? That is to say, can the process be fractured and the pieces broken off from the whole, or does the process consist necessarily of a consummate whole? This problematic is invoked and worked through in some of Kosuth's comments to Norvell. For instance, Kosuth explains the status of his Photostats, which, he states, were initially not works "of art at all, [but] just ... blowup[s], you know, of the idea. But, of course, over time they become considered paintings, they looked like paintings because they hung on a wall.... I mean, art's the idea, so it doesn't really matter what physical shape it's in." Here Kosuth introduces another important issue: the role of the form of a work of art. Is it not disingenuous to declare that the "physical shape" doesn't really matter? Clearly, the precise shape and form *do* matter, for they determine how a piece is to be exhibited in the first place. Indeed, how to show something that in many instances is just an idea or a thought has challenged Conceptual art from the beginning.

The challenge helps explain the preoccupation in these interviews with the record or document—with proving something's existence. As LeWitt acknowledges, "Some people's art only exists in the documentation. Well, the wall things of mine are a good example because once a show is over, they're destroyed. The only thing that remains is a photograph of the wall, a drawing of the drawing,

and maybe a verbal description of how to draw it. But the thing itself is gone.... That's why I want to be able to use this kind of method that Seth was working on, because that's the only way that these things would be available in his catalogues." Because Siegelaub is referenced in his role of "dealer" here, we must assume that making "available" refers not only to distributing the art but also to selling it. And here again we return to the importance of the exhibition catalogue and its vital role in validation as well as distribution. For the catalogue becomes a show's physical trace, evidence of it, the remains that can be examined, the fossil, as it were, that also dates an exhibit, placing it in history. The exhibition catalogue that memorializes the artwork, archiving for the future, also serves as a marketing tool.

Closely linked to the catalogue, which accompanies and supplements the exhibition, is the gallery. Indeed, most of the artists interviewed by Norvell question the role that the gallery has traditionally played in the dissemination of art. Barry, Smithson, Weiner, and Oppenheim are openly antagonistic toward the gallery because the art they are making does not fit into traditional viewing spaces; Kosuth and LeWitt, however, still endorse the gallery system. LeWitt thinks "the gallery situation ... a very good situation in that it's an optimum way of showing things." Whatever the artists' stance, however, the gallery's limitations cannot be ignored, for they affect the relationship between artist, work, and exhibition catalogue.

The problem of the "showability" of much Conceptual art epitomizes these limitations. For instance, according to Barry, "The gallery, certainly as it's constituted now, has nothing to do with the kind of art I do anyway. I think that the methods that some galleries have used in trying to present art of this nature [i.e., Conceptual art] ... are very inadequate.... Certainly the galleries have had their influence on the way art looks." Barry's last sentence in particular candidly states the main problem galleries have with Conceptual art: galleries survive only by selling products, and if the products cannot be displayed or have no material form, they are much more difficult, even impossible, to market. But if some of the artists are antigallery, they are not necessarily antimarket. Here we glimpse the function of Siegelaub's organization of exhibitions that exist as publications alone, thereby eliminating the role of the gallery.

Then there is the art that does not address the operation of the gallery as much as it finds its institutional legitimacy within that matrix. Indeed, in some cases, as with Kosuth's Photostats, the gallery transforms materials that are not initially presented as works of art *into* art objects, and relatively esoteric ideas into commodity items. And yet, as Kosuth was undoubtedly aware, the idea itself was "presentable," in this case through the medium of a blown-up photostat that in many ways mirrors the traditional appearance of a painting (large, flat, hung on the

wall). This is the point that Oppenheim makes when he observes that "if all of your work has to, in some form or another, be injected into the bounds of the gallery syndrome or the art world, that means it's always going to be of a certain type.... And I think the photograph is kind of the panacea of the earthworks—terrestrial and concept-oriented art or the written word." It follows that photographs or other such supplements allow the display of Conceptual works—most of them impossible to exhibit in a gallery because of their spatial or temporal dimensions or their immateriality. The photograph or trace thus documents and legitimates both phenomenologically and economically, though the work runs the risk of being fundamentally transformed, of ceasing to be what it was originally projected to be, becoming instead only what exists in the gallery. As Siegelaub asks when trying to discern or locate Oppenheim's art, "Is it on that piece of paper? the photograph? the writing on the corner? Is the art out there? ... In terms of its presentation, you go out and see big blowup photographs, and what is it about? Photography?"

These questions lead directly to what today is something of a platitude in the art world: whatever the initial intentions of artists, art is inevitably transformed by the gallery into something marketable. What is less readily apparent, and what the work and commentary of the artists and dealer Norvell interviewed in 1969 indicate, is that perhaps more than any other form of documentation, photographs were perceived as excellent marketing tools, for they are relatively easy to produce, reproduce, and display. Indeed, as Barry points out, photographs also function well in the magazine context, which is as important as the gallery context for the presentation and dissemination of information about art.[18] But the very process that gives the photograph or other initially supplementary document (Siegelaub's "secondary information") the value of art makes untenable the belief that art exists in an autonomous space or sphere, thus underscoring how completely art by the late 1960s had become a market-driven commodity. Perhaps this realization more than any other prompted so many of the artists featured in this book to remain ambivalent, if not apprehensive, about the relation of their work to its documentation. Retrospectively, however, it is clear that the artists Norvell interviewed who have subsequently achieved the greatest commercial success are those who quickly figured out ways to provide the gallery with marketable documentation.

Altogether, then, we see in 1969 very real concerns about a slippage from art to document that parallels the more general theoretical shift during the period away from art as autonomous to the perception that all cultural products function on the same plane, without depth, hierarchy, and intrinsic value or meaning. This shift brings us back to the present day and to the status of these interviews, which, because of who and what they include, have been transformed from their

original format—the absence of Kosuth and Andre changing both the appearance and the subject matter of *Recording Conceptual Art*. As in Conceptual art, ultimately only the document, or record—what Norvell calls the "oral history"—remains. And just as the gallery and its limitations previously determined the shape much artwork would take, now the restrictions of a scholarly book determine the form of *Recording Conceptual Art*. But as with most Conceptual art, which was determined to overcome the restrictions of the institution of art, the rich nuances, contradictions, and at times outrageous claims of the participants in the interviews break through and provide a panoply of captivating, extraordinarily provocative moments that will differ on each reading and for each reader.

NOTES

I would like to thank Nora M. Alter, Stephanie Fay, and the careful readers of the University of California Press for their editorial advice.

1. In the late 1960s Hunter College's master of arts degree in art was roughly the equivalent of what today would be a master of fine arts degree (which the Hunter College curriculum began to offer only in the 1970s). For a thoroughly researched study of the historical and institutional framework of the master of fine arts degree in the United States, see Howard Singerman, *Art Subjects: Making Artists in the American University* (Berkeley and Los Angeles: University of California Press, 1999).

2. As with the five epigraphs, all of the unattributed quotations presented in this paper come from Patricia Norvell's master of arts thesis, *Eleven Interviews* (Hunter College, 1969). Nine of these are presented in this volume. The rights to reproduce the remaining two interviews (with Joseph Kosuth, April 10, 1969, and Carl Andre, June 5, 1969) were not granted by the artists. The interviews remain in the Patricia Norvell archives, New York.

3. Norvell describes *Eleven Interviews* as a process piece in the Preface to this book.

4. Morris's *Money* (1969) was included in the Whitney Museum of American Art's exhibition *Anti-Illusion: Procedures/Materials*, May 19–June 6, 1969.

5. Siegelaub is referring here to the exhibition *One Month* (March 1–31, 1969), and in particular to the participation of Carl Andre, Michael Asher, Dan Flavin, On Kawara, Sol LeWitt, Bruce Nauman, and Edward Ruscha in this project.

6. For Walter Benjamin's theory of history, see in particular his "Thesis on the Philosophy of History," in *Illuminations*, ed. Hannah Arendt, trans. Harry Zohn (New York: Schocken Books, 1969), pp. 253–264, and Walter Ben-

jamin, "N [On the Theory of Knowledge, Theory of Progress]," in *The Arcades Project/Walter Benjamin,* trans. Howard Eiland and Kevin McLaughlin (Cambridge, Mass.: Harvard University Press, 1999), pp. 456–488.

7. One of Norvell's standard questions is, "How does documentation function in your work?" See Norvell's "Introduction to *Eleven Interviews*" in this book.

8. For a further discussion of Kaltenbach's "Time Capsules," see Cindy Nemser, "An Interview with Stephen Kaltenbach," *Artforum* 9:3 (November 1970), p. 48.

9. As Weiner puts it at one point during his interview with Norvell: "You take photographs sometimes just out of the normal—what do you call it?— touristitis: you just take a photo. And the important thing to remember is that this just shows what the piece could look like if it's built. But I don't ever show the photos in a gallery or anything else. They'll be shown occasionally in a catalogue."

10. Siegelaub, by the time of his interview with Norvell (April 17, 1969), had published the following catalogue-exhibitions: *Douglas Huebler: November 1968* (New York: Seth Siegelaub, 1968); *Lawrence Weiner: Statements* (New York: Seth Siegelaub with the Louis Kellner Foundation, 1968); *Carl Andre, Robert Barry, Douglas Huebler, Joseph Kosuth, Sol LeWitt, Robert Morris, Lawrence Weiner* (New York: Seth Siegelaub and John Wendler, 1968); *One Month* (New York: Seth Siegelaub, 1969); *Joseph Kosuth, Robert Morris* (Bradford, Mass.: Bradford Junior College, 1969). Indeed, for Siegelaub the catalogue was fundamental even for shows that displayed pieces in physical space. As he states in the catalogue for the *January 5–31, 1969* show: "The exhibition consists of (the ideas communicated in) the catalogue; the physical presence (or the work) is supplementary to the catalogue." See *January 5–31, 1969* (New York: Seth Siegelaub, 1969), n.p.

11. Jacques Derrida, *Of Grammatology* (1967), trans. Gayatri Chakravorty Spivak (Baltimore: Johns Hopkins University Press, 1976), p. 158 (bracketed element is in the translation).

12. In May 1966, for instance, Jacoby proposed an exhibition that would consist entirely of information—a self-reflexive gesture in which the only object displayed within the framework of the exhibition would be its catalogue. Similar to typical exhibition catalogues, the one proposed by Jacoby featured descriptions of the works in the show, accompanied by critical essays, preparatory drawings, and other relevant documentation. All of these elements were to serve concomitantly to complete the illusion that an exhibition was presented by the catalogue, and through their combined discourse to affirm the conceptual presence of that exhibition, despite its material absence.

This strategy of artistic production was then articulated in the manifesto written by Eduardo Costa, Raul Escari, and Roberto Jacoby, "Un Arte De Los

Medios De Communication (Manifiesto)" [A Media Art], in *Happenings,* ed. Oscar Masotta (Buenos Aires: Editorial Jorge Alvarez, 1967), pp. 119–122.

13. As LeWitt states during the interview: "It's the same thing, if you like, if you hear some kind of music and it sounds like just a mess of sound. If you were interested enough in it, you could read the score, and the score may be much more clear than the sound."

14. Fredric Jameson, "Periodizing the Sixties" (1984), in *The Ideologies of Theory: Essays 1971–1986, Volume 2: The Syntax of History* (Minneapolis: University of Minnesota Press, 1988), p. 195.

15. As Morris informs Norvell: "With a lot of things that I've seen, the documentation of that presentation becomes overpowering to the idea."

16. For an early articulation of this link, see Siegfried Kracauer, "The Mass Ornament" (1927), in *The Mass Ornament: Weimar Essays,* trans. and ed. Thomas Y. Levin (Cambridge, Mass.: Harvard University Press, 1995), pp. 75–86.

17. The first lines of Guy Debord's *Society of the Spectacle* (1967), trans. D. Nicholson-Smith (New York: Zone, 1995), pp. 11–12, read as follows: "The whole of life in those societies in which modern conditions of production prevail presents itself as an immense accumulation of *spectacles.* All that was once directly lived has become mere representation."

 Siegelaub articulated the distinction between "primary" and "secondary" information in the following way: "For many years it has been well known that more people are aware of an artist's work through (1) the printed media or (2) conversation than by direct confrontation with the art itself. For painting and sculpture, where the visual presence—color, scale, size, location—is important to the work, the photograph or verbalization of that work is a bastardization of the art. But when art concerns itself with things not germane to physical presence its intrinsic (communicative) value is not altered by its presentation in printed media. The use of catalogues and books to communicate (and disseminate) art is the most neutral means to present the new art. The catalogue can now act as primary information for the exhibition, as opposed to secondary information *about* art in magazines, catalogues, etc., and in some cases the 'exhibition' can be the 'catalogue.'" See Charles Harrison, "On Exhibitions and the World at Large: Seth Siegelaub in Conversation with Charles Harrison," *Studio International* 178:917 (December 1969), p. 202.

18. As Barry explains to Norvell: "We unfortunately have to work with not only the gallery format but the magazine format. We're talking about photographs and so forth. How do you present an art that can't be photographed in magazines devoted to color reproductions and things like that?"

INTRODUCTION TO
ELEVEN INTERVIEWS
PATRICIA NORVELL

I originally wrote the introduction that follows to accompany the tapes. It has been copyedited for this publication.

This work consists of eleven tapes of interviews made during the months from April through July 1969. The individuals interviewed are Carl Andre, Robert Barry, Douglas Huebler, Stephen Kaltenbach, Joseph Kosuth, Sol LeWitt, Robert Morris, Dennis Oppenheim, Seth Siegelaub, Robert Smithson, and Lawrence Weiner.

The intent of the interviews is to record the thoughts, ideas, and feelings of artists (in the case of Seth Siegelaub, of a dealer) about their work in relation to current changes in art activity and artistic concerns.

The evidence of change centers mainly on the role of the object in art. For many artists the object as art is obsolete. In their work, either the object is eliminated entirely or, if it is employed, its formal elements are subordinate to such concerns as material quality, natural phenomena, natural forces, location, process, or system. Where the art object is eliminated, some documentation of the art idea is usually substituted. Thus what is presented to the viewer may be photographs, written documentation and descriptions, or spoken information.

Certain artists are engaged in making works that deal directly with the physical environment. Although some of these works retain a high degree of physicality, they are often inaccessible because of size, temporality, ongoing changes, location, or multiple locations. Consequently, they too require documentation.

For some of these artists, the gallery as a showcase for art objects has become unnecessary. The activities of dealers such as John Gibson and Seth Siegelaub reflect this development. The Gibson Gallery exhibits only models, plans, and photographs of work, either proposed or completed. Seth Siegelaub has no public gallery space. A large portion of his work as a dealer centers on providing artists with situations or opportunities to make art that does not conform to the object-oriented gallery. These situations or opportunities often take the form of published books of artists' ideas or statements and catalogues of international shows. Two immediate effects of the exhibit "space" Siegelaub offers artists are to expand the accessibility of art—it can be bought or seen in books, newspapers, and catalogues—and to remove it, as a no-longer-transferable commodity, from the investor's world.

One difficulty these new works can encounter is the observer's reluctance to relinquish formal definitions and concepts as a basis for seeing and judging. These interviews were an attempt to clarify these elements for some of the new work. The primary questions covered in each interview are

1. Currently what are your artistic concerns and how have they evolved?
2. Are you concerned at all with formalist artistic issues?
3. Are you concerned with art objects?
4. Do your aims dictate the presentation of your work and, if so, how?
5. Or do you have choices in its presentation and, if so, what kind?
6. How does documentation function in your work?

The contents of the tapes speak for themselves. Generally, the artists address most of these questions when discussing their work. The tapes are records of individual points of view.

Since I wanted to keep the interviews intact, the tapes have not been edited—no deletions, no additions, no corrections. This results in repetition, ramblings, misunderstandings, pauses, and mistakes that would usually be edited out or corrected in an interview. One should bear in mind that the tapes record the thoughts and ideas of the individuals involved on a specific day. Some or much of what has been said might be revised by the individual today to reflect changes in his ideas and attitudes.

The tapes retain as much of the original interview situations as is possible without a visual record. This type of documentary interview provides information without analysis, interpretation, or criticism.

The tapes were transcribed verbatim to preserve the original concept and process
of this project as well as the historical veracity of the tapes themselves. Two artists
objected to this process: Carl Andre and Joseph Kosuth did not want to partici-
pate in this book unless they could edit their transcripts. Therefore the book went
forward without them, and their interviews do not appear. For ease of reading,
most "ums" and "ahs" have been deleted, run-on sentences have been grammati-
cally concluded, and punctuation has been incorporated to reflect the recorded
emphasis and meanings of the conversations. Brackets are used to indicate words
that have been added or altered. Totally indecipherable or inaudible passages are
noted, again in brackets, in the text.

DENNIS OPPENHEIM

MARCH 29, 1969

PATRICIA NORVELL: We are obviously in a very active period of expanding and redefining the boundaries of artistic activity. Jack Burnham has recently suggested that at the present a systems aesthetic is the major paradigm for the arts, and that we are in a transition from an object-oriented to a systems-oriented society.[1] I'd like to find out what your artistic concerns are, and how they evolve, and whether you're at all concerned with objects or formal artistic issues. How do the aims of what you are doing demand how you present? Do they dictate your presentation and, if not, what choices do you have in the presentation? And then one of the main problems seems to be the documentation which you are very actively involved in. How do you handle that?

DENNIS OPPENHEIM: Okay. Well, let me see, first of all, Burnham's writing on an alternative to object sculpture I read, and I think that for the most part he's ... ohh [laughs], what's this, an entourage? [Interrupted by people leaving] What was the question? [Laughs]

PN: Mainly I want to know what your concerns are. How you came to them and how ... ?

DO: Well, the aspect of objects, an object-oriented art, I think, is being rigorously examined by young sculptors. I think due to the clarity and the success of some of

the past sculptors—[Donald] Judd, [Robert] Morris, and [Carl] Andre—it became clear, or at least evident, that a point had been reached in a certain kind of work that couldn't really be extended. If much more time were to be spent on Minimal art, it would just be a redundancy, just a melee of reoccurring issues. So I felt this very strongly a few years ago and, ah, I felt in my own work a kind of an impasse with the manipulation of manual exertion over the media and the hindrance it seemed to have when placed inside of an exhibition hall. And all of these aspects I think are related and eventually were what overthrew the object, in a sense. [Pause]

Now the approaches other than object-oriented art are vast. You can examine them at this point in the new art—how sculptors are detouring from the preciosity of objects and the kind of thinking that's controlled by an object-oriented idea. My first attempt to work outside this range was very much in the bounds of a gravitation area. The part of an object that I wanted to dismiss was the fact that it seemed to protrude. The kind of objects I wanted to get away with or from were static protrusions from ground level. So to defeat that or to work around that I dug a wedge inside of a mountain in Oakland. And this did two things. It first of all created an immobile, ephemeral, nonrigid form, but it also created a piece of sculpture that was bound to its location. And in that you're using a viable medi[um] of a living kind of tissue with the earth, what you find in the earth. You have to certainly focus upon the applications of this. But I think more importantly with that indentation or with that hole, there became the question of where exactly is the object. If that hole is an object or if a hole is an object, then is it the indentation or the peripheral? And by scribing into land, where does your piece leave off and where does it begin? So I think that was a very important, or is a very important, part about excavated forms.

PN: Do you think that's true of Michael Heizer's work?

DO: Well, yeah. I think any hole made in the ground, especially an isolated excavation with a large area of land around it ... Ah, I mean, is your piece a large area of land with a hole in it or is it a hole? Is your piece the entire globe with a hole in it? I'm sure it is. I think that's the only way to evaluate it. I mean, it seems reasonable. I know your focus can be twofold. There's the negative area, but there comes a point where the negative area ends and the terrain begins and extends. So it's all part of the media, ah, and even as you extend your peripheral or periphery onward into different zones and regions, it still applies.

Another aspect of this art that I think is very influential to new sculptors is the fact that you are making something by taking away rather than adding. And this seems to have borne many fruits, pieces involving removals.

PN: You mean pieces that are on a grander scale. Because sculpture used to be that way—with stone carving.

DO: Well, yeah, there's been a lot said. What's more important, the finished Greek form of a residue of the chips, or the ... Is the finished piece as good as the raw form from which it came? But I don't think artists have ever been concerned with removals or the residue of an act. And although a lot of sculpture, a lot of technique, involved taking away, it wasn't concentrated upon, it wasn't focused upon as being a piece. I mean, like, I have ideas for pieces that involve merely sterilizing a surface, just a mere disinfecting of an area, as being the conceptual focus point. So this has never really been a concern in past terms. Although the process of, again, removing or eradicating has certainly been an elementary basic in sculpture.

PN: How do your aims actually dictate how you present your work or how you execute it?

DO: Yeah.

PN: For instance, your rice field. What are your concerns in that and your aims? Is that something that carries through all your work? And then how is that dictating the way you execute that piece and how you present it? And how you document it?

DO: Yeah.

PN: Your work is very concerned with all of them.

DO: Yeah. Well, I think the documentation of these terrestrial pieces is the weakest part of the aesthetic. I don't really focus upon the abstracting of the idea from the origin. I do it for various reasons. Um, I think eventually there'll be a solution for this. The aspect of the documentation that I would tend to reject is that it's taking us back into an object, or into a rigid static kind of form which is exactly what the new work doesn't imply. A good part of the processing pieces that I've done are pieces that involve following the processes of [how] a particular medi[um] move[s] in time and place. And to solidify this through a photographic abstraction is ripping a thing that's going with a certain force out and throwing it back to the dormancy of a rigid form of communication. The only way I can see right now of getting away from the advent of a photograph, which seems to be very popular now, would be to stop doing them and to allow your piece to live only in its own location. If others want to document it, I suppose you can't do much about it. The hope, and it's a bit pragmatic, is ... I think the eventual goal would be to try and execute your work or effect your work and have the communication operate within its own bounds or within the bounds of the piece. In that way the sculptor's role would be to interact or effect change within the network, and his piece would be the effect or the changes created from his imposition or his injection. So this could be compiled—again I suppose, we would have to revert to some form of study, some form of abstraction—to bring this information to be articulated again or viewed. It's a problem.

PN: Yeah. Because you don't get a total sense of anything, or maybe because they're too large of a system to . . .

DO: Well, I really think that the act of putting art up for viewing into galleries has to be examined. I wonder if it isn't . . . I wonder if it ever occurred to a person that in order to do that, in order to transcribe information onto . . . from one form to another and to house this inside an area for viewing or contemplation, cuts out an incredible amount of things that don't qualify, that just can't enter into these bounds. I mean if all of your work has to, in some form or another, be injected into the bounds of the gallery syndrome or the art world, that means it's always going to be of a certain type. It's going to be the type that can, and not the type that can't. So if we continue to think along these lines, I mean if we just won't accept art that just can't be communicated, then I suppose that's, in a sense, a loss for some. If some want to pursue an art that is esoteric and for themselves, and however it gets out, it gets out . . . I think the exertion made by artists past and present to tell people what they are doing has to be seen in some ways as a limitation. I mean all things can be handed over, but with the rigors which we now use in this art-world thing, it always kind of comes out with the same stamp. And I think the photograph is kind of the panacea of the earthworks—terrestrial and concept-oriented art or the written word. I mean, there's a certain loss; there's always a loss through abstraction. I mean, what's wrong with leaving the artwork where it is? [Pause] Leaving the piece done . . . Just do it, do it without trying to spread it around.

PN: But then what is the effect of it?

DO: Well, that's to the artist to follow. I mean, perhaps some of . . . A characteristic of the new artist will be this esoteric aspect, the fact that he doesn't need . . . in the fact that his work can't be sold, it can't be moved, it's ephemeral, it's ethereal, it's conceptual . . . the fact that it doesn't have the rigid body of past work. Perhaps he's not going to need the ah . . . kind of order that the past art has required. The gala openings . . . this kind of thing may not be essential to the new artists. I really don't think it will. I think the artists will just function and work as artists, and the abstraction and the showing and this stuff is going to become very much in the distance, very secondary. I mean it's starting to happen now. There are a lot of artists who don't document their works, they don't talk about them, they just do them.

PN: They are hoping their works have an effect on people.

DO: Yeah, well, the effect will come from the firsthand encounter, one hopes. I know a good part of the effect of some of the pieces done by some college students in Philadelphia came by secondhand abstraction. Some students who dumped leaves inside of an elevator and did a few things, really some nice pieces, and of course very few saw the work . . . [It was] just relayed by word of mouth. Maybe that's how new art's going to get around. Word of mouth. [Laughter]

PN: What about the time element? That's one thing that's changed, I mean it's changing, and that's something that interests me.

DO: I don't know much about time. What exactly are you talking about?

PN: The time element in the rice field is one example.

DO: Yes.

PN: If you want to talk about it. I mean there's a whole new time element. The time it takes them to cut the field and move it. It takes months and months for that piece to be executed.

DO: Yeah, well, again, I think the new art is ... There's a paradox here. I mean one has thought to reach timelessness, the critic's notion of a timeless object as being not only of universal consciousness but of a solid form of rigid matter that will live through the ages. I think [the] most timeless art of date [of today] is going to be this new seemingly ephemeral, process-oriented work because the major force of this work is its surge upon an effect, its direct assault upon a particular motion or a momentum. And its change can be recorded endlessly, through endless permutations. Ah, in that these pieces are working, involve outdoor areas, they involve an ecological kind of framework which, when effected by the artist, can create numerous side effects which themselves can reiterate almost a constant, never-ending change. I mean it's like a continental drift: it just will have its effects, because as soon as it makes a change, that change magnifies the additional change. This of course just keeps on going. So in that sense this new work has a very long span of existence.

PN: Do you think you are making any moral choices?

DO: Ah. Moral choices?

PN: Are you interested in the effect of what you are doing on mankind?

DO: Umm. Well, yes. Again, I think this work is going to reach the heights of public art. It's going to use work that's in the framework of the entire universal complex. So it's going to affect these people directly. And naturally it's on the artist's mind ... the way in which this is going to be, or the effects of this.

PN: In the pieces that you are doing now—of moving surfaces and transporting them—how do you make the decisions as to how you're going to cut the field or how you're going to transport them? The storage and things are done by the terrain, but how do you make your original choices and why are you making them?

DO: Well, I study a lot of contour maps, quadrangle maps, and I walk around the area. [For] my first piece in New Haven last summer, I just bought a quadrangle map of West Haven and located areas on it that I thought I might like to see. One spot turned out to be a kind of a grid, ah, or channels of water that separated large fields of swamp grass. This was next to a fertilizer factory and the city dump, which was very near the bay. And also on the contour map was a small elevation or a small mountain in the distance from this piece. So I took the contours of that

mountain—and I chose [this particular mountain] because of its size in relationship to this other piece of land—and I transcribed these mountain contours (I reduced the scale somewhat), transcribed them onto the swamp grass. So what I was doing was taking two-dimensional information that is an abstraction of height, inscribing it onto flat land so that flat land then contains the abstract qualities of height. And I filled these cuts with residue from a machine boring aluminum filings. I did this to ... Well, first of all, the piece, I should say, the piece, being located near the bay, was completely underwater at high tide, and I wanted something to kind of activate the grass, a visual kind of activation, while it was underwater. So I used the machine borings.

I liked the idea of just loose matter, just residue from solid form, as being part of the piece. That's really very much a part of my work, just loosely bound matter, just raw material, pulverized, granular matter—because there's a lot you can do with it, you know. There's a lot which artists haven't done with that distributional kind of form, form that you can scatter or toss up in the air, just toss up in the air. I'm really looking at all these things from almost a classical point of view, a very sculpturally oriented viewpoint. And because I do this I find it interesting, because I'm still very much a sculptor, but yet I'm beginning to embark on things that are usually concerns or have usually only been of concern to nonartists.

PN: You were talking about using loose matter. I wanted to know whether you were interested in it itself or whether you were interested in that for other reasons—whether that was a choice of material to use or whether you were interested in a material and the choices then were just how to use it.

DO: Yeah, yeah. Well, my choices in using loose or nonrigid matter basically stemmed from my first earth pieces, because essentially that's a structure of the medi[um].

PN: So then they're very closely related or evolved from formal art concerns.

DO: Right. Yeah, well, some of the newer pieces using liquids and matter in various states of composition and decomposition are now becoming a little bit more, ah, directed. [Pause] I'm working, about to work, with types of toxic or poisonous masses and matter ... using disinfectants as merely a way to, ah, erase periodically an area of bacteria which we can't see but which very much exists; ... using kill traps and poisonous ingredients to curb an extension of ... [an] organism or a boundary—change of boundaries—of organisms. So [I'm] using paint, rather than as an illusionistic field, as a medium to direct traffic flow or something like that. I mean just thinking in terms of raw material and sidestepping its use in past art, just using the stuff directly ... like almost following it from a source, the mine, and following the paint through all the processes, or the material to the end, and then using it for a specific act. It almost makes the reason that paint or mass was mined originally begin to tie in the entire process, the mining, to the end result. There's one piece that I'm going to do shortly where I am going to fol-

low the mining and processing of white paint—from the mining of the calcium, to the processing, to the distributing, to the eventual placement on the shelf. Then I'm going to use that paint, not as a visual surface, but to change traffic flow. Painters have never used paint to redirect traffic; they use it on canvas. So I think that's a subtle difference, some of the way this stuff is being inspected.

PN: Do you think then this is a matter of choice in what you are doing with it?

DO: Yeah, I just cite this as an example of how a material can be redirected and used and followed by an artist—that really doesn't have its tenets in the traditional approach. I mean, the fact that I use white paint to direct, to change the direction of traffic, ah, doesn't really imply I have much to say about traffic or white paint. But the fact that a material can be followed by an artist through a series of stages, and, ah, changed somewhat and used for a specific act, an aesthetic act again—that ... isn't a carryover from the past painterly concerns.

PN: Artists have just gone through a period of defining the area in which they are going to be involved and exploring it as much as they could. Do you think that people are now setting up similar limitations that they're going to explore to a certain point, or do you feel that you are opening up a larger ...

DO: Well, there are so many variables in the works that are now being shown. There [are] a lot of different approaches, I think. We're nowhere near the impasse reached by the gestalt-oriented or object-oriented art. Ah, I think that the new artists are going to have to ... or are going to require a great deal of help. I see a part of the new sculpture involving a tremendous compilation of data, knowing as much as possible, having as much information at hand as possible, being able to circulate through this information and using it for aesthetic transaction. Whether or not other artists are concerned with this or not, I don't know. I know many of them are going to spend a good deal of time trying to feel assured with this terrestrial kind of vision. They're going to bring to it a vestige of a loft-born art which is going to slow things down a bit. There's going to be a lot of misunderstanding of the potential or the things that a terrestrial art implies. And I think there's going to probably be a continual bog down because of the constant, ah, feeding into this thing of useless and irrelevant art-oriented acts. I think this art is going out of that uselessness into a form that will dynamically affect the culture. I think new sculpture will find a function.

PN: Do you feel just limited to sculpture?

DO: Well, I'm seeing it as sculpture. Umm, no, it's not. I'm not concerned with a theater. I'm not concerned with what we know as theater. Ah, I'm not concerned with the staged. I'm concerned with the real organization itself, not staging arbitrarily or for a theatrical effect within it. I think there's a difference there. But this kind of scope doesn't have to be viewed only by sculptors.

PN: Why do you shy away so from abstraction?

DO: Well, I just don't want to bring my ideas … I just don't want to weaken them through abstraction. They can live in abstract form outside of a visual abstraction. They can live in the, ah … I mean it's just more potent to leave them where they are. An abstraction is really a watering down, you know, especially in reference to this art, because for the first time the sculptor is actively working outside of a studio. There's no reason to carry this trade-school dexterity and subject his acts to a piece of matboard. It's a temporary kind of thing. [Pause] It's just going to take some gutsy people to get away from that.

PN: Do you feel that loft art is related to object art?

DO: Well, no. I used loft art as a definition of a concern, a type of sculpture which is really quite vast in its breeding but that was built inside of a loft. I mean there's only so much you can do inside of a loft.

PN: So it's like a medium then?

DO: Yeah. [Silence]

PN: It sets the limitations on what can be done.

DO: Yeah, certainly. I think the best of the new art is in many ways far different from the versions of a loft-, object-oriented image. It doesn't depend upon a compositional arrangement; it doesn't depend upon the kind of visual ingredients that were innately bound to the working and the material inside of a studio. This new art is working with things that just wouldn't occur to that kind of appetite.

PN: You were going to say something about Jack Burnham's …

DO: Not too much to say. Only that his statement that people are now more concerned with the way things are done than things, you know, I think is quite apt because there does seem to be a lot of possibilities for artists in the direction of the things that work around the object, or around the thing, or about the thing, rather than the thing itself. That's just one small part of what Burnham's talking about but, ah … Well, yeah, I mean people get very frightened when the limits are disengaged. I mean we all have limits, the world is a sphere, and that's our boundary, our physical boundary. So we grow out of the studio. We could just spend our life widening our boundaries until we're faced with the fact that we are just a very small speck. But, ah, I don't know.

PN: Now you were talking about a physical abstract. I'm talking about a theoretical abstraction of systems. Mathematics is a whole abstract field, a whole system, that has given, you know, given us a framework, a definite basis, and from there on you're free to do what you want with it. There are no limits, so long as you don't transgress the basic rules. And yet … the art that people are doing now is very much involved [with] systems, but no one is really taking it beyond a physical abstraction—except for certain people who are dealing with words, but then they're dealing with a different thing, they're still not dealing with one abstraction as a system. I don't see why it has to still be a physical phenomenon. Why are the con-

cerns being expressed in the mode that they are; why are there physical limitations put on them?

DO: Um ... [Silence] The alternative step is to be driven back into the range of symbols. I think past sculpture is being viewed very much as code or symbols. Opposed to what I think eventually will happen. Ah, when a sculptural force is enacted upon preexisting matter directly, and the piece exists on that plane and that plane only, where it isn't fed or recapitulated, where it isn't reduced or weakened through the visual abstraction, then how can you compare the two? The abstraction of your act is ... for what purpose does it serve other than to extend the idea to other people? I mean how far out of the range does the artist have to work, of his own range? I mean, I'm seeing abstraction in a very basic sense, a very elementary way. But this is a problem, because work is being done now that [engages] a larger arena or activity, and yet it has to be reduced back into symbols and such rather than be allowed to live in its own context.

PN: If it is abstract?

DO: We are assuming then that when an artist imposes an act, no matter what it is directly, as a direct assault upon the media of society ... let's assume the society is media ... everything is media. I mean, it is. And when the artist assaults that, when he affects it with the intent of an aesthetic transaction or interaction or activation, and without communicating beyond the act, then his act was not ... there was no abstraction from that. I mean, he just did it. Huh? So how does all that fit into what you're saying, if at all? [Laughter]

PN: What I wonder is why we are limiting ourselves.

DO: Yes. Who? Okay. The sculptors are limiting themselves.

PN: Yeah, to these acts. When what he's dealing with on a theoretical basis of, say systems, or affecting things, or conceptually concerned with activity, why is he limiting himself still to these physically bound activities which have these residues, visual residues or object residues, when he could be extending it beyond that into an abstraction?

DO: Yeah, but carrying it back into an abstraction, Patsy, would be carrying it right back into the visual world, right?

PN: I don't know.

DO: It seems to me that we've just gotten out of the world that you want to go back into. I think painting has dealt with this abstraction.

PN: Yeah, but you're still abstracting from ... you're abstracting, you're not ...

DO: I'm leaving it from where it came. Painters have had a reverberation ...

PN: But you're still ... with physical, with physical ...

DO: No. No. Physical in terms of an intangible kind of physicality, I mean, like wave lengths, time. Sculptors have never been as dynamically involved in time as they are now.

PN: Yeah.

DO: To do a piece that is located like on a time zone, you know, they just haven't done that inside lofts. Unless the loft happened to be on a time zone! [Laughter]

PN: ... on an airplane ... flight zone out of Kennedy.

DO: I mean there are all these physical things that are much more aesthetic that can be used sculpturally or by sculptors. So to abstract ... and let's assume that there is a certain potency and a certain rapidity and vastness of scanning that is part of the abstract ... by abstracting, you gain more; you allow for greater clarity and more profundity in a sense. But why is it that we can't think in terms of injecting that same dynamic of abstraction onto the real network. I mean, I know that our mind is more fluid. Our imagination is ... can be vastly more creative when it's not, ah, bound to a physical task. And a thought, a pure thought by itself, without the attendant of the physical load, can seemingly reach higher strata. But what's stopping the artists from generating some of this initial insight that's, you know, arrived at through a conceptual and imaginative vein onto existing matter? Why not actually invest your imagination onto, or superimpose it onto, existing matter and kind of see your ideas ... you know, just have them worked out. [Pause] I mean, it has to do with fantasy and nonfantasy. Abstraction ... theoretical abstraction ... That got me off track ...

I don't think I was very clear but I think in part I'm being kind of optimistic and grandiose to assume that the artist will ever aspire to any great ... will begin to parallel even some of the abstract quotients of past work by using a societal medium. I mean, it's obviously much more difficult for a sculptor to, ah, work in that range than it is with a piece of clay. But I think that's what these attempts are moving towards.

NOTE

1. See Jack Burnham, "Real Time Systems," *Artforum* 8:1 (September 1969), pp. 49–55, and Jack Burnham, *Beyond Modern Sculpture: The Effects of Science and Technology on the Sculpture of This Century* (New York: Braziller, 1968).

SETH SIEGELAUB

APRIL 17, 1969

PATRICIA NORVELL: Well, I'm not clear on how to start this interview because I'm not clear on what you've been doing.

SETH SIEGELAUB: Okay, well then I'll try to describe what I've been doing. [Pause] What I'm about in a way is that I sort of make available to artists, in a certain sense, certain situations in which they can make their art—certain conditions. Ah, it seems that in a certain sense there are not many opportunities in these areas of a newer sensibility in art for people to show their work. There aren't many contexts in which they can show their work. For one, the work is getting much more public. The work is getting much more, ah, less specialized in the area of experience. What I have been doing specifically is doing exhibitions and organizing publications that make available to artists different types of environments—I won't use the word "environments"—different types of opportunities for which they can make their art.

I publish from time to time—not that I'm a publisher. I have up until recently been a dealer. I'm no longer interested in being a dealer. I'm specifically interested in a few men as opposed to other men but rather interested in the idea of creating, ah … of being a point through which a lot of information goes in and out of, in a way. In a sense, my function may be very much like that of any tradi-

tional dealer, in a way, except that I don't have the public space. The nature of what I do and how I do it is much more private than a gallery in a sense. But I suppose that in some sense you could say I do, in a certain way, what they do. Except the type of art that I'm involved with and concerned about has to do less with materiality than ideas and intangible considerations, you see. And so because I deal with that, or spend some time working with artists making art in that area, the needs for presentation of the work, and things of this nature, are quite a bit different than just putting up walls and making them available to artists, which is what a gallery does. Because ideas don't have any weight, whereas materials and the people who make sculpture and painting tend to be much concerned about spaces because that's one condition of their work. But, you see, much of the work being done today, like [Joseph] Kosuth's for instance, there's no condition for space at all. Space is totally ungermane to the work. It exists in space on a different level. [Pause] So my adopting the need for dealing and consulting, functioning as an intermediary between essentially the artist and bringing it out to the community, one step beyond me—which is supposedly to museums, whatever, publications, or publishers—is essentially my function.

PN: It seems to me that your activity and the artists' activities are getting somewhat closer than . . .

SS: Yeah. Normally so, but I don't think it's any more unusual than it has been in the past with other interested parties in relation to artists. I don't think so. It seems I'm the only person who wants to get . . . It's not uniquely strange; it's just that no one else has taken the time. There are people like Dick Bellamy, who, at a certain point, you know, you couldn't tell where the artist stopped and where Dick began because he was so intimately involved. Ah, there are probably other instances, dating back to [Daniel] Kahnweiler at the turn of the century or so. But I don't think it's a unique position anymore. It seems I'm, in a certain way, able to do it, whereas no one else is able to do it. But that I suspect has more to do with the fact that no one else is really interested anyhow.

PN: I would think there would have to be desire . . .

SS: Right, right. I mean there isn't all that much excitement anyway. There's a lot of excitement going on with the art, but in terms of a public or something like that, you're essentially still talking to a void out there. There aren't that many people concerned about the men, or the types of exhibitions, I deal with.

PN: Do you want to tell me how you got started?

SS: Yeah. [Pause] I won't describe what I've done, I'll just give it to you as facts. In the early part of last year, there were a series of exhibitions with Carl Andre, Robert Barry, and Lawrence Weiner . . . The three [exhibited] indoors at Bradford College [in Massachusetts], but what they exhibited [at Windham College in Vermont] in April or May of last year turned out to be precipitous in a certain outdoor direc-

tion—Carl, Bob Barry, and Lawrence Weiner all made outdoor pieces in that situation. I've since done the "Xerox Book," the "March Show," the Douglas Huebler show, the publication of Lawrence Weiner's *Statements,* a show with Bob Morris and Joseph Kosuth up at Bradford, and I have a gallery, for lack of a better word, called the Gallery in California now.[1]

PN: What are you doing there?

SS: Well, Bob Barry had a show out there. In that situation, I've become sort of like a dealer in that way. We went out there and he made the show and I exhibited it. [Pause] What that means is not very clear either. His work in toto for the last year or so has been involved with energies, totally nonperceptible energies. And the series he did out there was called the *Inert Gas Series.* And what he did was just release a measured volume of five inert gases—helium, argon, neon, xenon, and krypton—into the atmosphere of Los Angeles. And they'll maintain their chemical integrity but will expand as well.

PN: Was this outdoors?

SS: Yeah, yeah. But there are no photographs. The show is not about breaking containers and releasing gas. He just did that. And I as a gallery just announced it.

PN: Well, that's one of the problems that the artists are facing: how to document their pieces because they're not able to be seen.

SS: Well, in many cases they are. There's no one who makes work quite like the way Barry does. Because he doesn't even have a piece of paper in the end to tell you. He doesn't even have a statement about something. When he's finished, he just has, you know, just the fact of having done it. It's his word that he did it at all. Ah, well, yeah, there are more general problems. Barry is a little bit different because in the case of Kosuth you have a newspaper. Even though it's not in fact the art, it's a record of the art—a public record of the art. Huebler has photographs. And there are various other means to transmit [the art information].

But Barry is quite a bit different. There's absolutely nothing. I mean, there's a piece in this room but you'd never know what it is unless I told you what it is. And even once you've been told—it's a radio wave piece generating radio waves—there's no way that you can be aware of it.

PN: There's no apparatus?

SS: Well, there is; there's an apparatus. I could turn the radio on, among a number of other things, but there's no way that you'd know it's there without me telling you. That's sort of a particular problem in the case of Robert Barry. But in the more general sense, what this is coming down to is that there are probably as many ways to do something as there are to do nothing. We're just learning about the other side, about the different ways nothing can be done. [Pause]

Before, meaning ten years ago, you could have said art was about information. Except the information before had to do with color, line, composition, and all that

bullshit, in which case the art and the presentation of the art were identical. [Pause] But here you're in a situation where the presentation of the art and the art are not the same thing. The art, in many cases, is over there in the bushes. [Laughs] And so, what you're getting to is that there are many, many different ideas and sensibilities around. But there are very few ways at this point to communicate what they are. You know, people use photographs, the written word. Doug Huebler's been involved in all this for the last two years, documenting things, like that piece—that's a complete piece. And of course its presentation doesn't have to be that way at all. It was shown on a table in an exhibition in January, I mean on a window sill or something, but that's only one presentation. It's not his decision as to how it's been presented. [Inaudible]

PN: What does he think about the presentation? Does he leave that up to other people?

SS: No, he doesn't care. It's not his responsibility. In other words, the reason for assembling this information is just to tell you that a work of art ... that something has been *done,* you see, whereas before, when someone painted a painting, what had been done and what you saw were the same thing. You had no presentation problem in the same way as this. Or even with Bob Barry's paintings of 1967, it was all there in front of you. There you needed to stretch the limit to know that they're one painting of four or five elements. Now it seems somewhat different. [Inaudible] So this problem of having a bottleneck of presentation, where you have all these different ideas, and everyone arriving down here with photographs, is one of the great things going on today. So you go into a room for an exhibition and you see, like, twenty men's photographs. But all the photographs are ... They all look the same, but in every case can represent a different aspect of a man's art. [The photograph] could be the art. In some cases the artist takes [the photograph], but in other cases they don't. Or, like with the written word or many other things. Ah, the problem of presentation of work is something which I have been able to get involved in, whereas other people haven't taken the trouble of just making available different avenues for presenting work. Before it had to do with just taking a space and making it available. But now, the problem becomes much more dynamic because there are many more different ways to present one's art. [Pause] In other words, this work of art was here even before these photographs were made. As a matter of fact, to see the whole piece you don't even need any of the photographs. Conceivably you could take any one of those things and the piece would be complete.

PN: Take any one of them?

SS: Just a written statement about what was done, you see. Or two photographs, not ten. Or whatever. Because all this is a record of the work of art, which is right behind it all, in a way. It's not the work of art.

PN: Right, I see that as a big problem with a lot of people's work. They present it and it's still sometimes an object.

SS: Oh, right.

PN: And yet there's a written statement of how they got there and it just seems like a stupid situation.

SS: Right, right. Well, not many people, not many artists … have been given that situation to be able [to] specifically apply their art to sort of a public exhibition condition. For instance, I said that there's a Bob Barry in this room now, and the only way you could be aware of this is if I tell you, but, you see, in this exhibition that I organized in January he had two pieces occupying a total room, two pieces in the room simultaneously. And because it was a public situation, there were markers up on the wall, standard stickers, which said "Robert Barry, 88 Megacycles," and "Robert Barry, 100 Kilocycles." So, while you didn't see the piece, you didn't have to be told about it the way I have to tell you in my home. It was a public condition. So that's a different way to present it. Because obviously I can't put a sticker up, because as soon as I do, that begins to become a work of art. Which is not the intention at all. I mean, these are just different aspects of how work is approached and how artists deal with this relationship. But in many cases, like when the Virginia Dwan had their earth[works] show, it was very misleading, because all it was about was photographs. You know, Mike Heizer had a big color slide which had nothing to do, you know … He looked like he was making light boxes or something. You know, it was a fancy presentation of something else. But of course at that point they weren't clear. And I don't know if, like, many people still are clear, where the art is.

PN: I don't think that's been straightened out at all …

SS: No, I don't think it has either. But I feel that by me making environments or situations available for people to use, things will change. Like this "March Show" [see figure 6], which I did … I just asked people to answer my letter and relate their art to the conditions I asked them to. And obviously some people's art is very germane to those conditions, whereas in other cases they're totally not germane to them. But that's, like, a man's choice. So by sort of eliminating, by getting into these possibilities, it becomes a little clearer, like, where a man's at.

PN: Right. One of the questions I want to ask you is, what were their artistic concerns and aims? What choices did they have in the presentation? It seems to me that you're giving choices.

SS: Right. Well, exactly like the "Xerox Book," which is a situation with all I requested. And this is a pretty standard format that I do for all my exhibitions. I give every artist the same available condition, the same money, even, when that's possible, when that happens. Everything. And actually the difference would be the art, or how they relate to it. So with the "Xerox Book" [figure 7] I just asked

for a twenty-five-consecutive-page project on standard eight-and-one-half-by-eleven-inch paper to be reproduced xerographically. And that was all. And let them do what they wanted to do. In some cases they were good; in some cases they were not so good. Likewise, with the "March Show" I gave each of the artists a day, which was quite presumptuous. And a lot of people did great things but there was also absolutely terrible shit in there. But I wasn't really concerned about that. That's their responsibility. Some people didn't want to have anything to do with it, because it wasn't germane, like Carl [Andre] didn't want to, or Dan Flavin—I mean, all for different reasons. I mean, in all there were seven people who didn't participate with a reply. But some of them consider themselves to have participated just by keeping the page blank, whereas others abstained not wanting anything to do with the damn thing. That's their decision, I don't really care. Some of them felt very uptight about being sent a mimeographed letter, and they didn't want to participate because they wanted a more personal approach. [Inaudible]

PN: I think that's something, though, that a lot of people aren't aware of. I mean, so far I haven't seen that much awareness of choices or of decision making about the work …

SS: Because naturally they go into the same situations. I mean …

PN: I don't mean specifically about your shows. I mean in general that …

SS: Well, because before the art and the information on the art were coincident. So you would put a painting on the wall, and that's all there was. You know, you didn't have that issue.

PN: But there were limits on what choices people were making.

SS: Well, you made painting or you made sculpture, and there was no question. [Inaudible] They were one and the same. Just like a piece of sculpture like this; it's very obvious … See, by being an autonomous, self-sustaining object, totally unrelated to anything else, you could do anything with it and the piece wouldn't change. There would be changes in perception and looking at it, but that's not an explicit concern of the man who made this—this is Huebler, about six years ago, five years ago. But you get into a situation of Weiner, this, in a sense, is what the art looks like. The same piece could look fifty thousand different ways. [Inaudible] If it was up here or up there. A piece was made … I think Joseph Kosuth has it, they traded a piece and it was an aerosol spray can, and it was sprayed too high so all this spray melted, you know, it dried before it hit the ground. So Joseph just swept it up and keeps the piece in a box. And Lawrence considers the piece having been made. This is only one aspect, one explicit aspect of his art, you see. Really, there's a piece of paper that gives me permission to make it, which is a little closer to what the work is about. It's a piece of paper that says "An Amount of …"

PN: You did it then?

SS: Well, this ... no. This I did. Yeah.

PN: You sprayed?

SS: Yeah. But he could have too. As a matter of fact, I think we both did ... I think Joseph helped too. But it really made no difference. But if I was bored with this thing, I'd just erase it, or I'd take it and put it in the other room. Or just scrape it off the floor. I mean, so it totally becomes ... But, like, if one asked [Weiner] at that point in his work what had changed, or if one asked him specifically what his work was about, I suppose (this is my impression) it would probably be specific ideas about general materials. [Pause]

And I suppose, my theory about Joseph [Kosuth]'s work is that, like, of all the artists alive, his work is about pure abstraction—pure abstraction.

PN: Kosuth?

SS: Yeah. He has no referential matter at all, absolutely no referential matter, no tangible referential matter. There's a big argument that can be made whether it's possible to have any ideas about nothing, or whether ideas always have to relate to a tangible world. It's a very legitimate argument. [Pause] Like, maybe it may be impossible to have an idea about something that doesn't exist in the world, which is one argument. But Kosuth would say, "No, no, that that's not the case at all." Of course you can have ideas about love or about, you know, meaning or definition—you know, things that are very abstract in their nature. But his work goes to a pure degree of abstraction. So there's no referential matter. His presentation is totally arbitrary. And these issues are sort of in a number of other artists' works since Joseph [Kosuth] or Larry [Weiner] or Doug [Huebler] got involved with it, but they don't have quite the *clarity* in their work. You never quite know, in a sense ... Like, with Oppenheim—where's his art? Is it on that piece of paper? the photograph? the writing in the corner? Is the art out there? After a while talking to him, it becomes a little clearer. You're probably clearer about it now. But in terms of its presentation, you go out and see big blowup photographs, and what is it about? Photography? [Inaudible] In other words, the conveyance of intent is of utmost importance. And I just like, in all cases, to clarify that intent for everybody. And it's done in many instances, like in the "March Show."

PN: Do you have any feelings about how this is going to resolve itself? How artists are going to get around? ... I mean, you obviously have a feeling because you are making decisions or choices for people, providing them with ...

SS: No, it just enlarges, in a sense, the scope of experience we know as art. I mean, how it'll resolve itself is just a moot issue, the way people used to ask [Ad] Reinhardt what you do after you make an all-black painting. It's just an absurd question. Ah, or [Jackson] Pollock or somebody. It's just ...

PN: I get the feeling other people are ignoring issues that are difficult to handle, for instance the presentation.

SS: Yeah, well, not many people in the position to exhibit are even aware of the issues. I mean, it's not an issue … Galleries or museums begin to become a cliché situation, because they're not equipped to deal with the art that's being made today. You know, they conform and it's new wine in the old bottles again. But I think that's becoming very obvious. And in a certain sense, that's why I've been able to function, because I create an environment that has nothing to do with space. I'm not associated with space. I don't have that load. You know, I have much more flexibility which I'll be taking greater advantage of in the next year. So it's like another situation. And the gallery becomes … If a man is not involved with art that concerns itself with space—the way, for instance, sculpture of any type does—but if a man is principally involved with ideas, well, you don't need a gallery to show ideas.

PN: No, right.

SS: A gallery becomes a superfluity. It's superfluous. It becomes unnecessary. [Laughs] It becomes unnecessary in terms of exhibition. It still retains its importance as the focus for money, for collectors, business and administration for an artist. But in this aspect of having a space it becomes totally meaningless.

If you broke down … Well, a few years ago I broke down, like, what a gallery does. What is its function? Its primary function is that it's a place for artists to put their work out. But it breaks down to many aspects. This is somewhat repetitive, but there's space, there's money, there's exposure or publicity, you know, there are a number of things. And I've just, in a sense, eliminated the idea of space. My gallery is the world now. This summer I'll do a show that will take place with about fifteen men in fifteen different cities in the world. And they'll make work, not necessarily outdoors, but make work germane to fifteen or sixteen cities.[2]

PN: Each artist will?

SS: Right. And I don't want to read implications into what I do; that's pretty stupid. But it doesn't need anything. The work is there. It doesn't need a space, I mean a space as we know a gallery space. The world becomes its space, which it always has anyhow, really. But I just want to deal with that aspect of it. This is how I think …

PN: It seems that you're making very definite choices, though.

SS: Oh, right. Yeah, because what in fact happens is that an exhibition, whatever that means now, is a very specific thing. [Pause]

PN: Under these conditions.

SS: No, any exhibition. An exhibition. I mean, if I say that I'm going to do an exhibition at the Whitney Museum, that's a specific situation. You know, you have to make a deal in terms of doing it there, and not necessarily somewhere else. In other words I'm making some choices, but I've been able to make choices on the basis of where I think the art is or what it's really involved with, you see. And

through the exhibitions, because I'm not a writer—I never write, I just do—through the exhibition certain things become clear (clearer, I suspect) by the making of the art. In the "Xerox Book" [see figure 7], everyone has twenty-five pages, and there's a concern in probably all cases with the repetition of something. But there are seven different aspects of repetition. And of the projects in there, only Doug Huebler and Joseph Kosuth don't deal with the addition of pages, don't deal with the amount of pages in the process of the Xerox. [Inaudible] Carl [Andre]'s involved the successive addition, the random addition of certain standard elements. Bob Barry's involved the accumulation of dots [see figure 20].

PN: Were the dots xeroxed on a page and then xeroxed again?

SS: No, no, a Xerox was made of the same thing twenty-four times and the last page was different ... But with the exception of Huebler and Kosuth they're all involved in a way with the idea of many pages of the same type, or essentially the same type. Lawrence Weiner's is physically just the same page twenty-five times. But within the context of his art, they're twenty-five different pages. It's the same statement, but it can be realized in twenty-five different ways. Sol LeWitt deals with twenty-five permutations of squares [see figure 24]. But that's their decision, you see. I couldn't have cared, you know ...

PN: I was surprised that they were all involved with an image on each page, whether it be abstract or not, and not with the whole system of the Xerox machine. I have a friend [Jed Bark] who's done a lot with the Xerox machine, and they're very beautiful things. [Inaudible]

SS: My thought about xeroxing—of course I have control over what the men did—was that I chose Xerox as opposed to offset or any other process because it's such a bland, shitty reproduction, really just for the exchange of information. That's all a Xerox is about. I mean, it's not even, you know, defined. So Xerox just cuts down on the visual aspect of looking at the information.

PN: Uh-huh. But a lot of their choices weren't appropriate for the Xerox machine.

SS: Well, perhaps ... [Pause] I expect that because of the art that's being made today there's a whole network of experience that is peripheral to the art. People like myself—anyone who doesn't make the art—are going to change, too, the idea of individual ownership of works of art and things like that, which are obviously becoming very passé conditions.

PN: Well, an impossible condition.

SS: Right. In many cases, it's totally impossible, because the experience is everybody's immediately. Anybody can have four tear sheets of Joseph Kosuth's piece by just spending twenty cents on a newspaper. Which of course is implicit in other conditions, of, like, how art is going to seek support, how the community is going to ... because the artists have chosen to involve themselves in the community ...

PN: Do you think that they are involving themselves in the community?

SS: Oh, yes.

PN: And how?

SS: Well, like the idea of one being able to take in all there is of a Joseph Kosuth or a Bob Barry by just opening their newspaper and reading about it, I don't see how you can involve yourself more. I mean, the information may still be esoteric but it's getting to them, you see.

PN: It's where they can get it if they want.

SS: Right. But it couldn't be more accessible. They may not understand what it is or what it's about, but that has to do with outside information. So in that sense, by making a piece that is an unlimited edition of, say, a million copies in the case of big newspapers, or something like that, you've ready made your art; you've extended your art to a million people.

PN: Right. Do you think there's much concern, though, with the artists about the community?

SS: Oh, I think that the obvious tendency is, on the whole, that. I mean, after one realizes that it's possible for any object or any material to be used for an art condition, or to be used to make art, the implication of an art whose condition is immediately public domain, say an experienceless art, in a certain way is … well … I've never heard any artist specifically concern himself with the community, but it seems to me to be very obvious that a condition of much art today has a lot to do with a desire to reach the community. [Pause]

PN: Maybe. I haven't gotten that feeling.

SS: I mean, men like Dennis Oppenheim going out to the countryside, and doing something in the countryside and leaving it. I mean, what can be more public than that?

PN: Yeah, but I don't think he's at all interested in the public.

SS: Oh, no, I don't think he is either but I'm not saying that. I've never heard anybody speak of the public, that they're interested in going to them. I'm just saying that it's implicit, it's very obviously implicit in the work that that's what they're doing. I mean, they don't make objects in the studio and leave them there, or put something out to only a few galleries. Instead its condition immediately transcends that, it's immediately out to the public. That's what I'm talking about. But no artist ever said, I want to reach the public; I'm going to do work outside. I mean, like, the New York show of sculpture is an absurd condition because it's just making the public aware of a very private art condition—art experience. There's nothing germane about that work being a public condition. But there's something more germane about Dennis [Oppenheim] doing something, even though it is off in Maine or something [see figure 1], out in the public space where anybody could take it in if they want just by going to the place. That seems

to me to be much more germane to the art. It's not a conscious purpose of the art; I'm not saying that. But one's awareness of it, one's communication of it, accessibility …

PN: I don't get the feeling from Dennis [Oppenheim] that he's aware that he may be affecting the public in any way. I mean, there doesn't seem to be a concern …

SS: Oh, no, no, no. I say I've never heard any artist say to me that they're involved in talking about the public. I'm just saying that the condition of the art being more public, as opposed to a more public condition—the fact that I explained the show of Robert Barry's in California to you, that's *all* there is to know. Someone sitting in the middle of California knows no more about that exhibition than you know now. That's all they have for it. They have a poster. [Laughs] But that's all. That condition is very, very important. The implications of that idea are very, very important: that you don't have to go to a museum to see a piece of sculpture. The idea that somebody will be able to hear about something and think about it in their home and still take it in as art without having to go somewhere. That's obviously the implications of such work. But it's not a conscious effort. It has to do with the internal need of the art itself.

PN: The thing that alarms me is the ecology thing or people, you know, tampering with the environment. It's going to touch a lot of people in an area wherever they are doing it. Like Dennis [Oppenheim] when he wanted to seed clouds and make it snow on San Francisco. He wasn't concerned with the people in San Francisco.

SS: Right, right.

PN: Which I think is a bit alarming. I mean the idea is not, but in actuality, the …

SS: But the people in San Francisco couldn't care less.

PN: Well, they'd care if it snowed three feet in San Francisco and they were, you know, getting killed. Maybe that's taking it a step further than the art is going to get. It's not a concern yet of the artist, though.

SS: No, no, I wouldn't … Ah, the idea of man changing his environment, or changing other people's environment in an art condition, is something that is obviously coming. I don't see it in any of the work that's being done today, but some of the ideas begin to imply that. I don't think the artists will work that way for the good of mankind. I don't see that. I suppose it would be a pretty groovy experience for people in Los Angeles or San Francisco to see snow. I don't think they ever have. That'd probably be pretty groovy. That's like a solo-type of experience. It's something to think about—whether you have three feet, or are totally inundated, or if you have a light little drizzle—you know, a nice little snow. It'd be pretty groovy to tell your grandchildren, "I was snowed on in Los Angeles!" [Pause]

I mean art is obviously beginning to reach out into provinces we thought were just, you know, life's. I mean, even just in the superficial use of materials, materials that were too common or considered verboten for art—putting art values

in—have been used expressly because they don't have the art load and can be seen the way Bob Morris's … [inaudible]. You know, especially because they don't have an art-connotative effect. They could be used freshly without, you know, the traditional hang-ups that normally make it art. There's a history of, like, marble or stone or welding now, something of this nature. This way of using things, taking them out of the life condition and putting them into the art condition, changing the context, changing the tension, has become a very, very, very, very important part of the art on many levels. Mostly in the area of materials. Even the idea of the claim of language being fine art, not poetry, not philosophy, but art, is a condition that … Well, since Joseph [Kosuth]'s been involved in it—he's seminal in it—it's possible now to be able to think of art in which language plays a non-poetic and nonliterary part. It functions purely as information. The same way that color was information before, language is beginning to function as information now. This is something that's already happened in the last few years.

PN: Uh-huh.

SS: Still, Doug Huebler or Joseph or Larry—Lawrence Weiner—in particular, get constantly thought of … the idea that they're making poetry or something. Joseph's accused of philosophizing, making philosophy or writing philosophy or something; Lawrence is confused with poetry. But that's only because people think that words are only capable of that type of information. [Pause] But that's the changing context. The same as when Carl [Andre] first made his bricks.[3] The idea of standard elements being put together to make a piece of sculpture. It's just like an absurd condition. It certainly was four years ago. It's fabulous what he did. It wasn't taken seriously. When I had his piece here, no one would really take it seriously as a piece of art.

PN: How long did you have it?

SS: About three years.

PN: And what would people do?

SS: Oh, they'd always trip over it then. People never trip over it now … People who see art never trip on it. It's only the other people; some people are not involved in art, a family or something. They would come in and knock it over because they don't think in terms of something that's on the floor being art. But people who are exposed to art would never come in and knock this thing over. And this is only in a few short years. Well, that's the process of acculturation. And it's part of history now.

PN: Right. But I think that one of the main things that's changed is that time is speeding up.

SS: Right. Oh, right. And that's pretty groovy. Because, what I think it means of course is that [the] artist gets his rewards quicker. The cause and effect between

what a man does and the community's reaction and response to it is quicker. And I think that's very groovy.

PN: That's still a very small community.

SS: Yeah, but I think that community's getting larger. I think they can't help but get … larger because of the fact that people will make something up in Maine. Or will go out and change the environment in California, as Bob [Morris]'s planning to do. How can they not get involved? I mean, after you take away the pedestal from a piece of sculpture, you're all operating on the same ground. And the implications of that … Okay, you finished working in a specified indoor area, and you take it outdoors to a public area … You know, all these things, you can't help it if people get involved. They may not like it. They may take another five years, ten years to understand it. But this time is getting shorter, as we've seen from Picasso when he did it to when he was recognized, or Pollock or Roy Lichtenstein. It's getting shorter; you know, hopefully cause and effect will be very tightly linked for an artist, and I like that idea. I think a man should be rewarded.

And the idea of an artist being an outlandish citizen in our society is a rapidly deteriorating idea. I think artists, for better or for worse, but I think for better, are being accepted as just other people in society. The same way, like, ah, they have this Art Workers' Coalition, running around from the Museum of Modern Art to pickets and things. And I'm kind of interested in some aspects of what they do … Why don't artists have an ASCAP [American Society of Composers, Authors, and Publishers] the way composers do? Why don't artists have a community of interest amongst themselves the way musicians have, an ASCAP or some musicians' union. You know, whereas a man can compose music and be relatively sure that when the music is played somewhere he gets royalties on it—you know, things like this—an artist has traditionally always been very skeptical of his neighbor and all this. Artists compete against one another and so there's been very little cooperation between artists for certain things. The only thing they can get together on is peace or war.

PN: Well, that's happening due to housing now.

SS: Oh, right. It's not even important what they do. I don't think, you know, it's fudging on an artist's integrity to be involved with other artists. I think that the best friends that artists have are probably other artists. And the people most sympathetic, most generally concerned about artists are other artists. Ah, it would seem very obvious that they should put together their interests against another world that couldn't give a shit about them, you know, except to collect their art, watch it rise in value, and donate it away or something. It would seem very valuable if they could get together in some organization to be able to express concern over their interests. If a work is loaned to a museum, you don't loan it for nothing.

The museum will pay a rental fee for the work. I don't see what's so outrageous about that. [Pause] People want to play music at a concert, and they charge everybody five dollars a head to come into the concert at the Philharmonic Hall. The composer gets a commission for playing one of his pieces, so why shouldn't an artist? I mean, it's obvious that it's a very rational consideration. But unfortunately, artists, up until very recently, have not concerned themselves with their interrelationship. They stuck with the idea that they were all in little proverbial castles in the air or something and each one had their own little area. They never talked to one another, or if they did talk to one another . . .

PN: They never trusted each other.

SS: Right, right. And now, the idea that they're all in the same boat . . . you know, their identification with Negroes, which is a lot of bullshit, really. But in the sense of what's going on at the museum with the Negroes and minority groups and things—but they are, obviously, an oppressed majority—you know, any artist would say . . . I mean, an artist, say, of Don Judd or Bob Morris's reputation, there's an artist, right . . . Well, like any half-baked executive in any shitty firm makes five times more money than they do. I mean, why couldn't they have the same reward? Well, of course they have the immortality, and the executive is going to die; I agree. But, by the same token, why shouldn't they get some rewards now? There's no equity there, because they're the last in line of what's important in our society, artists are. And that's beginning to change for the better. [Inaudible] But why shouldn't they combine in their interests? Obviously, the Museum of Modern Art, if everyone decided to not loan any work to them, or just make such great pressure on them so that every time they did a show they had to rent work from artists to show. Why shouldn't they collect? What they're doing is that they collect two dollars or whatever it is for admission, and they make a million dollars a year from admissions or something, and they take all that money and they give it to museum guards and restorers and paying their mortgage and in some cases, yes, collecting art, putting money back into art. But why shouldn't artists get some percentage of the gate?

PN: Yeah. I think the other things that people are saying about free admission and letting anyone show who wants, I think are dead fish. I mean, that's a silly place to be banging their heads up against a wall.

SS: Oh, right, right. Oh, there are a lot of very stupid issues there. But the idea of an artist having more control over his work and what's done with it are very legitimate concerns. There are a lot of very legitimate ideas. The idea of a Martin Luther King wing is absolutely stupid, but . . .

PN: But, like Joseph [Kosuth], how is he going to have control over his . . .

SS: Well, if he doesn't want any control over it, that's something else. He explicitly relinquishes control over it after he publishes it. That's one condition. But for some

fashion magazine to go to the Museum of Modern Art and take photographs and use art as a background, you know, that's a type of control. Or the fact that a museum should buy work at *x* dollars—or private collectors too, but let's say the museum—buy work for a thousand dollars and then sell it for two thousand dollars, and the artist doesn't get anything ... Well, what's that all about, you know? I mean, the inequities are so obvious that the artists are just coming to realize that if they get together with their interests, they'll be in a very strong position. Because this whole foundation, the Museum of Modern Art and all this horseshit—that includes collectors and most dealers, practically all dealers I suppose, and a whole network of things—it's all resting on this little thing called an art object over here. You know, there's this whole network of things going on, ranging all the way to *Life* magazine in Des Moines, Iowa. It's all resting on this small, little thing called an art object. And all they have to do is just withhold that, or just deal with that thing, you know, more intelligently.

PN: It's funny, though, that just when artists are beginning to stop making objects that can be used in that way, they're starting to protect them.

SS: Right, but you see, that all has to do with, I think, this idea of artists being in the community, a part of the community. There's no reason why artists have to be second-class citizens. The work itself is beginning to go out into a public condition. There's obviously something to be said about that interrelationship. They're not antithetical in this way. For in fact it makes no difference anymore what the Museum of Modern Art does with Joseph Kosuth's work ... has nothing to do ... They'll never own one; it will never be possible to own one of his works. Though, it would seem that by putting their interests together, regardless of quality or what they do, the artist can have a very strong position.

PN: Yeah.

SS: I mean, it's so obvious it's just absurd. Because when you have a contract to sign, a musician or something like that, you go to ASCAP, and they have lawyers and they take care of your interests and see that every time your record is played on the radio you get two cents or something, or whatever the agreements are. Why shouldn't the same situation hold true [for artists]? Or every time a man's work is reproduced, if he wants it reproduced, why shouldn't a man who makes the work of art control the reproduction of his work, you know, in magazines? There's this thing coming out that makes photographs, called the *New York Now* or something. It's a small portfolio and they have like five color photographs. I think Dennis [Oppenheim] was in one. I hope Dennis got money from it! I don't think he did. Right. Dennis was using it for publicity, okay, that's [considered to be enough]. But that's horseshit. He should have the publicity plus get the money, you know. But artists only lately are beginning to think this way. It's pretty absurd. Why shouldn't an artist get a percentage or royalty? It's only the magazine

that's making money. Okay, everybody has their problems. People have to pay royalties to artists for the use of photographs of their art. They may not be in business ... Well, that's a fact of doing business, you know. If you had to pay an artist a royalty for a photograph of his work, it becomes just as much a fact of life as paying a printer for printing, you know. One is obviously more expedient. Obviously the artist is hungrier, or at least is portrayed as being hungrier and more interested in having the exposure than in having the money. But, of course, with work that we're describing now, it doesn't make any difference.

PN: You can't make anyone pay for thinking about it.

SS: Right. Right. Really. So what difference does it make?

PN: Now, what are you doing about getting money? Are you going to, like, industry and things?

SS: No. No. I just deal with some patrons, rich people in the community. The same way money has always come. There's no difference that way.

PN: But what do you think about the involvement with industry?

SS: They have a lot of money. [Pause] They have sort of perverted interests in what they expect from art, the public relations value of getting involved with art, and all their business reasons to get involved. It's perhaps good. It's just another source of money. All money is the same to me. [Laughs] Big business's money or some private patron's money—it's the same thing. Big business is in a position to use it as a public relations tool, or whatever they want to call it, to exploit a lot of value out of being involved with art. But in the same sense, you know, certain collectors use the purchase of art to do the exact same thing too. But money is all the same. It's all green with numbers on it. It really makes no difference whether it's big business's money or not. [Silence] And the whole concern has to do with art. Money's standard, everybody has money; it's a standard commodity. But not many people make art. That's where *my* interests lie. So I don't make any difference; I don't have favorites. I don't believe in important collectors, only in important artists. [Laughs] It's an absurd thing.

PN: Yeah.

SS: Because I know some of the artists that I've been involved with have been approached by so-called judges like this. And they give you some line of horseshit about a very important collection, they say, "Sell it to me very cheaply because you'll be in my collection." And, you know, my advice to them is "Fuck you!" [Pause] That's their problem. You know, the artists can live without them very easily, but they're not gonna live without the artist very easily. Not if they want to make a reputation out of somebody else's art.

PN: Right. [Inaudible dialogue]

SS: Artists are now focusing interests. Like the Art Workers[' Coalition] have been focusing in on the Museum of Modern Art. Perhaps some real fat cats up there

deserve some scrutiny. The whole thing is a very archaic, self-centered, retarded institution.

PN: Yeah. I don't know. I wasn't looking at them [inaudible], which makes a difference. But my feeling was that, on the issue of an exhibition hall, they should just set up another situation of an exhibition center.

SS: Well, the first question is … it was my feeling a few months ago that … I don't think the Museum of Modern Art is worth the trouble. But if you're looking for publicity, that's perhaps as good a focus in the world to gain publicity from as anywhere else. They are obviously in more of a position, if all the negotiations are handled properly, to be subject to public pressure and publicity, bad publicity. And they'll have to respond to it. I mean, my way of functioning doesn't have anything to do with any of these museums [inaudible]. I mean, I know, obviously, some of the people who run them, but I'm not in touch with them. And whatever I do, I do in spite of them. I couldn't care less what they do with their shows. I don't even know what they're doing. I know more about shows in Europe or California than I do about what's going on here. But I don't really care what's going on, because what I do has nothing to do with it. I mean, I can go about my business in spite of these people, not because of them.

PN: Right, that's what's surprising me about the enthusiasm for the …

SS: But one has to remember the influence that the Museum of Modern Art has: it's probably the last stop in the culture chain before the people. You know, it's the very last thing in the long travel from the artist's studio to the public. The Museum of Modern Art is the most public relations–loaded situation that there is. And it seems if you're going to effect change and you want a certain amount of exposure from doing it, that's the place. I mean, you wouldn't go against the Alabama Arts Center or something that has, you know, the local cotton farmer or the local mayor sitting on the board.

PN: No, but you could go and establish something else …

SS: Yeah, but that's what I'm doing. And time will tell in terms of value what our positions were in 1965 or in 1969. In 1970 or in 1980 we'll look back and say, oh, yes, he was doing these things when the Museum of Modern Art was still fucking around with [Jean] Dubuffet shows or something, or doing whatever they were doing. And then that's a judgment, you see. In other words, this won't affect an artist until someone's in a position … I mean, I'm obviously indirectly affecting that change already. But I'm not interested in making the Museum of Modern Art an issue. I'm just going to go right past them.

PN: No. Right, but …

SS: But that's one way of doing it. But the needs of an artist are different. If I want to confront the problem and deal with the Museum, the so-called Establishment, together, I mean directly confront them, that would be another problem. It's not

my personal way of going about doing things. But I can just as well do that, you know, and really make their life unbearable. But that's not my personal style. I prefer not to get involved in it, you know, rather than make some kind of silly issues about it. Do you understand?

PN: Oh, I understand, but it seems like a funny issue for an artist to be spending that much energy when there are people around like you ...

SS: But there aren't that many ...

PN: They probably should be spending their energy getting more people like you than ...

SS: Yeah, but I'm doing it in spite of, like, what goes on down there. But there aren't many places an artist can turn. And I'm only one little speck on Eighty-second Street. And in five years there'll be enough people that the museum ... won't be an issue anymore. But now, conceivably, it is an issue, and you can bring certain things to a head. I think it's altogether too cluttered with too many nonsensical ideas and too many totally peripheral issues. But my aim is to make the fact known that there exist artists in New York, and they're a very strong group of people. America's reputation for its art has a lot to do with its reputation in general, even though it may precipitate down to the Lincoln Center or some horse-shit like public relations or real estate investment or something. And by going up against the Museum of Modern Art, the artists are putting themselves against a very public relations–minded institution in which, by arguing against the status quo, they can achieve certain things. I mean, for me, it will take five or ten years to do what, conceivably, these people could change in a few months if they went about it intelligently. Now which is a more lasting change, or which is going to open the floodgates, I don't know. But you see, my interest is in art, and the Museum of Modern Art has nothing to do with art. Only one thing has to do with art, and that's artists; that's all. [Pause] But to make this explicit, you know, I'm not a pamphleteer, I'm not fucking around with these people. I just do what I'm doing, I just do exhibitions, just advise, and just go about doing my thing. And I'm not really interested at all with the museums. But if I was, I'd obviously go to the Museum of Modern Art and bust their balls for a few months and really make life unbearable for them, which is what [the Art Workers' Coalition] is doing, and I think that this is very clear.

PN: No, that's what you're doing too in a way, just quietly going about and doing it.

SS: I know, I know. But it's different. In other words, the effect of what I'm doing, egotistically or not, you know, may not be felt until ten or twenty years [from now].

PN: Oh, I disagree. I think that it's felt right now.

SS: Well, yeah, because like it's the one outlet, but it's not enough to make a difference. It makes a difference for fifty or twenty people, who in some way, form, or

fashion I have involvements with for one reason or another. And that's the only thing. But it doesn't mean anything to the public. It's not supposed to because I don't think about the public. But the Museum of Modern Art creates a focus. If you have a choice to argue with anybody, that's the best focus. The next thing would probably be the Smithsonian, or the National Gallery in Washington, or something like that, some really, really loaded situation, because they can't take all the public relations pressure, all the public pressure that groups of artists going down there every day and fucking up their turnstiles and just hanging around and talking, legitimately, or just being pains in the ass. They just can't take this for too long. And if the artist uses his position properly, well, then they can make fantastic inroads in the museum in terms of getting what they want. And they will, they will, if there are a few people there to keep the pressure on very high. And that's okay. It opens up a bit more ... But that's a direct confrontation.

I don't think of my work in those terms, or as that type of thing. I just go about dealing with art and it will all be very clear in a few years. You know, like, why this and not this road, and why here and not there. And I know why it isn't here and why it would go here and not there. But I'm just doing it. I'm not making an issue out of doing it. I'm just going ahead and doing it. And, of course, more people know about me today than they did a year ago, but that's okay.

I'm not interested in focusing in on the museum, but if I wanted to affect the goals ... I mean, the idea of an artist having all these rights, and having all these controls over their work in museum situations is all very good. But I'm involved with specific art. While there are only two types of art, good art and bad art. And I think of myself in terms [of being] involved with *good* art. And that's a selective process. So I'm not specifically interested in fifty thousand artists picketing for their rights. Because of that fifty thousand people, there are five or ten artists there who would conceivably interest me. So I have to be much more selective in terms of my judgment, in terms of what I show, you know, how I spend most of my time. Because it takes it out of art generally, which interests me, to the specific art and tendencies and directions of certain artists. And that's how I direct my energy. And that's what I do. So while I can assist and do my little part in assisting artists generally for their rights, which I feel somewhat a kinship with or a feeling with because I'm downtrodden on the business side, you know ... [Laughs] So I can identify very easily with those goals and needs. But by the same token, after all the bullshit's over you still have to make selections. Out of those five hundred people who attended the open hearing the other night, there may have been ten important artists in that room, ten interesting artists.[4] And that's a consideration or a decision of *quality*. And it's a very selective one. And that's how I have to spend my time because, obviously, whatever reputation I have or don't have has to do with my ability to look at art, a decision to do this and not that.

PN: I don't understand how you got onto this. Do people feel that you should be doing something about it?

SS: No, no. I'm interested in what they're doing. You have to remember that we were discussing the idea of art going into public conditions. The other was an art issue and this is more of a sociological art issue.

PN: Right, right. But I get the feeling that you're defending yourself about why you're not involved in attacking the museum, or …

SS: No, no. I give them all the help I can. I was just speaking of the difference, or the importance, of an artist being able to control their work, their destiny, or things like that, which is something that I'm very much involved with personally, and helping and assisting. But it has to do with art, right, and it doesn't have to do with sociology. I'm interested in artists being as rich as possible. Possibly because I'm the next step. And maybe *I'll* be as rich as possible. But I was just speaking of the other thing because it's very germane to be involved in it too, on my part— and, I mean, for artists who are involved in it.

And after all this discussion of changing the institution or the mores of our establishment, you still have to view the quality of good art and bad art. And that's pretty real. And I have to deal with that selective process the way anybody in the world would have to deal with it, and I have to act on my decisions too. No, I'm not supplying a defense on that, I'm just sort of corroborating … not corroborating, rambling.

PN: How did you make the decisions to get into the activities you're doing now?

SS: I don't know. It just happened. Like Topsy. I was just born. I just is. [Laughs]

PN: What were you doing? Were you with a gallery before?

SS: No, no. I did have a gallery for years myself on Fifty-sixth Street. And I went through that for a year, a year and a half, but the public thing wasn't my thing. [Laughs] I wasn't good at dealing with people off the streets. So I became a private dealer two and a half years ago. And that's what I've been doing. [Silence]

PN: I see you as a very active element of the art at the moment.

SS: But I'm only a catalyst, in a sense.

PN: But that's a very important thing.

SS: Oh, I'm not deprecating my position. I'm just saying I'm only a catalyst; I only react to what I see around me. Which is the artists, you see.

PN: Everyone is leaving behind certain limits of art activity. They've made a decision they are going to broaden them. And so now they are making new choices about what their activity is going to be. You've had to make those same decisions and those same choices.

SS: I've in a sense been able to make it viable, in a certain sense, or even the possibility of it being viable, for an artist to make some important art decisions. In other words, I make it possible for a man who needs a gallery that's conceivably an-

other network in this world for showing his art or talking to the community. In other words, I've just said that it's possible to do this, and I've been doing this, and it's getting more possible than it was a year ago. But this is where it's had most of its effect. So now you don't have to be involved in a gallery or be uptight about not having a gallery. Say, ten artists now have no galleries. Before it was a sign of shame. It doesn't make any fucking difference anymore. Years ago you used to hear, "What gallery is he with?" You know, "Who's with who, with what gallery?" That doesn't mean anything anymore. It's totally a meaningless thing. It's very funny. I just thought about that now for the first time.

PN: I don't think that's all that pervasive yet. I think that's still a concern.

SS: But it's becoming less and less of a concern. Because by eliminating galleries, by galleries being played down and art being played up, you just have ... like within any gallery very good artists and very bad artists or very good artists and not so good artists ... And so you tend to focus in more on the art itself, the quality of the man and the art he makes. And so by me being a sort of nefarious and nondescript character, very little in the public domain the way, say, a Sydney Janis or [Leo] Castelli is, one focuses in much less on me, and just deals with the work. [Pause] Because I don't like the idea of being called a dealer. I'll be moving very far away from the position we know as a dealer over the next few months, concentrating only on exhibitions and books and special projects.

PN: It seems to me that you're almost making more important choices than dealers are in giving people a format.

SS: Oh, right, right. In other words, the value of it in a condition or in the art exhibition environment or the art exposure environment today ... I mean, I don't know, you can't really expect me to sort of evaluate what I do that way, you know what I mean? I just see voids. I was in Europe and in this certain area I see a void, and I'm going to go there next year. It turns me on because no one's interested in anything. [Laughs] And that, like, turns me on. [Pause] But it turns me on, the possibility of going there and sort of making trouble in a sense. I mean that's my own private joke, for just going ahead and doing something—shows, bringing some people over there. But it's all done here. I sit at my house for twenty-four hours, nineteen hours a day, from eight o'clock in the morning to six o'clock at night. I don't like to leave it, really. I just go out on a business lunch. But I sit here and it all gets done. Telephone. That's the way I like it to be. And that's why I like it in New York so much, because it's so easy to be in touch with people. Communications are so good. It really makes it very groovy. [Pause] And I don't usually have much to do with [anyone] more than artists really. I don't regularly talk to anybody except just the artists. I just go about sending out my letters and stuff.

PN: Um, you're not at all involved with, like, generalizing or theorizing?

SS: No. I mean, whatever theorizing or general … Not generalizing. What I do is what I think, which I think is true of the world. [Pause] I mean, I'm not an explainer. I'm not in the class of human beings who explains what's going on. I just do it. I don't write. I have no intentions of ever writing. I just will do an exhibition, and it won't have any writing in it. And you just have to deal with what you see there. How you want to see it, and whatever you want to do. And it's not really my concern. I can do it and that's it.

PN: One reason why I asked that question is because I've been reading Jack Burnham's theories about how we're switching from an object-oriented to a systems-oriented society. And I'm wondering whether you have any theories like that?

SS: No. I'm not interested in the future of art that way. I'm not interested in second-guessing or prognostication. I only can deal with what is, what work is being done. And as I see it being done I try to—if it interests me—I try to expose it, try to send it out to the world, as it were, as far as it can possibly reach. And that's all. I mean I don't make guesses. I mean, obviously it's implicit when you make a choice with a younger artist, you know, and are interested in his work, then obviously implicit in making that decision is that the art he's making is obviously important. And if he's a younger man, it's obviously dependent on the fact that in the future … But that's so obvious it, it doesn't even bear discussion. It's just silly. So in other words, there's nothing much I can do in terms of second-guessing art, second-guessing what's coming. I can see what's happening. [Pause] If you look back at the exhibitions that I've done, that's what I felt then. And how it bears on the future, well, I don't know. I think it's obviously going to have an important bearing on the future, as we all think that whatever we're going to do will have an important bearing on the future. But it's not something that I consciously sit around and discuss or think or try to figure out. I just react from what I see around me, what artists make. [Short break]

I've been away from New York about six weeks. Part of what's going on and prompted me to do this show that I'll be doing during the summer is the idea that information is going back and forth so quickly.[5] I like that idea and can see myself working in this area very much, being able to ship not things but ideas and people, and ideas about things, all over the world very, very quickly. So I think it's now getting to the point where a man can live in Africa and make great art.

PN: Right, sure. Maybe since we've gotten to the moon, anything … We can see a picture of ourselves even …

SS: Right, exactly. Well, we always could go to the moon. [Laughter]

And I'd kind of like to spend the time, as I will in the next few months, to begin working on something that will really begin to speed up the communications abroad, people abroad, ideas going back and forth. The idea of making New York an anticenter really turns me on.

PN: Joseph [Kosuth] was talking about that and how it's such an open thing. The structure is going to be international …

SS: Oh, right. Well, it is; it is. That's how I've been spending much of my energy. I'll probably move to Europe for a few months next year. Wreak some havoc over there. But I like the idea of things, information, people, ideas moving back and forth. And now that has much to do with a quality of the art too. It can travel very easily, and it can be seen on a primary level, not just photographs of something but the something itself. The idea of primary information as opposed to secondary or tertiary information. Or hearsay. It's happening very, very quickly. And it makes communications even quicker. Just send a letter in the mail and you know what it's about. You don't have to wait for a painting to arrive, like someone in Europe wouldn't see a Pollock until the late fifties or early sixties, whenever the show took one over. Those days are over. And the idea that people can make art wherever they live, that they don't have to necessarily come to New York and be part of the scene, I like that too. Like, [Douglas] Huebler doesn't live in New York; he lives up near Boston. And while he comes in now for many reasons very frequently, well, too frequently … But the idea that someone can make art living in the middle of nowhere is a very strong idea. There are certain other pockets around the world that I've come across where people are making art, like Iain Baxter in Vancouver working away up there, and [Daniel] Buren in Paris. These are some of the people that will be in the show during the summer. But they won't make art in New York. They'll make art in Paris or Vancouver.

PN: The N.E. Thing Company?

SS: Yeah, the Thing Company. Right.[6]

PN: Is he [Baxter] doing word things?

SS: Well, he's been involved in an awful lot of things for an awful long time … He has an unbelievably fertile mind.

PN: Do you know Steve Kaltenbach's work well? He was in your "March Show."

SS: Right, right. He's also in another show I'm doing up in Vancouver next month. I think well of Steve. Have you spoken with him yet? His work is all over.

PN: I think he [Kaltenbach] has a whole different way of dealing with people than the others, such as Joseph [Kosuth]. There's a whole emphasis on a human aspect in [Kaltenbach's] work. Joseph's is abstracted.

SS: [Inaudible]

PN: I love Joseph's parrot. It sat through the whole interview chewing on an electric outlet. It took it completely apart. It does it to every electrical wire in the place.

SS: Does he let it run loose?!

PN: It's in the studio room. He closes the door and has windows covered with wire so that it won't get out. It just wanders around.

SS: It shits on everything?

PN: Talking away and chewing on every electrical cord in the place. [Laughs] It's going to electrocute itself.

SS: That's very good. Yeah, I heard about the parrot.

PN: But it can sit spouting all his ideas.

SS: After Joseph dies, the parrot has all the information. That's a funny idea. That's a sweet sentiment.

PN: Amy Goldin has just written an article on this art, saying how she thinks it's sentimental, romantic work.[7]

SS: Well, I don't know. That word "this work" or "those works" is so, so broad. I don't know if she's referring to Bob Morris or if she's referring to Alan Saret.

PN: She starts off speaking about Steve Kaltenbach.

SS: Because there are too many different types of work going on here to be able to say something concrete. I don't know what the word "romantic" means. [Laughs]. It's a tough word. [Pause]

PN: One of the ideas I had when I started thinking about this work that I'm doing was to give people the option to use the interview in some way. I am also involved in documenting things. I asked the artists if they wanted to participate in any way—take a tape and document something they were involved with in a different way.

SS: It depends how they interpreted what you just asked.

PN: I asked Alan Saret, and he wouldn't do it.

SS: I don't think that you'll have much trouble speaking to people. When people listen to me, that turns me on. I suppose many artists feel that way.

PN: I find this [tape recording] machine so terrifying.

SS: It is; it is.

PN: And people are being so brave that they don't admit it . . .

SS: You can get a less obtrusive one. But I'm not really intimidated. Some people, I assume, would be.

PN: I should think the whole idea for an artist who is busy making things or ideas to be putting themselves down on paper as a permanent record of themselves might be unnerving. But it doesn't seem to be. There's a great interest at the moment.

SS: It gives them a chance to get on record with certain things. What you're doing, from a purely archival point of view, is very interesting. That's why I took your name—because I could see someone wanting this information at some point. Pretty interesting work.

NOTES

1. Siegelaub refers to the following exhibitions: *Carl Andre, Robert Barry, Douglas Huebler, Joseph Kosuth, Sol LeWitt, Robert Morris, Lawrence Weiner,* the "Xerox Book" (New York: Seth Siegelaub and John Wendler, 1968); *March 1–31,*

1969, the "March Show" (New York: Seth Siegelaub, 1969); *Douglas Huebler: November 1968* (New York: Seth Siegelaub, 1968); *Lawrence Weiner: Statements* (New York: Seth Siegelaub with the Louis Kellner Foundation, 1968); and *Joseph Kosuth, Robert Morris* (Bradford, Mass.: Bradford Junior College, 1969).

2. The show Siegelaub refers to here is *July, August, September, 1969,* that featured the work of eleven artists in eleven different geographical locations: Carl Andre (The Hague), Robert Barry (Baltimore), Daniel Buren (Paris), Jan Dibbets (Amsterdam), Douglas Huebler (Los Angeles), Joseph Kosuth (Portales, New Mexico), Sol LeWitt (Düsseldorf), Richard Long (Bristol, England), N.E. Thing Company (Vancouver), Robert Smithson (Yucatán, Mexico), and Lawrence Weiner (Niagara Falls, New York, and Ontario).

3. Carl Andre's first brick piece was *Lever,* 1966.

4. Siegelaub refers to the gathering organized by the Art Workers' Coalition on April 10, 1969, formally called "An Open Public Hearing on the Subject: What Should Be the Program of the Art Workers Regarding Museum Reform and to Establish the Program of an Open Art Workers' Coalition." For the proceedings of this event, see *Open Hearing* (New York: Art Workers' Coalition, 1969).

5. See note 2.

6. The N.E. Thing Company was the artistic partnership/collaboration between Iain and Elaine Ingrid Baxter from around 1965 to 1970.

7. Amy Goldin, "Sweet Mystery of Life," *Art News* 68 (May 1969), pp. 46–51, 62.

3

ROBERT MORRIS

MAY 16, 1969

PATRICIA NORVELL: What I think I want first, if you would, is to record what you're interested in now—how you became interested in it and how you have evolved into what you're doing.

ROBERT MORRIS: Well, I'm doing a lot of different things, or several different things. And that's always been the case, I guess. I've not done one thing to the exclusion of other things, it seems.

The thing I'm working on now is the project for the Whitney, the show that's coming up. It's a project where I asked them to borrow one hundred thousand dollars against their collection, or their real estate holdings, and invest that money for the time of the exhibition with a view toward making a profit on that investment, or beating the loan, so to speak. And then I would get half of the profit. So they didn't get a hundred thousand dollars, and they couldn't borrow it against their collection, but they did get fifty thousand dollars. And they're investing that.

PN: They're doing the investing?

RM: They're doing the whole thing. It's all up to them. What I think will happen is that their investment will be very conservative and will probably just balance the interest on the loan, so it will cancel itself out. And the stipulation was that they

would have to show whatever they wanted to regarding this project. I mean, I just presented the project. And they could make visible whatever aspect of it that they wanted. What they seem to be doing now is to be collecting all the documents, and they'll show those—which is the record of the work. I mean, that's one thing they could show. They could show other things, but that's what they cho[o]se to show—it's the simplest. And I don't know exactly where that came from. [Pause] It's the interest in using some kind of transaction, I suppose, as the work of art—some process in terms of a transaction.

PN: What made you make the decision that you weren't going to make any of the decisions?

RM: Well, I think it all goes back to the dirt piece I made at Castelli [see figure 8], where I worked on it every day.[1]

PN: Oh, yeah, at the Warehouse.

RM: That piece I worked on every day, and what was left was what was seen that day. Then I got the feeling that if I was interested in that sort of aspect of the work—as something that changed constantly—it might be possible to find already existing systems or processes that I wouldn't have to actually do the labor act, where it would exist already. And since I was working up there with a hoe and ... really ... it was kind of agricultural in some way, it reminded me or suggested the possibility of doing something really agricultural. So I had the idea of—and I've already presented this project to a group of, well, people in Houston, where they're sponsoring a lot of earth projects. And I proposed that they just plant a crop over a section of land, rent a section of land and contract [with] a farmer to plant a crop, whichever one was making money, and harvest it. And I would get half of the profit from the crop, whatever it was. [Laughs] In that case I would use nature, really, or farmers—but basically nature—to have the thing go on. I wouldn't have to exert myself in any way. I wouldn't have to do the physical labor.

And then that suggested other things. Like what other things exist where you could initiate something and have an already existing organization of energies or whatever to complete the thing. So I've always been involved in process in one way or another. And this is just one manifestation of it, I guess.

PN: What are some of the other things you are doing?

RM: Well, that's the main thing. The other things are continuing other projects that are probably more familiar, like the literal earth projects[2] I'm still working on. [Pause] That's about it right now.

PN: Do you feel that with the new works you've completely broken formal concerns?

RM: Umm, well, it depends on what you mean by formal concerns.

PN: Well, for one, you're not making objects, so you're not involved with composition and issues that deal with objects.

RM: Well, I'm not, in these cases, dealing with a set of plastic properties that I adjust until I like them. But in some sense there's still an object involved. In the case of the agricultural thing there would be a field that you would go see, I suppose.

PN: But you wouldn't be making any of the decisions then.

RM: No, I'd initiate the whole thing and it goes on from there. But I've done that in a minor way in a lot of the pieces that became objects. I found that after a certain point I could remain ignorant of processes of, say, manufacturing and materials, and still make objects. And it was interesting to me because that allowed me to use the people who made them. I mean, I would present a very general situation—I wanted this kind of thing—and let them suggest what kind of materials might work best, or what way of fabricating might be best, so that I could use their imagination, their knowledge to ... In other words, I built contingencies into the thing, I left it open-ended so that I wouldn't have to make all the decisions. They could come up with things, which I would approve of or reject. I was pretty much involved every step of the way but I didn't have to preconceive the whole thing. And this is just a step beyond this, where I have taken or latched onto some particular ongoing process that is already pretty well established in terms of how—what the outcome is—so that I don't have to be involved in every step of the process. It's like a step beyond manufacturing things, by using the manufacturers themselves. I can use finance or agriculture, which is so much more organized and almost predetermined.

PN: But why the interest in the predetermined situation?

RM: Well, partly because I am interested in seeing things that exist in time, I guess. In that earth project [at Leo Castelli's gallery] I actually was there and had to make changes throughout time [see figure 8]. But I wasn't interested *especially* in any kind of formal, ah, ... Well, I was dealing with formal properties, you know ... One was as good as another, it turned out, to me. A little dirt was as good as a lot of dirt, or whether it was spread out or in a pile didn't seem to make that much difference. So that while I was dealing with formal things or [things] that you could see, ... I wasn't particularly interested in adjusting those things to each other, it turned out. I was interested in the fact that they changed and that you could see them in different stages. But one was no more critical than the other. I mean, the thing never resolved itself. It went on for three weeks, and then that was the end of it. I was interested in seeing the stages, so that whether I did it or whether somebody else did it didn't make that much difference. And now I find situations where I really don't have to be there and do it. And it's just as acceptable to me that other people do it.

PN: Do you ever think of teaching in this way?

RM: How do you mean?

PN: In instigating something ...

RM: Yeah, well, I've been away a lot this semester and I've had people come in and take my course over. And I find that probably more valuable than my being there all the time. I mean I can use other people's sensibilities to make the input into the class, and it seems to me that's probably more valuable to people to get a lot of different kinds of input than just my particular organization of things. So, it seems to be compatible with the interest. [Pause]

PN: I have specific questions that I was asking. And the first was what your artistic concerns are and how they've evolved. And whether you're concerned at all with formal artistic issues or with objects. And whether your aims dictate your presentation. And if they do, how? And whether you had choices in the presentation and what kind of choices. And then there's the question of documentation.

RM: Well, in some of the things that I'm doing now, like the temperature project in L.A. and various other things, the documentation is like a residue or sediment that comes out of the whole thing. And I don't do it to get the documentation, but it's like one edge of the piece. And it has a sentimental value more than anything else. You can't locate the work in terms of its record. It's like a series of snapshots or something.

PN: Well, that's true of your dirt piece too.

RM: Right, yeah, you have a series of photographs, and I have notes about what I did every day. But it's really just like a photo album or some kind of sentimental thing. That's all it means to me. [Pause] The interest was in doing it, seeing it go through those stages—engaging in the process—and not the documentation.

PN: Are you concerned with the documentation in any of them?

RM: No.

PN: Since that is what's being left to the public or to anyone who wasn't there.

RM: Well, that's the record, you know—that's what's left. And I feel like it's true of all art. You know, fifty years, a hundred years old, you just have the record. It's not alive anymore, it's completely dead as far as I'm concerned. And it becomes a record. Like art history's a record. The objects don't have any vitality in them. And I guess I think of my records as the same sort of thing.

PN: Just sped up a bit.

RM: Yeah.

PN: Could you say anything about how you went into Minimal, and out of Minimal into what you are doing now? [Pause]

RM: Well, it's really complicated. I mean, it takes a long time to talk about all those things. I could outline some of the things, I guess. I was involved very much in these things when I was making paintings. I had a very definite method for making the paintings, which had to do with working on the floor and on a scaffold and so forth. And it was a very methodical method. I mean, it was just a way of producing something. It got down to a method of manufacture, and that didn't

have much to do with the image. That seemed pretty unacceptable, so I stopped painting.

Then I started making objects like the *Box with the Sound of Its Making* [1961], where the record of the making was preserved, only it was in the dimension of time, or sound. And splitting those two things apart seemed to be a certain kind of resolution. And as I began to make the big objects, the so-called Minimal things, many of them were static, but many of them had a process or acknowledged time in one way or another. They either permuted in space or their parts changed, or else I involved the manufacturer in some way. So that that's always been an element in the work.

Then when I started using soft materials like felt, it was ... A lot of the concern was to move even further into that direction where whatever is a priori in the work does not necessarily show up. And so you have the whole element of process of production there—that is one thing—and then the image is something else or what's left. And besides that, there's even the other layer of indeterminacy in the final thing, that it changes each time it's set up. So that ... well, it seemed like a break, [though] it isn't in some ways. It's still a concern. I can still see the preoccupation continuing.

PN: In what?

RM: In the soft things. [Pause] That's a very crude kind of outline of what goes on.

PN: Do you think that you're functioning in a new framework? Or presenting a new framework for art, or art activity?

RM: In terms of what?

PN: In terms of the activity or the result or the aim of the work ... A lot of people feel they're involved in redefining art activity or giving art a future.

RM: I think that's been true in the whole twentieth century. Art's proceeded by questioning its premises. And for a long time you could make enough interesting and valid questions in terms of changing the formal properties within an object. And maybe what's happened now is that premises are being questioned on the basis of the physical existence of the thing. But I see the same impulse continuing that started a long time ago.

PN: Of questioning?

RM: Of questioning. Yeah ... redefining, finding new premises. It's like the circles keep expanding. [Pause] So art's always in a process of redefinition.

PN: It seems like a larger break once you give up the objects, though, or you're going more into time.

RM: Yeah. Um ... Well, you can't judge it in the same way. I mean, even though I've always been involved in the temporal aspect, the process aspect, I did have an object. But I don't think any of those objects resolved themselves completely in any

kind of formalistic reading. So that to read those things formalistically seems to me to be *misreading* them. To want to locate whatever the thing is about in terms of plastic properties is only part of the thing, has only been part of the thing for me always. So the things I'm doing now may have less and less to do with particular plastic properties than they did before.

PN: Uh-huh. But then the difficulty is in presenting it, which becomes documenting it. Even though you say you're not interested in, say, the documentation, it is all that is left for communicating what happened if someone wasn't present.

RM: Yeah. Yeah.

PN: So that that's what everyone is left to deal with.

RM: Uh-huh.

PN: And with a lot of the things that I've seen, the documentation or the presentation becomes overpowering to the idea. So that it is the presentation that it is being judged by, which then goes back to old issues.

RM: Yeah, yeah. But I think that's just seeing it in past terms, you know. It's like bringing those formal values, judgments based on some kind of formal object existence, to the thing.

PN: But you don't think that it's something that the artist has to deal with? You think that it's more a problem of the observer?

RM: For me it is because I'm not particularly interested in those records. [Silence] Things are just as weird and as curious as they always were, for me—whether you're dealing with records or making something. [Silence]

PN: How do you see this changing the whole structure of the art community? Of galleries and museums and dealers?

RM: Well, it's obviously going to have an effect. The galleries are all predicated on selling objects—physical things. Ah, if physical things don't exist, then galleries are pretty irrelevant, I guess. And you can't deny that there are certain kinds of feelings, I think, on the part of everybody that have to do with not liking that kind of reduction of art to a commodity. I don't think anything that … You could overemphasize that, but I think it's undeniably there—that resistance to art as a commodity.

In other ways it doesn't change art at all, because still the work is communicated in one form or another. Ah, it still gets communicated. So that the ideas and the intentions and the whole structure of art is pretty much available to people.

PN: But not in the same way.

RM: Not in the same way. But I don't think it's made art less remote, that's what I mean.

PN: Oh, no. I think it has the potential of making it more available.

RM: I think it's just as available anyway.

PN: But it seems that it's putting … Well, someone like Seth Siegelaub seems to be making decisions that, in the past, artists would have made. I think that, like the role that he's taking on or, say, that the Whitney's taking on with you, are activities that artists were involved with or involved themselves with before—a lot of the decision making. And what Joseph Kosuth has people do, picking out type and picking out what newspaper his definitions or his outlines are going to go into, are all things that the artist used to handle himself. And now either dealers or museums or other people are making those decisions.

RM: I don't see that.

PN: Well, Joseph's piece in the show in Switzerland [3] was in three different newspapers with different type, and all of that was left up to the people in Europe to decide. He made none of those decisions.

RM: Yeah. Yeah.

PN: I mean … and you're leaving all the decisions to the Whitney about where they're going to invest and everything. That's like making a decision as to what color you paint a sculpture. It's making the decisions of the structure of the piece …

RM: Well, I think that, say, for example, in the pieces I had fabricated that looked very minimal, in many cases, especially the later things, I used … the fabricators [more and more]. Like, I would come with a very general idea and say, you know, "I want this thing a certain way. What kind of materials can I have?" And they would find the material. Usually the things go through many stages, and they end up looking very a priori, like I decided it all. The fact is I didn't. And I used their particular kinds of knowledge or even imagination to make decisions. And I purposely left it open-ended. I didn't want to make all the decisions.

PN: Why didn't you, though?

RM: I didn't find it necessary. It just didn't seem necessary whether I made all of the decisions … I mean, I'm purposely interested in keeping the thing *open* in that way. [Pause] Because certain kinds of … So many plastic properties are just as good one way as another. I mean that's the whole rationale for using chance, I think, which I've also done. Is that … It isn't … I'm not concerned with that total control or those finely attuned adjustments. It's equally acceptable to me whether they're one way or another. So that even work that for me ended up being an object was a result of a whole series of contingencies that was very purposeful. And I think that that's probably gone on a lot more in the past than people realize. I'm sure [Peter Paul] Rubens used that very method. [Pause]

So I don't see anything particularly new about that particular structure of using other people—to have them make the decisions for you, or set up a situation where chance makes the decisions for you. I see that as having gone on for a long time.

PN: But not as to the whole structure of a piece?

RM: Well, the whole structure is still, ah ... I mean, people still institute or initiate something still, you know. Like, I initiated that project with the Whitney or the agricultural project or one thing or another.

PN: But that's within ... You gave them a very big structure. I mean, Rubens would be saying this is the thing to do. He wouldn't be giving [inaudible] ...

RM: Oh, undoubtedly it's broader now.

PN: Yeah, much.

RM: Yeah, but still the artist is setting the situation up. I mean, he initiates it. It's his idea; it's his overall structure. The particular outcome or form of it may be contingent upon other people's decisions. But if you're not dealing with a lot of formal, plastic adjustments, if to bring them into a very refined kind of controlled relationship isn't the issue, as it hasn't been with me for a long time, then those things are pretty irrelevant whether they're one way or part of another. Like the Whitney ended up ... They're not going to make any money; they're not going to have one hundred thousand dollars. But still the transaction occurs. And that's what I'm interested in. If they had made money, that would have been interesting. I mean, I could have taken the money and probably doubled it by giving it to particular shrewd art dealers to buy modern art and sell it very fast—which might have been interesting. It's still a project that could be done. But it isn't necessary that I insist on that.

PN: Making money?

RM: Yeah.

PN: Where do you see this going?

RM: I don't know. I can't predict it. [Silence]

PN: Are you still doing that piece [the temperature project] in Los Angeles?

RM: Yeah.

PN: I feel like works like that predict a larger involvement of people and animals and areas and elements that I don't think artists are concerned with.

RM: What do you mean?

PN: Um, like the concern seems to be with the idea of executing a project without concern for the factors that are involved in it, like whether you're killing animals or life of some sort, and whether that's an important issue. I mean, if on a small scale it doesn't do much, on a large scale it would. It could affect a lot of people or ...

RM: Are you saying there's a lack of morality?

PN: No, I wouldn't say that. But I mean, I wonder where that becomes a lack of morality ... whether art's going to contain itself enough so that it doesn't get out of bounds. I assume it's going to. I mean, I don't see how in the near future it can. But the implications of some people's work are, I think, a little scary.

RM: Like this project in L.A. It interrupts the ecology in some way.

PN: Yeah. I mean interrupting [the ecology] is a very interesting idea but then what is it actually doing? There are atomic bombs interrupting it, and things like that. Do we need more people doing that?

RM: Yeah. Well, I don't know. If you read [Alexander] Veselovsky, you can't be too moralistic, it seems to me, about things like that. His point of view is that life continues under a great many circumstances and catastrophes, not unlike, say, the releasing of the atomic bombs that has already occurred, that altered life— not only life but inorganic configurations as well. So that it just produced different forms of life. I can't be very moralistic about things like that. [Silence]

There are plenty of people who are concerned, like [Buckminster] Fuller, [Herbert] Marcuse, and all those people who feel that there really is the means now to change things qualitatively for the better. Things are getting out of hand—the degree to which people can alter the environment. I don't think artists are anywhere near having that kind of power, and I don't think they ever will be. [Silence]

PN: I guess so.

RM: I think the thing I'm doing does have certain kinds of implications. And I'm really concerned to subvert the kind of particular technology that I've gotten my hands on, which is strictly a war technology that I'm using. I'm using a company that makes, ah … services, missiles. These heaters and coolers are made specifically to service ICBMs. But I want to bury them all. [Laughs]

PN: And what do they think of that?

RM: I don't know. I haven't approached them yet.

PN: Do you have the area?

RM: No, I haven't got that either. So far it's just an idea. [Silence]

I think that these projects that artists do that are interruptive of technology and the environment, if they do anything, it just points out … it throws into relief, that that kind of thing is quite possible now. I mean, I don't think, it's not destructive. I think … It's not illustrative either, but it focuses that fact that people can *really* change things, you know, by using technology. [Pause]

I think that's what art should do. I mean, if it remains on a purely decorative level, it's very effete. And I think that's what people feel now—that art that just deals very hermetically with plastic manipulations is pretty effete. Not only is it effete, but it's servile to the economy—or to a particular kind of economy.

PN: Yeah. Because art's not that actively doing anything about changing its role in the economy.

RM: What isn't?

PN: Art. I mean, I don't think … It is still taking money. It's not giving back permanent commodities.

RM: No, but some art is. I mean, art that remains an object and is put in the marketplace is the most amiable kind of capitulation to capitalism. [Silence]

PN: Where do you see support coming to artists from in the future?

RM: I don't know. I think that what happens is that artists start out without any support, and then … ah … The support right now, I suppose, comes from the media, in some way. That's the audience and that's the … I mean, I don't know what you mean by support. Do you mean money?

PN: Yeah. Because before someone would purchase an object, and the resale value would be better. And they obviously can't purchase an object and sell it again now.

RM: No, a lot of art they can't, no. Well, I think a lot of it plays on the guilt of people who have a lot of money. And art, I think, is still dependent upon the kinds of things it's always been dependent upon. For artists to realize their projects, they have to have some kind of patronage. That's often been converted into a very profitable situation by people who [had] been patrons. [Pause] And I don't know where it will come from in the future. I'm sure that people could profit from things in a variety of ways. People with certain powerful means of money can perhaps not realize an investment kind of value supporting art that doesn't produce objects, but they certainly get the prestige kind of return. [Pause] Same way with the museums—now they're doing the same thing. They're certainly getting return for supporting this kind of art. To the degree to which they do it, they get a return on it.

PN: Yeah. It looks more like just saving their necks, though, on that one. [Pause] Do you see things developing into what Burnham refers to as a systems-oriented society rather than an object-oriented society?

RM: Well, I think there's a lot in what he says. [Pause] I mean, society's certainly very concerned now with processing information. And process seems to be really becoming more and more apparent in its relevance. But people like Fuller have said that for a long time, you know: that services are more important than objects and will continue to be more important than objects. Ownership is not nearly so important as having the access to services—which is a kind of systematic use of things rather than ownership. [Pause] But a lot of things he says about … He seems to put a great weight on artists' using certain kinds of sophisticated technology and developing that into a kind of aesthetic, and I don't think that's very relevant.

PN: The show that you organized at the Castelli Warehouse, what do you feel your role was in that?

RM: Well, I wanted to see all that work in one place, I guess. It was particular people I had liked for some time, and I suppose what I really wanted to do was to choose the work. In some cases I couldn't, or the work wasn't available, so I had the people do whatever they liked. And [I] wasn't pleased with what was in it. But I thought that most of the people shared a certain kind of premise and then

wanted to see all that work together. There was that space available, and I talked Leo [Castelli] into doing it. I think it's interesting to get a lot of things together that share that premise and see what happens.

PN: What premise?

RM: Well, the very direct use of materials and things that involve process in one way or another. Or a concern with making art with different methods and assumptions than what we've seen for a while. And my role was just to get it together, I mean, to use my influence to find that space, and bring these people together. I think it was certainly misinterpreted by a lot of the media. You know, that I … [that] somehow all of these people were children or something, which was ridiculous. It's hard for an artist to function as a kind of curator or as a museum director, and it always creates a lot of misinterpretations. [Pause] But I was glad to see the work. I mean, that's what I wanted to do.

PN: Yeah, I think a lot of that depends on one's intentions.

RM: Yeah. My intention was to see it all in one place. I didn't have anything in there. And it was unavoidable that my name should be attached to it, I suppose. And I think it functioned well for the people who were in it, to see their work in relationship to … It was a very close kind of dialogue between the various people involved. I mean the differences … That's another thing: the differences came out very sharply and I think *that* was interesting. [Silence]

PN: But you didn't think of that in any way as dealing with your art. I mean, this was just a side interest?

RM: Dealing with *my* art?

PN: Yeah. I could see some people making that their art activity. Saying they would put the show together was their art.

RM: No, not at all. It had nothing to do with that. [Silence]

PN: Is there anything that you want to say about your work or … about current events?

RM: Well, I guess one of the things I feel [about] all of this art that's coming along is that it points out a different way of … I mean, I think that art that's dealt with quality—like painting and all of sculpture—has seen quality as a kind of … both in very empirical and idealistic terms at the same time. I think the kind of Modernism that [Clement] Greenberg and [Michael] Fried and those people talk about … their insistence upon art as something that is pure and is located within the confines of the relationships of strictly abstract plastic values … It's both very very concrete, nonalluding, and self-contained. I think that asserts that the art has to remain, or have its relevance, in terms of this independent object that's independent of context, independent of one's getting involved with it in any physical way—it's there, out there. It's a very kind of empiricist idea of the object: it's out there, it has its properties; and you come to it, and you judge its properties. I

think it has that aspect to it, [while] at the same time it's very idealistic. I mean, it's an idealistic and empiricist notion at the same time in that it also denies that art should have anything but those things; that [it should make] any kind of allusion to time or subject matter or anything else they define as surrealistic or theatrical or one thing or another. So that they're setting up a situation that is both … that has a kind of naive empiricism about it and also is very idealistic. And I think that it's a kind of desire for the art [to] be very, very transcendent in one way or another—very removed from life. And I think that the art that's coming along now rejects that whole issue of something being a pure, transcendent object that has its value in its formal properties. I think that sort of thing is now so familiar and so academic that anything that exists in those terms is very decorative—it can only be decorative. You can't ask any more questions in terms of the adjustments of formal properties that are going to come out being anything more than decorative. I think that art right now is very impure and I think that's very good.

PN: Impure in those terms.

RM: Yeah, it's gotten away from that kind of idealism.

PN: And is that what you feel then is the difficulty in judgment?

RM: I don't think that you can judge it in formal terms any more. I think those are very irrelevant.

PN: Do you feel that you can judge art in any terms?

RM: Sure you can, yeah.

PN: In what terms?

RM: I don't think you can specify a set of criteria. And I think that's what's interesting about it, that you have to bring all different kinds of things to it. It isn't representational. I mean you can't … It's not those terms—but it isn't pure. It isn't something that you can decide on the basis of significant form anymore. And you have to decide on a much broader spectrum of responses that have to do with assessing the person's imagination, and, oh, a number of things that are not completely independent of what one would have assessed the other art on, either. But I think that art that's being done now is simply not resolving itself into formalistic terms. Because I think art which does resolve itself into formalistic terms is purely decorative, because those modes are pretty exhausted, or they're exhausted because they are so well understood. And what's interesting about this art is the degree to which it *isn't* understood. An art that deals with process or ideas, or anything that's not resolved in those very academic formal terms, you can't judge in those same ways, so that things are opening up and I think that's [what's] valuable. I don't think you can predict where it's going to go.

PN: Do you feel that with each piece then you have to find a whole new set of values to be judging on? Or do you feel that there are things that are similar that can be judged within the new work? [Pause]

RM: I think that the new work is operating on different ... it's more complex. It isn't more complex; it's less complex in formal terms. Because I think much of the new work is fairly simple in formal terms—in terms of, you know, line, shape, color relationships, and so on. It's simpler, at least at any given moment. Although some of it may involve itself in some change to the point where it's different from one day to the next or from one time that it's set up to the next. Or, it may be visible only in terms of records or one thing or another. So that what's there in terms of a formal encounter is pretty simple. But I think that it's more complex in other terms—in terms of associations, in terms of ... how it's relating to the society, its relationship to the market, its relationship to technology. I think it's making more ... It exists in a more complex way—which is impure, an impure way. And I find that very interesting. It makes the art more vital to me. [Silence] I've forgotten the question.

PN: Do you think there are new bounds being set up, though, within which artistic activity is defined? Or do you feel that that's just opened up completely? That would come in with judgment. There must still be things to which one would say, "No, that's not art." But is that just an individual decision, or do you think that there are general ...

RM: No, I think that I pretty much have to accept [Morse] Peckam's definition there where it's strictly operational—where he says that art is whatever is seen as art or dealt with as art. And that's not a formal definition or a structural one. It's just an operational sociological one, a social definition. I have to agree with that. But I think you can make ... you can somehow approach art on a more structural level than he does, not necessarily a formal one. But art still proceeds, it seems to me, in widening its limits—in attacking, widening, opening its limits. And, ah, that's somewhat structural; it's not strictly sociological. And I think that's happening now; those limits are being widened. The other day ... I went to some seminar where people were complaining that art's really broken down now, that there are no limits for it, so that it's just breaking down. And the reply was that art isn't breaking down, but everything else is breaking down in terms of what was previously excluded from art. It can now be incorporated. And I think that's more what the situation is now. One doesn't have to make art in formal terms. One can make it in any number of terms. So that it's much broader and that makes judgment much more complicated. It makes the whole idea of connoisseurship completely irrelevant, because you don't have people producing a set of closely related things that you can then pick and choose. You have to judge art like you judge a person almost: how individual it is, how broad it is, how much it includes, or what its implications are, how it thinks. Not in what it controls. [Silence] I don't have too much more to say.

PN: Okay. Just one last thing. So you don't feel, then, that another limit is being substituted.

RM: Well, I'm sure that there is a limit now that we don't see. And when that's seen, then that will be widened. Yeah. I mean, I think that's what's structural about art as opposed to what's sociological. Once the limits are seen, then they will be questioned. And maybe right now in the midst of breaking out of the object, it's hard to see what the limits are. But I'm sure they're there. Anything that's structured in art is still structured; it has limits and tends to have shared limits from one time to the next. So that I'm sure that those will be found and defined and widened. It's hard to say exactly what they are right now. One knows they're not formal.

NOTES

1. Morris refers here to *Continuous Project Altered Daily*, a work installed at the Leo Castelli Warehouse in New York, March 1–22, 1969.

2. In early 1969 Morris was working on a number of "earth projects." These included *Continuous Project Altered Daily*, mentioned in note 1, as well as the Evanston, Illinois, *Earth Project*, 1968–69, and the *Ottawa Project*, 1970.

3. Morris refers to the exhibition *Live in Your Head: When Attitudes Become Form* (March 22–April 27, 1969), curated by Harald Szeemann for the Kunsthalle in Bern. At this venue Kosuth exhibited a part of his so-called Second Investigation (section 1 of class 2 of the German-language edition of Roget's *Synopsis of Categories*, the section entitled "Place in General," which consists of four parts). The work was presented in the form of anonymous advertisements published on March 9, 1969, in four of Bern's daily newspapers: *Tagwacht, Neuen Berner Zeitung, Der Bund, and Berner Tagwacht.*

4

STEPHEN KALTENBACH

MAY 24, 1969

PATRICIA NORVELL: What I want you to do is just start talking about your work and how it's evolved, your interests. If that's okay with you. Just go through your evolution.

STEPHEN KALTENBACH: First ... I guess there's one time, which was December of 1966 and January of 1967, that I sort of consider the most ... a sort of a very important time in my own work. It was a time when I wasn't working, making work that much. It was stimulated by an assignment. I was still in school. I was a graduate student, taking a seminar from Robert Mallory. And he gave us an assignment, which was to describe our work physically. All our past work. Describe the development of the work up to the present time.

PN: Describe it how?

SK: Describe it physically.

PN: With an object or something?

SK: With an object. Describe what we've been doing, what we've been making. Then he said, start again and describe philosophically, parallel to the objects that you've described, what you've been trying to do or what you think you've been trying to do up to the present time. And he said, then come up with a proposal for a new work. In other words, extend what you've been doing. And I'd never in the past been developing my work through ... It was on a much less conscious level. I

would do something, and there would be aspects that would appeal to me and aspects that wouldn't appeal to me. And I would follow the paths that appealed to me, and it would slowly move; the look of it would change … And the change and the development of it became very crystal clear, just laid out on paper. So I found out that a lot of the things that apparently were very important in my work suddenly seemed much less important. And some of the things that I really hadn't ever consciously been aware of became very important to me.

Some of these things are … I was doing multiple clay sculptures, smallish, the biggest one was, I think, three feet in the longest dimension, and they were two to five units, exactly the same, and they were set up in a very severe line, evenly spaced. I was involved with using the surface, if possible, to get from ceramics with glazes and that kind of thing. And I was involved with a sort of art nouveau, curvilinear silhouette, and I was involved with … Well, that, those things seem to be most important. Also I was getting into—I had a little more money—so I was getting into very sexy materials like polished brass and all the beautiful colors of Plexiglas you can get and that kind of thing.

But one of the things that I hadn't really considered consciously was that I was really bothered by the pedestal thing … the means by which a sculpture, a small sculpture, was held up in the air. So I'd been making these things to fit on furniture, kind of functional furniture. In other words, the shape was often determined by the shape of the furniture that it was made to go with. When I had it all written down I realized that I was really interested in fitting what I made into a real environment. I was also working in a very minimal direction. I'd been, over the past two years previous to 1967—January—I'd been, one by one, removing the number of elements in my work. They were becoming simpler and simpler. I realized that you could only remove so many elements from a volumetric form and still have a volumetric form. Finally it has to go. So if I wanted to continue working that way, I would have to begin reducing the number of elements in the environment which intrude and which complicate the visual experience.

So I decided with that, and trying to fit the piece to the space, I would completely take over the space and control everything from the door in. And I made a series of drawings, which I guess you've seen, the room constructions, which are completely normal rooms in every aspect, from the color to the ceiling fixtures to the door, everything, with one single manipulation. For instance, the peaked floor, which was a floor that was shaped like a pyramid, but it was covered with carpet because it was mostly equivalent to a floor, more equivalent than anything else. There was no flat floor in the room; it completely went to the edge of the wall. I think that's the first thing that was really very consciously cerebral about my work, I guess. And somehow that experience really stimulated a desire to … for a kind of logic[al] development. And I began to like that way of working, much

more than the sort of gut kind of feeling working that I had been doing. It was really a switch for me in a way, I think—in a way.

So, I began thinking about other things. I also at that time began to smoke grass. And that was very important. It really … While I was writing this paper was when I first started smoking grass, and I really felt that, in a sense, I could remove myself from my ego a little bit and see myself and my work more clearly. And I became much more aware of my bad work. And I guess I began to like it a little bit more, being really aware of it and not feeling that I had to sort of keep out bad elements in my work or things that I didn't like, I guess. [Pause] I began to trust the feelings I had while I was on grass because I found that, for the most part, they were more logical than I would normally come up with. An example is I was stoned out one day, and a friend of mine told me that they were going to have eight models in the figure drawing class because the models were coming up at the end of the year as a sort of a thank-you. They were doing it for nothing, because the university had been hiring lots of models all year. And so these eight people came walking into the room without any clothes on at all, the men too, and they had this long bolt of African cloth, and they just started unrolling it and wrapping themselves up in it. It was such a beautiful thing. The cloth really took over for me, and I was really aware of … Suddenly, it became very clear that manipulation of material and cloth had had a part in art for so long, and I was really also developing a like, at the same time, a liking for a traditional basis for everything I did. It's sort of like if all other excuses for this work fail, then at least I can say well, they did it then too, you know, in another way. So, that's not really the way I feel about it, but I just had that liking for a traditional background.

That feeling about the cloth started me on the drapery things I did, and I went this way and that way with them. I was influenced by some of the things I learned from the room constructions. For instance, I decided that if I make a rug-shaped piece of cloth, which could be folded in ten different possible ways, and install it in such a way that looks fine on my floor, somebody might buy it in the Bronx, in a tiny apartment, and it'd look terrible on their floor to them, maybe to me, I don't know.

PN: Were you giving the ten different possible ways as specifications?

SK: [Laughs] Yes. So what I decided to do is that I would simply come up with a shape of cloth, for instance a square shape, and I would decide on ten different ways, or five different ways, whatever I came up with, to fold it that I felt looked nice. And then, if a person was interested in having a piece they would choose a piece of cloth that would react in somewhat the same way and they would choose the size and the color and the kind of cloth. And they would simply then follow my directions in their place. And I'm not convinced that they always make good decisions, as far as I'm concerned, about what they wanted but they did as far as they were

concerned. And I guess that sort of suggested the possibility that as an artist I really didn't have to control everything. [Pause] This has led to a lot of other things. In fact, some of the things I'm interested [in] now are things that I control hardly at all.

One development from that, a direct development, was that there was a traveling show of soft sculpture that Lucy Lippard put together that was going round the country to, I don't know, fifteen or twenty small museums and universities around the country. And I decided that … She wanted one of the cloth things for that and I thought that well, maybe … Ah, well, I'd already noticed that I'd changed from canvas; I had been using canvas just for my models. I changed to felt and I really liked the felt, so I thought, well, in a university museum situation the color and kind of material really doesn't matter that much, but why should I impose my California–New York aesthetic on how this thing should be folded when the piece is going to be in Vermillion, South Dakota, or Ithaca, New York? So I simply chose a shape and sent it around with the instructions that it should be dealt with and arranged any way they wanted to do it [see figure 13]. I guess I felt that that was maybe a more developed or more interesting way to handle it than the earlier way.

PN: Did you see results of that?

SK: No, I didn't. But when it was in Ithaca, Abby was up there—Abby's my girlfriend—and one of my students had seen it up there. So I called Abby and told her to go see it. What it was … Someone had put brass curtain rings all through the top and hung it from wires from the ceiling. And they'd destroyed the instructions that were supposed to appear with the piece that it was to be arranged by the person in the show. So again I was getting full credit for the piece as it was up there, which I thought was very interesting. I liked the fact that somebody had the guts to take my work and completely destroy it and change it and yet give me credit for it. As a matter of fact, I'm interested in doing that myself [laughter] with other work. [Silence] Ah, let's see. About the same time …

PN: When is this? This was what, last year?

SK: Yes.

PN: Sixty-eight?

SK: Well, since about March of sixty-seven I've been working very sporadically on the thing, on the cloth thing. Every three months I would spend a day doing things. Very often those things would be stimulated by somebody wanting a piece for a show. Most of the time. It's really been an area of minor involvement for me. [Pause]

About the same time, around March … that must have been … I wasn't into astrology then at all, but since then I've found that astrology really predicts pretty much what I'm going to be doing generally … And that must have been a good

time for new ideas because I was really hit by three or four things right within that two or three months, from January to March. Another thing I was into thinking about was legality, and laws, and the fact that a great many things that are illegal really aren't immoral. I'm sure the thing that really started me on it was marijuana. I'd been all my life inured with those kind of—is that a word?—those posters that show people in all stages of degradation after taking marijuana, which of course immediately led to heroin. And to my delight and surprise, I found that that wasn't really the case with marijuana. I was neither habitually addicted to it, nor did I have any desire to go on to other things. Although since, I must admit, I've gone on to mescaline. [Laughs]. Which is also a very great thing. I recommend it highly. [Pause] The fact that people could go to jail for five years for smoking marijuana, the fact that for selling marijuana twice to a minor in Colorado one could be put to death ...

PN: No kidding!

SK: I began to think of other laws, like I read in the paper last year about a guy in Boston, or in Massachusetts someplace, who swore in public—he said goddamn—and he was given thirty days in jail under a three-hundred-year-old statute. And so I thought of the possibility of breaking some of these laws that really aren't unethical and sealing the results—sealing the evidence in a time capsule so that I could sort of document my feelings about the laws but not pay the piper for what I'd done. So that was what I thought about those things. However, June came along and I had to work because I was saving up money to come to New York.

So I really wasn't doing very much from June to November. When I finally got a loft here and settled down a little bit and I started to work, by that time my ideas about the capsules had changed quite a bit. And I'd made three capsules ... That was from November sixty-seven to the following June, June of sixty-eight. Actually, I'd started another one in California through a friend of mine. And that one I still haven't completed yet; I still need to do a couple of things to complete it. But I told a couple of people specifically what was inside the capsule, and I found out that that was the wrong thing to do, that the secret quality of it itself and the enclosure of whatever-it-was inside, if anything, was really important. So now I never say anything about the contents, and I won't even admit that there are contents, although I don't swear that there [aren't]. And so, I don't know ... There are people who don't like that as much—they'd just rather know what's inside—but that's my decision, I guess. I really decided that was the way they should be handled, so I never say anything about the contents anymore.

The first three I made were capsules, which demanded a very specific environment. So I couldn't sell them, simply had to take them and give them to the

people that they were made for, made to keep. One was for Bruce Nauman, who's been, I think, my primary influence over all other people. And one was for Barbara Rose [see figure 14], which is very much about me. And that one ... it's obvious on the outside that it's about me. It says "Barbara Rose, please open this capsule when, in your opinion, I have attained [national] prominence as an artist." So I'm not really giving away any information there; it's obvious. [Pause] The one at the Museum of Modern Art is to be opened when I die, and that's in their special collections. I gave it to them to keep.

PN: Do they show that ever?

SK: No. They keep it in their special collections, and it's available for scholars or for anybody who wants to go see it, I suppose, who knows about it. But it's simply a container, that's all that you can see.

PN: Are the instructions written on the outside?

SK: The instructions are engraved on the outside, all of them. Since then I've been, of course, thinking about the possibility of selling them. And for a long time I just couldn't come to terms with it, it was [sigh] just ... [Silence] It seemed the other way was much more viable, I guess—although I don't have the things about selling work and that kind of ... although I did like the aspect that they weren't for sale and they couldn't be sold because it sort of avoided all the art-world stuff. But since I've been thinking about making them to sell, it's turned out to be an area with a lot of potential. And I'll be making a lot of them to sell. Also I think it does something to my reputation, which it has with several people who liked me and liked my work very much because it wasn't for sale. And so that changed their ideas about me somewhat, whether true or false, I don't know. Well, that's about the time capsules, sort of.

PN: Now the ones that you're going to sell ... Will you wait until you find out who is going to buy one before you do it?

SK: No. Sometimes yes, sometimes no. I haven't considered making one specifically for someone who is interested in buying it. But there are several of my friends who want to trade for a capsule for their artwork. And for those people, I'm not making them until I have something that's about them—that has to do with them. The ones I've made to sell so far—I've finished five, and they're nonspecific—they do not require a specific environment.

PN: What kind of choices are you making in what you put in them? What are your guidelines that you're working within?

SK: Those things are all secret. [Pause] Yeah, but it'll be obvious, you know, soon, when they're opened. I haven't made one yet that will remain closed more than ... Let's see, well, the one that Barbara Rose has may never be opened, but I really do think it will because I intend to build a reputation for myself.

PN: Well, the one at the Museum [of Modern Art], though, won't be.

SK: The one at the museum won't be opened until I die. The one Bruce has won't be opened until he's notified, and I'm not speaking about when he'll be notified. I'm not notifying him. It's all set up that he will be notified by legal authority when the time for the capsule to be opened [comes]. [Silence] I seem to have this ...

PN: Yeah, I was just asking what choices you were making because you're out of the realm of normal art choices, it seems. I mean, I was wondering whether you feel you are or whether you feel you're still working within a traditional manner.

SK: Well, my choices are really limited by my imagination, which is sort of limited by what I think is valid. Ah, and I'm sure that my ideas about what is valid as far as art goes are limited to what art is, you know. A good example is again about the same time, March 1967 ... two years previous to that, about sixty-five, I was a ceramicist. The only three-dimensional work I was doing was in ceramics. I was doing a little bit of sculpture, and I felt a little bit superior to the normal potters because I was a ceramic sculptor, which is obviously more "high art" and better than just ceramics. And ... At least that's what I felt; that's what all of us felt out there who were ceramic sculptors instead of plain old potters. And so one of the things we were interested in doing was bugging the regular old ceramicists. And we would do that by showing things that were a little bit outlandish in the ceramic shows and stirring up a little controversy and talking down to them and that kind of thing. And one thing I did for that, there was a show and I made a proposal for a mound of clay, eight tons of wet clay of throwing consistency packed against the wall in a kind of mound shape. Of course it was rejected—the idea was unthinkable. And to me it wasn't artwork; I was doing fired clay, small pieces, and this was simply a thing, you know, that I did to the show.

Two years later, I saw some pictures of Indian burial mounds and that kind of thing, which really turned me on. I'd been doing drawings for shaped gardens that were sunken into the ground and had trees growing in them that would just stick up above the ground, maybe three feet or so. All of those drawings are in Australia now, or a lot of them are; I have a few still. But I really became interested in using earth and planting it with grass and that kind of thing. Now that's about the same time too. But even then I wasn't convinced that what I was doing was really—like other things were much more important ... The room constructions were really art; I knew they were art. Those things were ... I liked them and I liked doing them, but I didn't get that much instant acceptance for them because I think the people there at the university were operating under the same thing. Although the people I really admired did like them quite a bit. But I didn't really trust those people. Even though I really admired them, they were just a little far-out. Like, Bruce Nauman was there, and he had a fantastic influence on me—very strong—but I didn't show much at all until I got out of college, be-

cause I just had to get through all of my preconceptions. Preconceptions really determine what a person can do, I think, to a great extent. A lot of the things that artists there could talk about they couldn't do. And a lot of the things that they could talk about are things that Bruce began to do—not that Bruce got his ideas from them. I don't know, maybe, I'm sure there's some of that, I've finally gotten to the point where Bruce is a little less immortal and a little more of a human being, and I think I'm even noticing that I'm influencing him a little bit ... which is really good for me, although it may not be true. It just may be something that I want to see; I don't know. But there is *that* thing, so I think the contents of the capsules are limited mainly by what I can imagine as being appropriate, what I can see, what I can accept as appropriate—what I can accept as art, I guess. Although I guess, I'm sort of—I don't know what it is—I guess lately there's nothing I can't accept as art. I just haven't seen anything for a long time.

PN: That's one thing that's happening, though. People are ... broadening the whole boundaries of what is art. And one question I've been asking people is if they're substituting another limit, a new limit for what art is, do they see it?

SK: Yeah, I do. My limit is ... ah, art is whatever an artist can make it, I guess. It comes from ... the last couple of years ... Another thing I think is equally important as grass and Bruce Nauman was that I'd never taken any art history courses until I was a graduate student, and I'd never read any art magazines or anything like that. I'd keep away from that stuff. I really wanted local influence. [Laughter] But I took three art history courses in one semester and it really blew my mind. They did because I had some good teachers and I saw how art worked, and I saw how artists worked, and I saw that artists made art because they knew they were artists, and they also knew what art was because they knew what art had been. And finally I began to see art as an English word which is used to describe what is considered to be art, which is what artists have made. And I realized that, like, if artists were truck drivers and art was really the word that was used to describe truck drivers, then artists would be driving trucks and it would be very acceptable. Then I realized that, like, art doesn't remain the same. It's continually changing, and it's not that Webster gets together with his cohorts and redefines the word every year or so, but simply that artists are slowly moving away from what art is and taking art with them. So art sort of follows the artists.

So it seems to me that really the limits to what art is are what the artist can con the public into accepting, on one level; and also what artists can conceive of doing, on another level. And I think that there are a lot of factors that determine how fast something becomes art. Like, I think within a specific culture an artist can do certain things that can be accepted as art immediately or in ten years or in a hundred years. In another culture that may be more into accepting, he may be able to do a lot more, or what he does may be able to be accepted a lot faster. I

think eventually almost anything that an artist does, if he makes it known that he's an artist, if he feels he's an artist, becomes accepted as art—almost anything. Ah, maybe anything. I think that the art that isn't accepted as art is done by the artist who doesn't make it known that he's an artist, that what he's doing is artwork. And even some of that is. There are a lot of people working who consider themselves ... like Simon Rodia and the guy in California who shapes full-size trees—he does art. Not art—what is it? Bonsai with full-size trees. Like, he did a row of oak trees that spelled his signature in longhand, and it's really very much like his actual signature, and he has pine trees tied into a bowline knot and things like that. Just incredible.

PN: Where is that?

SK: Oh, it's not far from Rodia, I guess it's a hundred fifty miles north, somewhere inland from Santa Barbara. I've got to see it; I'm going to see it this summer. It really sounds like ... I hope it's as good as it's been described to me. [Pause]

PN: Do you feel ... um, this whole year there's been a kind of excitement, or a feeling, that people are going further or really making breakthroughs in art. Do you feel that we're taking bigger steps in opening up the field of art than in the past? [Pause]

SK: Well, I think that really depends on the individual artists. Ah, I think sometimes it depends, you know ... Like, some artists still make very conservative ... I'm thinking of Richard Serra, who I think is an artist who's pretty conservative in what he makes and very far out in what he thinks. But I still think that he doesn't consider what he thinks as art as much as what he makes. [Marcel] Duchamp, I think, did things which are still being just understood and discovered. So I think that he specifically is one of the people who is one of the greatest germinal artists to have ever lived, he and [Leonardo] da Vinci [laughs] are probably the two that come to mind. And I sort of suspect Winston Churchill, I think really Winston Churchill considered his life as a statesman his major work, and he was simply painting just to keep up his reputation as an artist. [Laughter]. However, very few artists have won a world war. [Pause] He certainly did build a reputation for himself. I think Yves Klein was very interesting that way. I don't know, I guess it seems to me that culturally we're able to ... We're permitted to move faster now.

PN: Yeah, everything's absorbed ...

SK: Everything's absorbed faster, so it's moving faster, and it is really exciting. I don't really think that people are any more inventive or smart or anything.

PN: Yeah, no, I mean that ...

SK: I think like a person born nowadays if he were raised in a tight art culture would come out a tight art maker. Ah, and I don't think that's bad either, you know. I think tight art makers can make very great, fine things. But being what I am, I guess I'm ... people ... I guess I like myself okay and so I like being what I am,

and so I like being in a looser, faster-moving, developing kind of thing. The developing to me has really become primary.

I'm really having a hard time making objects now, and the objects I do make seem to sort of drop out as evidence of my discoveries. Anything that I think I can understand seems to become potentially a way of working so that—I think I mentioned this on the other side of the tape—the fact that as I understand information and I get information, I ... if I feel I do anything to the information myself, I'm really anxious to pass it on. And I don't ... the traditional methods of passing on is doing a work and having people seeing it and having people understand what's new in it and doing it themselves. And now it's really, I think, becoming very traditional to, instead of that, simply pass the information on. Say you understand something, you say, "Hey, I understand this." I personally, I think it's just my own taste; I like to do things very underhandedly. And so I come up with devices for doing it. For instance, a couple of years ago I was ... well, whenever it was, a year and a half ago when I just got to New York—and again it was grass that was one of the major things which helped me ... I had this gray space that I used to photograph the cloth thing, and I was sitting just staring at it, and I was drunk—I mean I was stoned on grass—and I was listening to a record. And suddenly I began to see pictures on the gray thing ... It was almost like I was watching a movie. And then I turned off the music and I tried to ... I got a book and I read a little bit in the book; visually, it was a very strong book. And I began to see things again. And then that brought back all kinds of things I used to do, like daydream. I used to be an incredible daydreamer. I used to be great at conjuring up color three-dimensional imagery, you know, for my daydreams. And it seemed to me that that's just another way of making an illusion. I thought that well, you know, with all of the, ah, evidence that ESP and that kind of thing really does exist and that it may be something that can ... a muscle that can be developed as much as any other muscle ... that someday an artist may simply just expose his head directly to other people, and that may be the way he expresses himself. And being unable to do that, I felt that possibly there'd be other ways to go directly from head to head, or as directly as possible. The obvious thing is through language, which is what most people use.

And so I got into writing things. Well, the first thing I did was a movie screen with a little script that went along with it ... And it was a very clumsy thing. The script wasn't very interesting; it was kind of like a *Gulliver's Travels* thing, with a little town that was all very colorful and a ship. And I tried to take the person from seeing the town to being tied down in this cabin on the ship, and the person being as large as the ship itself. And I guess I didn't like that very much. It wasn't very successful, and I really didn't need the movie screen, I found out.

PN: What was shown on the screen?

SK: Nothing! It was just blank. You would just look at the screen and listen to the dialogue and attempt to picture it as it went along. It didn't work very well. The next thing I did was … I decided that maybe using what's already in a person's mind would be more effective. So the spring of last year I used my class, because they were sort of a captive audience. And I had them close their eyes and use some meditation techniques to sort of slow things down, calm down, [come] to a peaceful state. Then, using as minimal a number and complexity of cues as I could, just word cues, I tried to take them back to a time in their childhood, sometime which was very pleasant, and tried to get them to zero in on the major moment of that time—the best time, the best moment—and then tried to get them to fill that picture out with all the senses to a … as complete an experience of that moment as they could. And I just called it a recall experience, for want of anything else to call it. And it was really very successful. A couple of the kids went out crying a little bit, and a couple of the kids went out real excited, and a couple of the kids went out stoned, you know. And the rest of them were, I think, at various degrees of noninvolvement. Most of them were actually pretty involved, though. It was a good thing. I was very happy with the way it turned out. I think it was very clumsy. My cues could have been much better. And I got a lot of good advice from them all on it.

I've been thinking of presenting something like that in a theater situation, kind of like a mind play in a way. Where instead of having the acting going on on a stage, the cues would come from the stage, and it would go on in a person's head. There are some hassles with it, though—like any noise really seemed extremely detrimental. And it's just … I don't know, it's something I'm really interested in, and yet it's something I really haven't done much with since. I guess it's just because I've been involved with doing other things. Ah, since then I think there are … I've seen other artists who are working on these similar things. There's an artist from Boston who just does imaginary sculpture which … I don't know. [Pause] I guess it's not as interesting to me. It's sort of like it's still a combination of both things, he's still doing the old sculpture, but he's doing it in the imaginary sort of mind way. And I think that that isn't too logical. Ah, like a cube of air, imagining it hovering over the desert—it's still about the old physical things. But I'm sure it's going to go into, it's not going to stay there, it's going to go into the … I think, things which are more compatible and logical with the mind. Just … much more can happen. It's obvious to me. Much more.

Ah … [Silence]

Let's see, what haven't I talked about?

PN: You haven't talked about the *Artforum* ads at all.

SK: Oh, right. Well, that's … oh, and I haven't talked about the influences, that comes first. When I first got to New York, I showed a friend or a person who is very close to my own work—he's an artist—I'd met him for the first time, and I showed

him my work. We had been doing very similar work for a long time. And he was into … I showed him this one specific group of things that was something he was working along too. I think that his things looked much more like a friend of mine's than did my things, but we were working the same materials and generally the same approach. And I saw … I came to his studio about three months later, and I saw a lot of my pieces around, only done in his way, much bigger and much better. Of course at first I felt a whole thing about, you know, what artists feel when they feel someone else has taken their work and that kind of thing. Which is something I'd been constantly dealing with. And I thought about it for a while. Of course I didn't say anything to him, and then I realized that it's really a compliment in a way. I mean, it just shows that he really liked my work more than anything he could do. Anybody that's going to be that influenced obviously is that influenced, you know. And something that seemed really ludicrous to me, that anyone would be uptight about it. And that was the last time I've ever been uptight about anyone being influenced by my work, whether strongly or weakly or whether they admit it or not.

And that suggested the possibility of actually trying to do my work through other people. Two things have come from that. One is that when I'm talking to an artist—I'm not doing it anymore, by the way—but when I was talking to an artist who I felt had certain interests and who I felt I possibly had some things that could help him, I would as nonchalantly and as, like … I would give what I had and wait and see what happened. And I would write it down, what I'd given. It didn't bear fruit a lot of the time; most of the time it didn't. But I can't really say that. That kind of thing is very, very hard to measure. Very often I suspect that the ideas I gave were ideas they already had, possibly. Ah, so quantitatively there was no way for me to decide what happened with my work. But nevertheless I felt that I was really doing work. And it occurred to me that this was another way to escape my own tastes. Ah, by taking a principle that I was working with and channeling it through someone else, the resulting work is really about that person. As it had been in the test case, the first case I'd known, they were my pieces, they were, like, exact duplicates, but they were … Well, the size was different, the scale was different, and the approach to the material was different. And I really liked them better than I liked my work, my pieces. And that was one of the things that really bugged me at first, I think.

PN: That you liked them better.

SK: That I liked them better. And then when I realized the ramifications of it and the possibilities, that it was a very freeing thing. And so I think that I have about fifteen attempts to influence recorded, and I have about four obvious successes and a few that I really can't tell. Of the four obvious successes I really can't tell either, you know—I mean, for sure I don't know—it just appears that that's what

happened. And I sort of do consider that it's my work, but I really can't take credit for the objects, and I don't try to. It would be ludicrous to, right? Since then . . .

PN: Are you publicizing any of this, or is this being left to history?

SK: No, no, it's secret, because I think it's something that is loaded egowise, you know, potentially, and I'm not into causing anybody any uptightness or feelings that I'm trying to get credit for what they did. And, besides that, I . . . The same thing's happening to me, and I'd be blind if I didn't admit it. I think they're . . . I do see people, and I do see ideas that are very, very strong to me. And I have good examples, like the sidewalk plaques, where all . . . which are almost duplicates of Bruce Nauman's work . . . which keeps me humble enough, you know, to keep from getting [laughs] any godlike feelings or anything like that [that] could come out of this kind of work. Since then I guess that that kind of thing is . . . The major thing is gone to other things. Like, I don't really try to do that anymore. I'm again willing to just let it happen naturally if it does. You know, I talk to people, and they give me their ideas and I give them mine, and I don't try to record it anymore. But I'm into something I call teach art now, which is—like with my students—it's the more traditional way of doing the same thing. And in a sense, I think it's more logical and less specific because I'm trying my best in teaching art not to give them my ideas but to push them to get their own ideas. But again, I can still accept that as my work because anything can be your work, anything, I feel. Anything that you can imagine as being your work is your work. And so, like, I'm making a statement that teaching art is one way of expressing myself. So I pass on my taste while successfully opening the possibilities for those students that have opened for me. So again, it's a two-way thing. I get a lot of ideas from my students, a lot of good ideas. And the exchange, even if it's not from them, the exchange clarifies my own ideas. So . . . I don't know, it's . . .

PN: But the one question that brings up to me about a lot of the new work, and a lot of your work, is how you judge it. On what grounds does an observer judge . . . you know, evaluate your work? And that your presentation is on the . . . what you're saying is almost impossible to make any judgment on . . .

SK: Right.

PN: Except for as an idea.

SK: Right, right. I think the idea can be evaluated. I think nothing else really can. And I think that may cause some hassles for a while, but already people are accepting the possibility that you really can't criticize this kind of work. And as a result, art critics, the really imaginative ones like Lucy Lippard, are into passing information rather than making their own value judgments. She doesn't write anymore, hardly at all. And in a sense, they're really becoming artists.

PN: I feel that about Seth Siegelaub as a dealer too . . .

SK: Seth Siegelaub is really . . . Yeah, yeah.

PN: He's becoming an artist, although he won't say that.

SK: No, he won't admit it. I've tried to get him to admit it.

PN: I did too.

SK: Yeah, I really understood all those possibilities through writing that article that I wrote, that little article. I guess I gave you a copy of it. It was a short article on art expression. And all those questions seem very valid ones like that art dealing and art patronage and art criticism, art writing, all those things, in fact just living, you know, could really be valid means for an artist to express himself.

PN: Well, what you're getting into is a lot of lifestyle, I mean a style of life ...

SK: Yeah, right.

PN: You know, functions of life.

SK: Guys like Yves Klein, I think, really ... and [Marcel] Duchamp, both. Although I didn't really realize it until I understood it myself, and at first I thought, hey, that's my idea, you know, "become a legend" kinda thing, which is the next ad coming out at *Artforum*.

PN: But now that in *Artforum* you're documenting, you're presenting a ...

SK: Two things. There are fourteen thousand copies of *Artforum,* so instead of simply sitting down and talking to you, if I have an idea that could be used, why I'm sitting down talking to fourteen thousand people. Not really, though, because a lot of the things I put in *Artforum* are not understandable to an awful lot of people who read the magazine [see figure 15]. In fact, they aren't even identified as information. But I guess that the way I feel about that is the same way I feel about that article I wrote. In the article, again, it was the same thing. There were possibilities that occurred to me, and in teaching and in talking to my friends and in writing the article, I was interested in passing on the possibilities. And the same with *Artforum*. The ads are passing on possibilities. But I couldn't get the article published. And one of the ... There were two reasons: one, that it's clumsily written, because I'm a clumsy writer. I'm just not good at dealing with words, although having dealt with words so much, Abby says, I'm getting a lot better, which is, you know, very nice to hear. But the other thing was that I refused to offer examples. For instance, I would say it is possible to manipulate an object by manipulating the environment or by manipulating the ... God, I knew it all by heart at one time ... It's possible to manipulate an object by manipulating the nature of the object by manipulating the nature of the environment or the nature of the observer. And it's possible to manipulate an environment by the same thing, and it's possible to manipulate an observer by manipulating the nature of an object to the environment or by manipulating, simply, the perception of the observer himself. [Pause] They wanted examples, like, well, in the case of Dennis Oppenheim, he did the manipulation of this and that. But I feel, and I found out in my teaching, that if you have to supply your own examples, well, you really learn the lesson. And so I just leave

it open, and you have to draw the real parallels. And I feel that way with the ads too. A lot of the time they're very straightforward, like the command thing— "Build a reputation," "Tell a lie," "Start a rumor," "Perpetrate a hoax."

PN: Yeah, but they don't say how to do it.

SK: They don't say how to do it and that kind of thing, but nevertheless they're very— pretty straightforward. Some of the others were really much less straightforward. And I think some of them are so much that they're kind of like time pieces in a way. They're going to require some time to get into. It's not because I'm, like, so far ahead in my thinking, and it's not because I'm smarter than anybody or anything … It's just because, like, that's my … that's where I really come in. I like being mysterious, and I like disguising my intentions a lot of the time. And I really do that. In fact, I've really gotten into it lately.

For instance, I did a piece for the Simon Fraser University in British Columbia, and it was handled by Seth Siegelaub.[1] And I made a proposal that the university give me two hundred dollars to do a piece. I couldn't reveal anything about it, the nature of it, at all. Well, the university turned me down, of course. Their excuse was that the money had to be spent through normal university channels. In other words, it was available for buying materials or that kind of thing but couldn't be just given. So I came up with another proposal that they buy an ad in the *Vancouver Sun*. The ad was a duplicate of an existing ad, which was "Rent a Backhoe or One Yard Crawler with Operator," and it gave three phone numbers. Well, that's earthmoving equipment; it's into moving earth. Well, they wrote back and said that, or they called Seth and said that, they gave me a counterproposal that they would run the ad in the school paper but not in the *Vancouver Sun* because, like, to run two ads the same—I'm sure that had something to do with it—it just didn't make sense. Ah, however, there was information which I couldn't give them because it would have altered the art action too much. That information was that the company which runs the ad in the *Vancouver Sun* belongs to my brother, who has an earthmoving company, luckily in Burnaby, and that when the ad appeared in the *Vancouver Sun*, he would have removed his ad so that no net physical change would have taken place; nothing visible [would have] happened. [Silence] I guess that it was kind of my New York graft piece, I felt, because it had to do with, like, helping my brother out, and it had to do with doing something but not doing something, a lot of the things I was interested in doing. So they refused that.

So the third thing I sent Iain Baxter, who's the person who's, again, very much like me … There's three or four artists who are really; we come up with the same ideas completely independently, exactly the same ideas … [Silence] So I wrote to Iain and asked him to try to determine as best as he could the factors or people or whatever, who or what was involved with the failure, who was responsible for the failure of the university to handle the proposals I'd given them. And then to go to

STEPHEN KALTENBACH

them and direct to them a severe tongue-lashing. And I gave him a couple of phrases that he could use if he wanted to and said that he could use foul language if he wanted to. And that's the piece. Now he will either display the letter or not or just give the tongue-lashing or whatever he wants to do; it's up to him. But what I haven't made available yet, but what I will make available sometime, is that I planned the entire thing. When I was approached to make a communications piece, I tried to think of an aspect of the university itself that I could communicate about or talk about or expose, and I really decided … Oh, I'd just gone through some things at [the School of] Visual Arts where I teach—Visual Arts is, like, one of the most enlightened, loose-hanging administrations in the country, I think—and yet they still have things that they have to deal with that I think could be improved. So I decided that in a university … the setup for handling things like this is generally pretty rigid and doesn't have much latitude for accepting things. And so that's when I decided to expose … And the way I did it was to make a couple of proposals, which I specifically felt would be unacceptable for one reason or another, and to expose that unacceptability. And so I planned the two that I thought … Of course one of them might have been accepted, which would have drowned my whole plan, but it worked out very nicely. And so then I directed criticism toward the aspects that were responsible for it through Iain Baxter—which was the entire piece. But that kind of, I don't know, mystery story thing of keeping the real ending till the last is something that I've always liked in literature, and I guess I like it in my own work. [Silence]

PN: In those pieces, then, you're leaving choices up to other people?

SK: Oh, yeah. Always. I just can't make my own decisions. [Laughter]

You know I'm a little cold. I'm going to put on my coat. Let's see. It's one o'clock. How long have we been going? Is there much more tape?

PN: There's a bit.

SK: Well, let's see, what else do I have to talk about? Is there anything else that occurs to you that … It's much less garbled than last time, right?

PN: Uh-huh.

SK: Well, why don't we just cut it now, and if I have more to tell you, I'll be glad to tell you more.

PN: Okay. Great.

NOTE

1. The Simon Fraser exhibition to which Kaltenbach refers, titled *May 19—June 19, 1969,* was organized by Seth Siegelaub and took place in Simon Fraser University's Center for Communications and the Arts, Burnaby, British Columbia.

5

ROBERT BARRY

MAY 30, 1969

PATRICIA NORVELL: What are your artistic concerns now? And how have they changed? How did you get to them?

ROBERT BARRY: Well, I guess I've always been concerned with very fundamental problems. And ... I guess the big problem is trying to find out exactly what those problems were, that is, what questions I should ask, rather than having any real answers.

As an example, my current art sort of takes a couple of different paths. One is concerned with transmitting my ideas through telepathy [see figure 16], that is, bypassing any kind of material, even words or language, and transmitting the ideas from one mind to another. And I believe that that can be done consciously or unconsciously. These ideas are transmittable. Whether or not they're picked up by other people, or whether they're consciously picked up by other people, is another question. And this, I believe, raises a lot of fundamental problems as far as the existence of a work of art is concerned: just how much is needed, and how much has to be known about a work of art, before it does exist. I think it questions the very *being* of any work of art. Things like that.

Then there's another kind of work that I do which deals with the unknown; that is, the actual nature of the work of art is not known by anyone, including my-

self. For instance, I did a piece which deals with the contents of that part of my unconscious which is particular to the unconscious. That is, because of its nature, it can never come into the conscious so that, because of its nature, it can never, ever be known by my conscious mind. It will always remain in the unconscious. And then, of course, the question arises: Does that work of art really exist or not? These are all problems that I guess I'm interested in. [Pause] Ah, it's just sort of, you know, just … It's sort of like a search for me. It's the really fundamental things which I'm looking for, I guess.

PN: How do these works manifest themselves? For instance, this unconscious one, how is it presented? Is it only by you saying that you're concerned with …

RB: You see, you have to … That's part of the problem. You see, what this does is—it sort of defines art; it sort of defines the problems of art. In other words, you're not really asking the right question. The artist *making* his work of art is entirely different from the artist *presenting* his work of art. And art for me is making art, myself. And if in the process of my making art it involves things which are invisible, which you can't see, which I can't see, or which are imperceptible, which we can't perceive through our senses, then that's just the way it has to be. And then we also have to recognize the fact that you can never totally know what's going on in my mind anyway; that any object which I present to you and you perceive in your perception of that object brings with it all the fantasies and everything else which you associate with those things and which I have no control over anyway. So I simply can't even worry about presenting, or worry about how it manifests itself to you. It's not really a problem when it comes to my making my art. My making my art is a … Well, it's like an existential thing: only I can do it. It's a … You know, it's like [Jean-Paul] Sartre says: "Only you can experience your own death, your own making love, your own" … anything. It's your personal experience, which really no one else can have.

Now, if I decide to present my art to someone else, there's a question why I do that. And what happens to that art when it is presented? You see, these are the fundamental questions. And one thing that happens is that I immediately have to start thinking about other people. And how do I make it known that this work of art exists? One way of making it known, of course, is through language, which in some ways is a very wonderful thing, and in other ways it's very imperfect. And you see language is really sort of like symbols devised by other people which I'm forced to use. So I immediately have to start making certain compromises and work on a whole different plane, a whole different level.

Now, there are some artists who incorporate that, incorporate the presenting of their art into the making of their art. I think that's been a traditional way of doing things. In other words, a man who makes a painting starts with a certain idea in his mind of what the painting will be or certain ideas that he wants to work

out. And then as he gets involved with his paint ... The painting begins to take on a certain being of its own. He sort of has a dialogue with this other being which he has created. And he has to deal with the limitations of the medium, so other ideas present themselves which are suggested by the material that he's working with. So what he ends up with is an object which is a combination of what he does, and the limitations of his medium, and so forth, and so on. Whereas I don't really work that way. So that therefore my making of the art becomes more personal things, something which only I can really experience. And there are all kinds of problems involved in presenting it. But as I say, I keep those two functions entirely separate, and always realizing that I can never present ... I mean, can't ever even hope to present my experiences and my art to you or to anyone else the way I experience them. It's just, you know ... it just can't be done. It's just an impossibility.

PN: You started out painting?

RB: Yes.

PN: How did you get to where you are now from painting?

RB: I don't really know, actually. I don't think anybody really does. It's really not even a fair question to ask because, um, ah ... essentially it's really none of your business, you know. First of all, things that motivate artists are never really on the surface anyway. I sort of keep changing my mind as to how I got that way. I mean, it's a fact that I did and the art exists. That's a fact; that's what you have to deal with. My motivations, my reasons for doing it, are something which I don't even completely understand. And the more ... and the older I get, the more I realize why I did it. But I really don't know exactly why. And sometimes I think I do, and then I change my mind. You know? The fact is that I did get to where I am and ... and that's, that's really what's important. [Pause] In other words, I think it's important to deal with what is presented. Ironically enough, that's what ... that's what you have to deal with, rather than sort of trying to get off the subject as to why did I do it, or how did I do it, or when I was born—or, you know, that sort of thing, which I ... which is not really important. [Sigh] I don't know if I've answered the question. I mean, it's really sort of ... one thing ... maybe one way of answering it is to ... I mean, I could sort of recount the work that I did before that and talk about some of the things that I was involved with then. But then where do you start? How far back do you go?

PN: Well, that would be your choice [laughter] how far back you wanted to go. I would be interested in having you do that. [Pause]

RB: I'm not really sure.

PN: Okay ... You see, one reason is that there's a very strong feeling today that art activity is being redefined. And we're shedding ...

RB: Art's always being redefined.

PN: Right, but on a much more active level than, say, at the beginning of the century. Although this whole century has been doing that, this past couple of years has seemed very active. And I wanted to find out how people thought they were doing that. What were their new choices? How they thought they were doing something different. Or what they were redefining. Were they setting up new limits? They're shedding old limits of art activity and setting up new ones. Is there any idea as to what they thought they were getting rid of? And one way of doing that is just to go through what the person's done and at what stages they did ...

RB: Okay, well, let's see. In January there was a show that Seth put on, which included myself and Joe Kosuth and Larry Weiner and Doug Huebler, which, I guess, was a very important show. And in that show I had several pieces [see figure 17]. The two which were in the gallery itself, if you want to call it that—the place where the show was—consisted of electromagnetic energy fields, which I guess you might call radiocarrier waves. And at that time I was interested in making objects, if you could call them objects—I guess maybe they were not, in the traditional sense of objects—which were totally outside of our perceptual limitations. One of the things which I tried was to deal with all of those other parts of the electromagnetic spectrum outside of the visual arts, that very narrow band in there which we perceive as light. And part of that spectrum involved radio waves. I also did, let's see ... I did a microwave piece, and a gamma-ray piece, which is of the very, you know, smallest waves. The radio waves are very long waves ... So what I was trying to do, really, was create something which really existed, and which had its own characteristics and its own nature, but which we couldn't really perceive. And then of course the problem was, how do we deal with such a thing? how do you know about it? what does it mean to you? and so forth. And of course those are problems which other people have to handle and which I handle myself in my own personal way. Ah, then there were other beautiful characteristics, things which I liked about it. For instance, the fact that these things pretty much exist forever. They're ever changing. They expand out into the universe, always. They're ever expanding, these carrier waves.

And so I did a series of things like that. I went out to California and did a show for Seth [Siegelaub] where the material was inert gas, which is odorless and colorless and imperceptible.[1] And I did a series of pieces there, what I guess you might call process pieces, where I simply took small, measured amounts of inert gas and then released them or returned them back to the atmosphere [see figure 18]. And what I was doing really was creating an ever-changing form once again. Because the inert gas is of course chemically inert—it doesn't mix with any other material; it doesn't mix with itself—so that it really never changes, that the mole-

cules constantly expand, creating a larger and larger piece until it's completely absorbed back into the atmosphere. And of course this is something which no one can see.

PN: But you actually did physically do it?

RB: Yes. And that's … I always do what I say I'm going to do; that's very important. Ah, it's important to *me* to do it. You see, that's part of the making of the art. It might not be important to *you* that I do it or to anyone who knows about my art. It doesn't really matter to them whether I do it or not. But it's important to me because it's part of my development in the actual making of it and just seeing what happens when I do make it.

And then I guess the next one was dealing with the electronic energy which takes place in the body itself. The body is constantly producing electronic energy, changing chemical energy into electronic energy. And I have always been involved in telepathy and parapsychological phenomena, and worked along those lines using mental energy as a medium. [Pause] Um, let's see, before that I did things which were almost invisible. For instance [motions to ceiling], up there you can just barely see a piece, that nylon thread which was stretched across the ceiling and comes down on the other side … It's a piece where I created very large things but the nature of which was so … was such that you couldn't really see it too well, such as that nylon wire and things like that [see figure 19]. Or before that I did paintings, not unlike that orange one over there, made up of very small panels which would be placed very far apart. And there were some which were much smaller than that which would be placed in the corner, and things like that. In other words, at that stage I was sort of involved with the space between the panels—the emptiness between the panels—and the panels really just defined that space. What did I do before that? I made paintings which were painted on the edge of the canvas, so that the front would be blank.

PN: Now with your recent work, the problem that I see and which other people share is that, in communicating with it, it has to be documented to be presented. Are you concerned with that at all or are you leaving those choices to other people?

RB: Well, my method of presentation is that I sort of start first of all with the idea of *no* presentation … And then I say, well, the next step, what is the *least* amount of presentation that I can get away with? Maybe it's just a sticker, given some title which is a descriptive title. And then if it's in a show, just put the sticker on the wall describing it. Ah, that's about it. And that's pretty much where it stands right now. As brief as possible a description in fairly technical language … I try to make it as impersonal as possible.

PN: Why have you decided to do that?

RB: Well, so that it doesn't confuse people [laughs] when they look at it, I guess. I try to get as little interpretation on my part as possible into it. But even that is lan-

guage use … The use of language is very difficult. It's something which is not natural to me. I dislike using it—of course, naturally I have to use it.

PN: Now, I think that one problem in your work is that people are presenting it in visual documentations which are distracting from the piece. People get involved in the presentation, criticizing it with old standards, and don't focus on the issue that the artist is concerned with.

RB: Yes, that is a problem. And hopefully that will be worked out. [In] the very latest work I'm sort of insisting that there isn't any visual business at all. And in certain magazine articles, I've sort of just decided that there aren't going to be any photographs. You see, I sort of allow photographs because they sort of prove the point that there was nothing to photograph … But now I think I'm just going to not have any photographs. Just leave it be. You see, these are all problems which I don't pretend have been thoroughly worked out. And I don't even want to have to try to *explain* what I did six months ago, or a month ago, or two weeks ago, because since then I feel that I've evolved to a better way of presenting it. As I go from one thing to another, different problems present themselves, so the method that I used for presenting work six months ago doesn't work now. [Pause]

Now, for instance, I sort of feel that the piece I'm doing for a show in Seattle by Lucy Lippard transcends all time and space and things like that.[2] I mean, there just isn't anything to photograph. There isn't a place. It doesn't exist in a place. You know, it doesn't even exist in a time. In other words, the piece … There are pieces which I do which exist in the future, which can only be made known by someone who has the ability to see into the future, the complete nature of which I don't even know—when and where and what it will be like when I do make it. But if I decide that there will be a piece, does that mean that the piece exists? See, that's the question that is immediately posed. So there really isn't anything to photograph, there's no picture of anything, there's nothing solid. In fact, the only person that could tell you what the nature of it would be would be someone else, not myself. Someone who was able to, in some way [sigh], know about it before it actually happened. And of course that also …

PN: Before you knew about it or before it happened?

RB: Before I know about it consciously, yes. And this also poses the question about the nature of time and the nature of place and things like that. [Silence] See, there's the whole question of the existence of an object. I did a piece for Lucy Lippard's show at Paula Cooper's which is an electromagnetic energy field; something similar to what goes on between the poles of a magnet.[3] But it's of such a nature, and the intensity is so low, that it almost doesn't exist at all. In fact, it might only exist in theory. Or it goes in and out of existence. It's so weak, you know, it's like taking a magnet and pulling the poles very far apart, very distantly apart. Well, how much of that field still exists? I think it does exist. But there are

all kinds of pressures on it pulling it out of existence, so that it's constantly in and out of existence. And if it exists, it exists right at the very edge of nonexistence, which is sort of the nature of the piece. That's what it's supposed to be.

PN: What do you see is the function of your work? I mean, art in the past was either decorative or transcending an immediate object or moving people. How do you see your work functioning in this world?

RB: All of those things, I guess. It's really a sort of questioning of the nature of art and the nature of reality, for me anyway. I suppose my way of doing it is ... art that is ... I think [Martin] Heidegger says, "Poetry is revelation," and I think you could say art and poetry. Art is revelation also. And he says poetry because he was interested in language, and I don't think he knew much about art or visual art, so he *would* say poetry. But I think art also allows us into certain realms which the sciences and philosophy don't enter.

PN: This may be a difficult question, but what kind of choices are you making in your work, I mean other than, say, presentation? In the past, people would be presenting objects—some people still are—and they would have placement choices, color choices, formal choices. Do you think you have a whole new set of choices you're working from or working within? Or do you think that your aims are dictating things and that you don't have as much choice?

RB: Yes, certainly your aims do confine you to what you're going to deal with. But then, I guess ... You know, so do our bodies and the limitations of our minds and so forth. We're all three-dimensional creatures. I try to, as much as possible, to present things or deal with things as they are, without changing them too much. Without imposing my will or, as much as possible, imposing some preconceived system on them. I guess I'm sort of like a phenomenologist in the sense that "being" sort of reveals itself, hopefully, and that I cannot reconstruct it in any way. By that I mean there's no system or theory that I can construct that will reveal things as they are ... reveal the real.

PN: But you're not just claiming things; you are affecting them. You are releasing the inert gases, you're not just saying that they're there. So you are ...

RB: Uh-huh. Yes. But I'm doing what comes naturally to them, you see. In other words, I don't try to force electricity through it or make it glow or put it into some other context. I do what it was meant to do.

PN: Right, but you're still not just like a scientist identifying something in its natural state, just lying around.

RB: But you see, a scientist ... It's already been identified, you see. I mean, it's not ... but in a sense that's what I am doing. Yes, I guess you could say that it is a kind of "found object" idea ... Or at least it's an outgrowth of that basic conception, which I think was one of the great discoveries of the twentieth century as far as art was concerned.

PN: But, well, I suppose you're doing the same things … transferring it to a situation like a gallery or, I mean, where it's called attention to through a structure …

RB: Yes, well, that's the whole idea, I guess, of a gallery, is to separate what is art from what supposedly isn't art—to make some kind of distinction. In other words, to get someone to focus on it in a certain way, to zero in on it or however you want to say it, to call our attention to it [inaudible]. Someone puts it in a gallery or puts a sticker on the wall or does something to it.

PN: But do you feel that the gallery as it exists now is going to be a necessary structure? I mean, Seth isn't working within that structure.

RB: The gallery?

PN: Yeah.

RB: Oh, I think that the gallery, certainly as it's constituted now, has nothing to do with the kind of art that I do anyway. I think that the methods that some galleries have used in trying to present art of this nature—say, as an example, Steve Kaltenbach's show—are very inadequate. In other words, putting up photographs and things like that can be very, very misleading. [Pause] Certainly the galleries have had their influence on the way art looks, no doubt about it. I think it's becoming very evident now. The kind of art which is still being produced by galleries is sort of a second or third or sixth generation of artists who were painting for galleries. So many of the shows, I just feel, are really decadent in the way they look. I don't want to mention any names or anything like that. But they're just not really serving the function anymore in the way they did in the past.

PN: How do you see their function changing?

RB: Oh, I don't know. That's very hard to say … I don't even know what galleries are going to do. I've never really [sigh] dealt with galleries too much. I don't really know how they're going to change. That's not really something I can … really think about …

PN: I see, in specific instances, the people who are the dealers or representatives are making choices, that artists—presentation choices, format choices—that artists would have made in the past. But I don't think that it's recognized that they're filling that function. I mean, perhaps in the same way the major galleries as they exist now are doing the same thing. They're making the choices that you're presenting, in general, objects or paintings, so that they are …

RB: Well, you see, it's just become so established that it's not … That's why I said there are so many new problems involved in presenting this art which haven't really been solved yet. I mean we unfortunately have to work with not only the gallery format but the magazine format. We're talking about photographs and so forth. How do you present an art that can't be photographed in magazines devoted to color reproductions and things like that? It's possible that the gallery can adjust to it, the idea of focusing, using the gallery as a place to focus ideas. It's

not inconceivable. I think that that's probably what it will be and that they'll just stop having great big larger-than-life-size reproductions and photographs of things, and maybe even cut out tables with all kinds of documentation on them. I really don't like that too much. I think that the documentation sort of gets in the way of the art.

PN: So then what about the whole economy of art which is based on commodities? Objects that increase in value. Now there won't be any?

RB: Yeah. Now they just don't exist. That will really be a test of the collector, I think. Collectors, if they really like art, just won't be ... [won't] have their little objects to prove that they're art lovers. But I guess that if they're really willing to spend money on art, they should just spend it on the artists themselves and help them continue to live.

But then I'm speaking as though ... all the art from now on isn't going to have any object attached to it. I don't know that that's the case [chuckles]. So I don't ... I mean, I can conceive of myself having a show in a gallery without having anything in the gallery. And you know, so long as that's the way it is, that's okay. You know, I think that's the way it would be. I really can't speak for anybody else. I don't know how they would do it. I just don't think that it's really been handled very well in the past.

PN: What hasn't?

RB: Shows which deal with things which have to be documented. And also I really don't like most of the documentation that is done, anyway. Some of the documentation has to be so involved that it just becomes like a little art object itself. With some notable exceptions, of course.

PN: What about the question of judgment, whether a piece is good or bad?

RB: It becomes very difficult. I don't even think that there'll be that judgment. I think that the whole definition of art will be changing. The thing just *is*. I mean, how can you criticize a carrier wave? How do you criticize inert gas?

PN: In cases like that I would think you would have to focus on the idea of what was being done.

RB: Right. Either you accept it as a worthwhile idea or not. But you can't say that this line is too long, or this line is not long enough, or these colors don't work together, or they're very harsh, you know. I mean, there'll just have to be some other way of dealing with it, which I think is good.

PN: What about museums? Are you at all involved with them?

RB: Yes, I've done work for museum shows.

PN: Their function in the art system?

RB: What usually happens is that the work is generally mentioned in the catalogue or something like that. There is no object in the museum. Although I must ... Actually, what I did in ... The only works that I've really shown in museums are older

works. That is, like three months old or something like that. [Laughs] There's one piece, I think it was in Bern, where I had a radioactive source on the roof which emitted particles out into the outer space, creating a great ever-expanding form, which, of course, was totally invisible. That's how I handled that situation.

PN: Is that a traveling show? With the big catalogue? The Bern show?[4]

RB: I think it does travel, yeah, sure.

PN: Will your piece travel as radiating currents from each place?

RB: Well, the Earth travels in space anyway.

PN: I know, but will it be picked up and placed on top of the next gallery?

RB: That's the idea, yes. Or it doesn't even have to be that, because I did a piece for a show in Los Angeles or San Francisco, I don't remember, which was a carrier-wave piece, which—there was a little device which produced it and then it was turned off ... and then that piece exists somewhere in outer space, ever expanding. And it obviously can't be brought back to the gallery. The show travels around and the piece exists somewhere as a great big sphere of energy expanding. But the only way it's known is in the catalogue of the show or something like that, you see.

PN: The work that you're doing in telepathy seems to me the most difficult. Your other ones have a comprehensive quality to them.

RB: Well, I don't really do that anymore. I mean, I haven't done one of those for ... There are a couple of pieces which are ... I mean, I'm not going to do it anymore.

PN: Which?

RB: Well, say, the energy pieces or inert gas, or something like that. I haven't done any of those in a couple of months.

PN: And the telepathy ones ... Some of those are conscious and some are unconscious?

RB: Well, yeah. You see, sometimes there's a conscious effort to transmit telepathically.

PN: To specific people?

RB: Well, you see, that's part of the problem with telepathy. I believe that the mind is built in such a way that it has evolved to a point where it fights against telepathic communication. I believe that it was probably a very natural occurrence many thousands of years ago. But through evolution, we've been able to build up these defenses against it. And sometimes when you try to concentrate very hard—in other words, doing a function of the mind which it's meant to do or which we're used to doing, that is concentrating very intensely on something—that can probably be the worst possible way of transmitting telepathically. Whereas the best telepathic transmission sort of takes place unconsciously, where you don't even know you're doing it. So that the latest of the telepathic pieces, we just assume that the ideas will be transmitted telepathically, instead of consciously trying to do it.

PN: Well, then, are you taking no credit for it?

RB: Of course I take credit for it. [Laughs]

PN: Well, how do you convince one or prove to one that it had anything to do with you? Say someone gets an idea. You have no …

RB: Hmm. Oh, I don't do telepathic experiments. I mean, I just …

PN: Not experiments, but if you're …

RB: I don't ask people to tell me if they had an idea and then tell them, "That's right; that's what I was thinking." It doesn't work that way.

PN: But what are you doing? I mean documenting that or even communicating that seems almost an impossibility.

RB: Well, you see, if you deal with ideas which cannot be put into words or images … the unspeakable … then the only way that it can be communicated, if you want to communicate something, is through telepathy. And the problem … We just simply don't deal with that problem of what it is that's being communicated. We just say that something is communicated and that's all there is to it. Now, I'm communicating it. Whether anybody picks it up or not is something else. In other words, I wouldn't say I'm communicating it; I'd say I'm transmitting it. If someone picks it up, then that's communication. Someone might pick it up a thousand years from now. Someone might pick it up five minutes before I've thought about it. You see, because that sort of transcends time and space, and these things sort of exist for all time, so to speak. It's very difficult to … [pause]

PN: Yeah, I … It's taking it very far, that kind of invisibility of a work.

RB: [Sigh] Right. [Pause]

PN: Are you presenting them? I mean, are you documenting them in any way? I mean, putting a sign up saying you're doing it? Or are you not even [inaudible]. Is this something that you're just verbally telling people?

RB: No, it's … it's a … I don't understand your question. How is it? … How do people know about it?

PN: Yeah. How are people? …

RB: Well, as I said before, if a piece is put into a show, if somebody wants to put a piece in a show, it's put in a catalogue. It's announced that …

PN: You deal with it the same way then?

RB: Right. That there is a certain kind of mental state—a certain type of volitional state—which … I will have during the run of a certain show. Say that's a piece. Now there's a situation which everybody experiences at one time or another but which is really sort of impossible to describe in words and certainly impossible to *adequately* describe. So we simply don't bother to. You know, I suppose, [we] bypass that problem, it's not really necessary to … And how anyone deals with that situation that I've presented is just … You know, it's just up to them. And that's about all there is to it.

PN: I was just curious about the presentation of it. On how you ... you're dealing with it in a similar way as you did your other pieces—a description of it. And I thought perhaps you were eliminating that too, in this case.

RB: Well, let's put it this way: with as little description as possible, with as little interpretation as possible. That's the way it's now. What I generally do is set up a series of works, for instance, a psychic series, a telepathic series, an electromagnetic energy series, an inert gas series, which I deal with.

PN: Would you like to say anything more ... about your work we haven't covered?

RB: Well, let's put it this way: I could probably say a lot more. I don't know whether I want to. You know, I don't know; it's up to you. I really don't know ... if there are any questions that you might have.

PN: Well, we've covered most of the questions I specifically wanted to. The other questions are more general.

RB: Like what?

PN: Just feelings about the structure of art. Like Jack Burnham feels there's a systems aesthetic functioning now. And whether you have any feelings about the structure of the movement in art? Would you put any descriptions on it? He says we are going from an object-oriented world to a systems-oriented world. And that art is ...

RB: I think the art is ... The *word* "art" is becoming less of a noun and more of a verb. I think it's sort of an in-between place now—a kind of a noun-verb. And ... I think we're beginning to realize that ... I don't think that we can really look at objects anymore without thinking of them as existing in time, and as ever-changing things. Thinking not so much about the objects themselves as what possibilities are inherent in them and what the ideas are in them. [Silence]

PN: Are you concerned at all with the purity of medium? I mean, do you feel that you're involved with an activity that is confined as an art activity?

RB: Yes, there's just no other word for it. Art is so ... It just sort of means everything and it doesn't mean anything. It certainly isn't philosophy and it certainly isn't science. [Pause] I guess artists just define art by what they do. And I don't hesitate to call what I do art. I'm not sure what you mean by purity.

PN: Well, remaining within a specified structure, a pure structure, which isn't concerned, say, with humanity, dealing with science, affecting other areas of activity.

RB: Do I use other areas?

PN: No, not that you use them, but do you ... So you're not concerned with educating the masses or affecting social reform with your work?

RB: Oh [sigh], certainly not as a primary consideration.

PN: Yeah. I mean, one can ... For instance with mathematics—one can be interested purely in mathematics, or one can be interested in it as a tool of physics ...

RB: Yes, I understand.

PN: I mean, some people use art as a tool, and other people are using it just as art and have strong feelings about it. [Pause]

RB: Well, I guess the ultimate question is, why am I an artist? [Pause] I can't answer that really in any really specific way. I guess it's a sort of an ontological question. [Pause]

PN: Yes, but why aren't … the one question I … that I'd like to go back to is choices. What—in your selection of subject matter, for instance the inert gases or telepathy—from what reservoir are you making these choices? What are the defining limits of what you would choose from? [Pause]

RB: I guess I sort of committed myself to a point of view a few years ago, and ever since then I've been searching for the limitations of what I can choose from. If you're going to make art which exists outside of the very arbitrary limitations of art perception, and you're going to try and deal with questions of the nature of its existence and how it constitutes its reality, and so forth, and all the other problems, part of the search, really, is trying to define your limits. I guess that's part of why you're an artist: to see what you're capable of. That's about it. And to define your limitations. And, as I said, it's an ontological question. It's a question of establishing your … your existence, establishing your being and seeing exactly what it is. And [sigh], I think one reason why an artist presents his work is to establish or define the being of the work that he has done, aside from psychological or personal reasons. And that's exactly what happens when he does present work: he defines what that work is, really. I guess that's why a person is an artist, ultimately.

PN: Do you think that it's only looking back that one can see the limits and define them or clarify the choices?

RB: Looking back and looking forward. I think we always look into the past and into the future. There is no now. We're either in the immediate past or the immediate future. The whole spirit of art is to look ahead to see what's given and to see beyond it. And always question. Never settle for anything. Always question. Always be a threat to the established values—including what you yourself have set up.

PN: But are you aware of the choices, the direction that you're going in?

RB: Yes, I think so.

PN: What type of choices do you think you're making? I guess it's not … People have dealt …

RB: I think you're trying to fit me into some sort of historical situation.

PN: Well, perhaps. But then if it isn't, then I'd like to establish how it isn't or how one doesn't …

RB: Everybody exists in some historical situation. You can't get away from it. [Laughs]

PN: I mean, if this isn't the right pattern for you, then what would be? People have been dealing with manipulating physical objects or, you know, givens—you had

space, you had volume, you had canvas, you had paint—and they made choices within that structure. Now the choices that you're making, how are they different from choices—given choices that people have been dealing with?

RB: Not particularly, not very different really. It's just that I've chosen different things to work with, that's all.

PN: Just a different limit, you mean?

RB: Well, instead of choosing oil paint, I chose something else. It's also a question of what *not* to deal with also. I deal with space and time, but I deal with space and time in a different way than Alexander Calder deals with space and time … [Pause] I guess the basic idea that maybe you're trying to get at is that … [Sigh] It all sort of centers around what an artist does choose to work with. Maybe even more than what he does with it once he's made that choice. I myself try to do as little with it after I've made the choice as possible. In that sense, I suppose I could be called a materialist, in that I don't impose some process, some alien process, onto the material I've chosen. I just simply use it the way it is or think it's meant to be used. There are some artists who call themselves materialists who really are as much materialist as any artist of the past has been, but … what they're doing, really, is sort of imposing a system or a method or whatever—a certain set of ideas that they have, their own personal theories—onto this material which they find … [Pause] I don't know if I answered your question.

PN: No. Yeah. I'd still … I don't know if you can answer the question of how you made the choice of what area you were going to be dealing with … which is, I guess, what I'm asking.

RB: One looks around and sees what the possibilities are, then chooses one. [Laughter]

PN: Yeah. I feel … Do you want to go on more, or do you feel okay about it?

RB: It's your …

PN: I feel fine. I think this is good … for now.

NOTES

1. The exhibition Barry refers to here is *Robert Barry / Inert Gas Series / Helium, Neon, Argon, Krypton, Xenon / From a Measured Volume to Indefinite Expansion / April 1969 / Seth Siegelaub, 6000 Sunset Boulevard, Hollywood, California, 90028 / 213 HO 4–8383*. It was organized by Seth Siegelaub and took place April 1–30, 1969.

2. Barry here refers to the exhibition *557,087*, organized by Lucy Lippard, which took place between September 5 and October 5, 1969. Barry's untitled work consisted of the following information: "All the things I know but I am not at the moment thinking—1:36 PM, 15 June 1969, New York."

3. The exhibition referred to here is *Art for Peace,* curated by Lucy Lippard, and open throughout the month of October 1968 at the Paula Cooper Gallery in New York City.
4. *Live in Your Head: When Attitudes Become Form,* Kunsthalle, Bern, Switzerland, 1969, exh. cat. by Harald Szeeman.

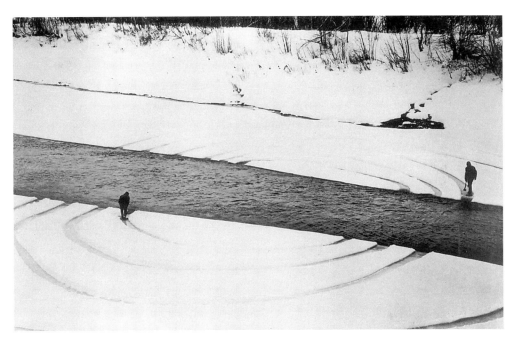

1. Dennis Oppenheim, *Annual Rings,* 1968. United States/Canada boundary at Fort Kent, Maine, and Clair, New Brunswick, 150 × 200 feet. Schemata of annual rings severed by political boundary. Time: U.S.A. 1:30 p.m., Canada 2:30 p.m. Ax, shovel, ice, snow.

Four tons of paper data from the floor of the New York Stock Exchange is removed and this residue is transplanted to Park Avenue South, where it will be housed in an area defined by the specifications of a roof perimeter.

The spatial limits of the clearinghouse floor dictate the manner in which the paper residue organized itself. In the same way, a Cyclone fence directs the accumulation of wind-blown matter, thus functioning as aesthetic block.

This paper becomes free-moving architectural fuel, undirected yet responding to the imposition of preexisting bonds. The exchange floor is an architectural mold for symbols representing distant locations.

Transactions involving a span of three thousand miles take place on the stock exchange floor. The residue at the end of the day carries vestiges of the distance between two points: the point at which a buy order and the point at which a sell order has been issued. Though it lies dormant on the floor, it is conceptually still active. A spatial transaction is implicitly contained in the material: a web of components interacting within a continental grid.

At 2 p.m. the clearinghouse floor is filled with the highs and lows of stock transactions, the permutations a stock has undergone during a four-hour period. By removing this data from a ground level and carrying it up sixteen stories, I am raising the level of residue that was actively housed on a lower plane. The material will be held at the top of a building; the building forms a base for the piece. The roof is viewed as a terminal strata for passive information. The Manhattan skyline becomes a tight complex of core samplings of varying depths.

2. Dennis Oppenheim, *Removal Transplant—New York Stock Exchange*, 1968. Stage #1, trading floor. Stage #2, 50-x-100-foot roof area. Four tons of paper data.

The route from Finisterwolde (location of wheat field) to Nieuwe Schans (location of storage silo) was reduced by a factor of six times and plotted on a 154-by-267-meter field. The field was then seeded following this line.

In September the field was harvested in the form of an X. The grain was isolated in its raw state; further processing was withheld. This project poses an interaction upon media during the early states of processing. Planting and cultivating my own material is like mining one's own pigment (for paint)—I can direct the later stages of development at will. In this case, the material is planted and cultivated for the sole purpose of withholding it from a product-oriented system. Isolating this grain from further processing (production of foodstuffs) becomes like stopping raw pigment from becoming an illusionistic force on canvas. The esthetic is in the raw material prior to refinement, and since no organization is imposed through refinement, the material's destiny is bred with its origin.

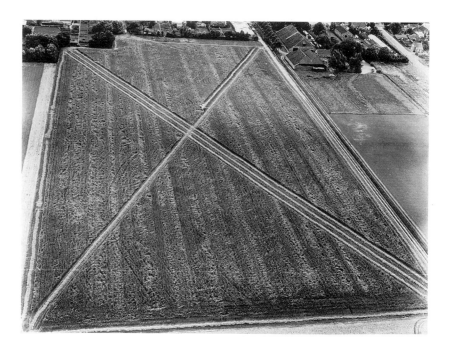

3. Dennis Oppenheim, *Cancelled Crop*, 1969. Finisterwolde, Holland. Wheat field, harvester. 505 × 876 feet.

4. Duane Michals, *Seth Siegelaub*, 1969.

5. Seth Siegelaub, cover of
March 1–31, 1969 (New York:
Seth Siegelaub, 1969).

6. Seth Siegelaub, second page
of *March 1–31, 1969* (New York:
Seth Siegelaub, 1969).

CARL ANDRE
ROBERT BARRY
DOUGLAS HUEBLER
JOSEPH KOSUTH
SOL LEWITT
ROBERT MORRIS
LAWRENCE WEINER

First Edition
1000
December 1968

Siegelaub/Wendler. New York, N. Y.

7. Seth Siegelaub, title page from *Andre Barry Huebler Kosuth LeWitt Morris Weiner,* "Xerox Book" (New York: Seth Siegelaub and Jack Wendler, 1968).

8. Robert Morris, *Continuous Project Altered Daily*, 1969, as installed at Leo Castelli Warehouse, 1969. Earth, water, paper, grease, plastic, wood, felt, electric lights, photographs, tape, tape recorder. © 1999 Robert Morris / Artists Rights Society (ARS), New York.

9. Robert Morris, *Card File*, 1962. © 1999 Robert Morris / Artists Rights Society (ARS), New York.

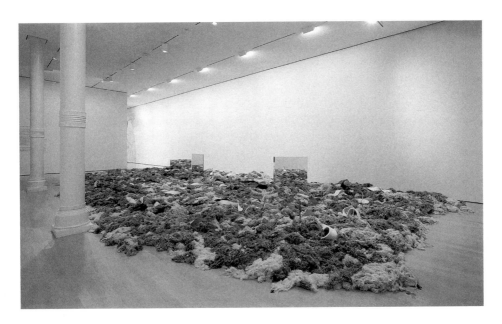

10. Robert Morris, *Untitled (Threadwaste)*, 1994 refabrication of 1968 original. Asphalt, mirror, threads, copper tubing, steel cable, wood, felt, and lead. Variable dimensions. © 1999 Robert Morris/Artists Rights Society (ARS), New York.

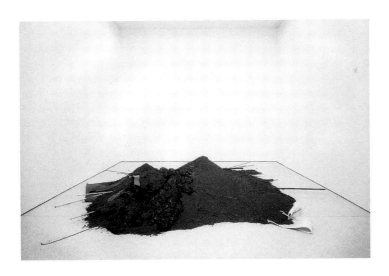

11. Robert Morris, *Untitled (Dirt)*, 1994 refabrication of 1968 original. Earth, grease, peat, steel, copper, aluminum, brass, zinc, and felt. Variable dimensions. © 1999 Robert Morris/Artists Rights Society (ARS), New York.

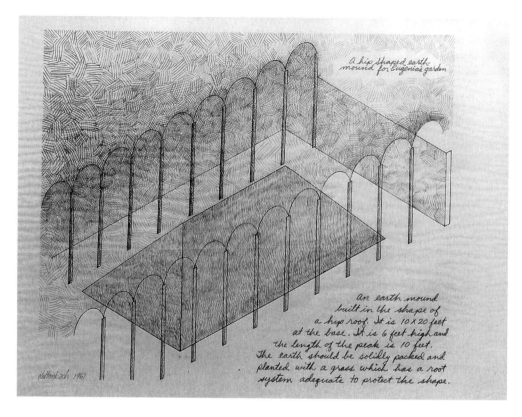

Within the drawing:

a hip shaped earth
mound for Eugenia's garden

Kaltenbach 1967

An earth mound
built in the shape of
a hip roof. It is 10 x 20 feet
at the base. It is 6 feet high and
the length of the peak is 10 feet.
The earth should be solidly packed and
planted with a grass which has a root
system adequate to protect the shape.

12. Stephen Kaltenbach, *Earthworks*, 1967.
Pencil on paper.

13. Stephen Kaltenbach,
Canvas Piece, ca. 1967–68.
3-x-9-foot canvas. Piece
was provided with nine
suggested variations for
its arrangement.

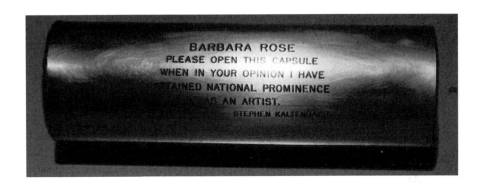

14. Stephen Kaltenbach, *Time Capsule*, ca. 1968. Stainless steel cylinder, approx. 3 × 10 inches.

15. Stephen Kaltenbach, *Art Works*, 1968. Offset on paper. Page size, 10 ½ × 10 ½ inches, image size, 2 ¼ × 4 ⅜ inches. Published in *Artforum* 7:3 (November 1968), p. 72.

I. Catalogue

1. TERRY ATKINSON and
 MICHAEL BALDWIN

 Hot Warm Cool Cold
 1967

 22 Sentences:
 The French Army
 1968

2. ROBERT BARRY

 Telepathic Piece, 1969

 [During the Exhibition I will
 try to communicate telepath-
 ically a work of art, the na-
 ture of which is a series of
 thoughts that are not applica-
 ble to language or image.]

3. JAN DIBBETS

 Perspective Correction
 1969

 3½″ x 5½″
 Printed postcard
 Simon Fraser University,
 Canada

4. DOUGLAS HUEBLER

 Duration Piece #8
 1969

 Material: rubbed surfaces
 Time: 32 days
 Burnaby, British Columbia,
 Canada

5. STEPHEN KALTENBACH

 Life Drama
 1969

6. JOSEPH KOSUTH

 VIII. Eventuality
 (Art as Idea as Idea)
 1968

7. SOL LEWITT

 Simon Fraser University
 Wall Drawing
 19 May - 19 June, 1969

 Eagle Mardo 174B
 and Eagle Mardo 174
 HARD 2 H
 Rendered by Rosemarie
 Gagné and Malcolm
 Ramsay

8. N. E. THING CO. LTD.

 V.S.I. Formula 3
 1968/1969
 35 mm, Anti-halation
 Microfilm
 12′ long x 1 1/16″ wide

 [180 photographs taken
 every 2° (0° - 360°) with a
 1000 mm lens and 180 photo-
 graphs taken every 2° (1° -
 359°) with a fish eye lens
 (Alternately edited)].

9. LAWRENCE WEINER

 A rubber ball thrown
 at the sea
 1969

16. Robert Barry, *Telepathic Piece,* 1969. Page from
the catalogue for the exhibition *May 19–June 19, 1969*
(Vancouver: Simon Fraser University, 1969).

17. Robert Barry, gallery space being occupied simultaneously by *88mc Carrier Wave, FM,* 1968; *1600kc Carrier Wave, AM,* 1968; *40khz Ultrasonic Soundwave Installation,* 1969, as installed in the exhibition *January 5–31, 1969,* organized by Seth Siegelaub, New York City.

18. Robert Barry, *Inert Gas Series: Helium,* 1969. On the morning of March 6, 1969, somewhere in the Mojave Desert in California, 2 cubic feet of Helium were returned to the atmosphere.

19. Robert Barry, *4 to 1*, 1968, as installed at Paula
Cooper Gallery, New York City, October 22–31, 1968.
Nylon monofilament, screw eyes, 7 × 28 feet.

ONE MILLION DOTS

20. Robert Barry, page from *Andre Barry Huebler Kosuth LeWitt Morris Weiner*, "Xerox Book" (New York: Seth Siegelaub and Jack Wendler, 1968).

SIMON FRASER UNIVERSITY
MEMORANDUM

To ALL STUDENTS, FACULTY, STAFF AND
INTERESTED PARTIES

From JAMES WARREN FELTER
EXHIBITIONS - COMMUNICATIONS CENTRE

Subject WEINER PROJECT

Date MAY 21, 1969

A RUBBER BALL THROWN AT THE SEA

LAWRENCE WEINER

21. Lawrence Weiner, *A Rubber Ball Thrown at the Sea,* 1969, as exhibited in the catalogue *May 19–June 19, 1969* (Vancouver: Simon Fraser University, 1969).

22. Lawrence Weiner, page from *Andre Barry Huebler Kosuth LeWitt Morris Weiner,* "Xerox Book" (New York: Seth Siegelaub and Jack Wendler, 1968).

LAWRENCE WEINER, New York

30

An object tossed from one country to another.

23. Lawrence Weiner, *An Object Tossed from One Country to Another,* 1969, as exhibited in the catalogue *March 1–31, 1969* (New York: Seth Siegelaub, 1969).

2.

24. Sol LeWitt, page from *Andre Barry Huebler Kosuth LeWitt Morris Weiner*, "Xerox Book" (New York: Seth Siegelaub and Jack Wendler, 1968).

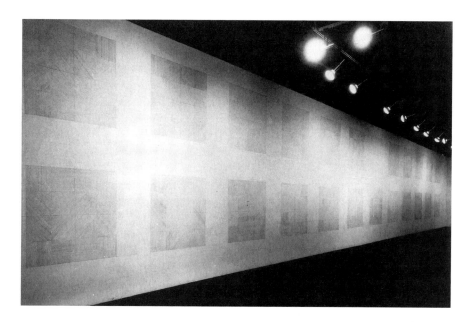

25. Sol LeWitt, *Wall Drawing #2, Drawing Series II (A)*, 1968, as installed at Ace Gallery, Los Angeles, November 1968. Twenty-four drawings in black pencil. Drawn by Mike Maglich, Tony Day, Sol LeWitt, Guy Dill, Jim Ganzer, and Jerry Kamitaki.

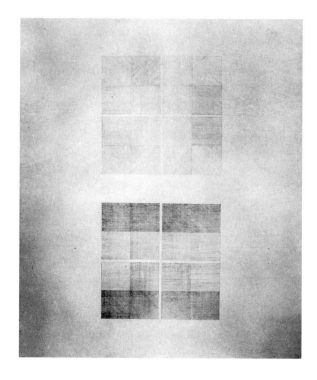

26. Sol LeWitt, *Wall Drawing #1, Drawing Series II 18 (A&B)*, 1968, as installed at Paula Cooper Gallery, New York, October 1968. Black pencil. Drawn by Sol LeWitt.

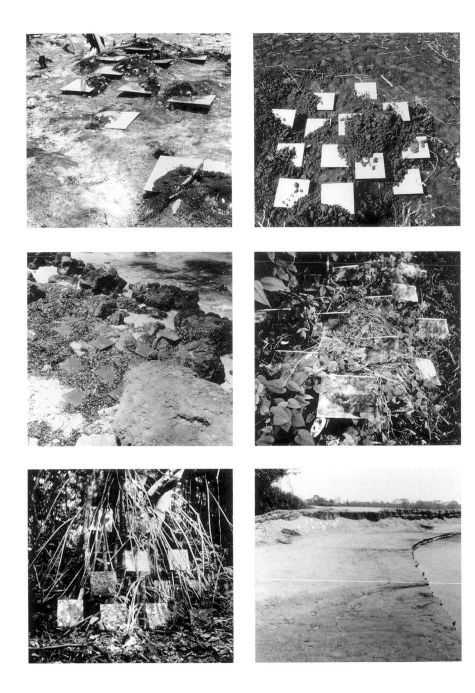

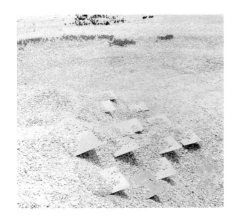

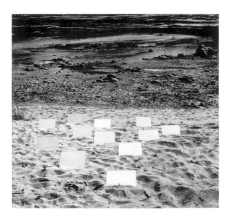

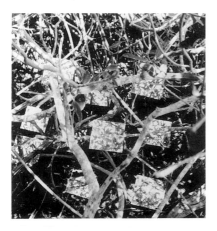

27–35. Robert Smithson, *Yucatán Mirror Displacement,* nine displacements, each with nine to thirteen 24-×-24-inch mirrors, 1969. (Read series across, beginning at top left.)

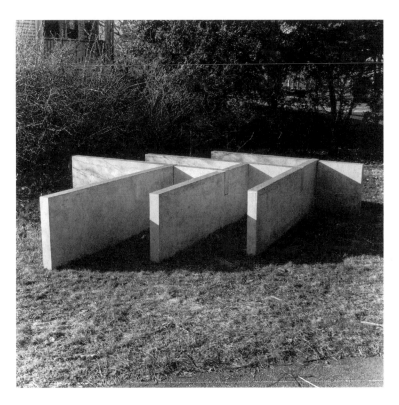

36. Douglas Huebler, *Bradford Series #14,* 1967. Cement.

On February 7, ten photographs were made of snow lying 12 feet from the edge of Interstate Highway 495 in both Massachusetts and New Hampshire.

Each photograph was made at an interval of every 5 miles; of every 5 yards; or of every 5 feet; or of a variable combination of all of those intervals.

The photographs and this statement constitute the form of this piece.

37. Douglas Huebler, *Location Piece #5, Massachusetts-New Hampshire,* 1969, four of ten photographs.

During a ten-minute period of time on March 17, 1969, ten photographs were made, each documenting the location in Central Park where an individually distinguishable bird call was heard. Each photograph was made with the camera pointed in the direction of the sound. That direction was then walked toward by the auditor until the instant that the next call was heard, at which time the next photograph was made and the next direction taken.

The ten photographs join with this statement to constitute the form of this piece.

a

b

c

d

h

e

i

f

j

g

38. Douglas Huebler, *Duration Piece #5*, New York, April 1969.

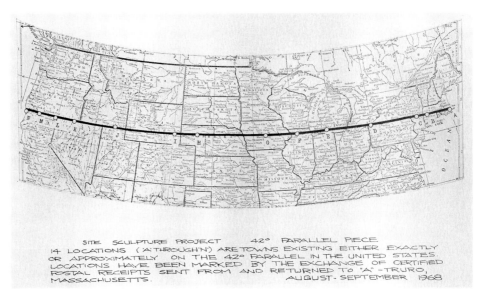

SITE SCULPTURE PROJECT 42° PARALLEL PIECE
14 LOCATIONS ('A'THROUGH'N') ARE TOWNS EXISTING EITHER EXACTLY
OR APPROXIMATELY ON THE 42° PARALLEL IN THE UNITED STATES.
LOCATIONS HAVE BEEN MARKED BY THE EXCHANGE OF CERTIFIED
POSTAL RECEIPTS SENT FROM AND RETURNED TO "A" - TRURO,
MASSACHUSETTS. AUGUST- SEPTEMBER 1968

Fourteen locations from Truro, Massachusetts (A), to Smith River (N), existing either exactly or approximately on the 42nd parallel in the United States have been marked by the exchange of certified postal receipts connected with letters to the Chambers of Commerce of each selected town. (The letters were requests for maps of the immediate area.)

The piece was brought into existence when all the documents were returned and rejoined with the sender's receipts. (The fact that a degree of variety obtains in the returned documents does not alter the intention of the work.)

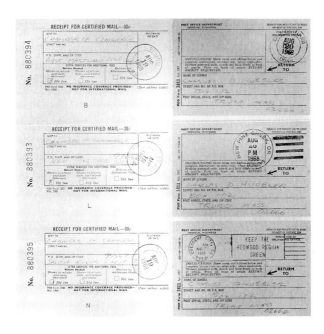

39. Douglas Huebler,
*Site Sculpture Project:
42nd Parallel Piece*, 1968.

LAWRENCE WEINER

JUNE 3, 1969

LAWRENCE WEINER: I started working more or less in what you could call this vein around 1960 in California. I did a piece, the full implications of which weren't quite realized even by myself, which was a field cratered by simultaneously exploded TNT. And from there I was building structures that were placed in the landscape. And continued to do this. And then I attempted to bring this art back into the studio. And in doing this, what I tried to do was to make paintings that I would avow were not unique objects, and it was only the idea of painting that counted. [Pause] And it was a rectangular canvas with a rectangular removal. The person who was receiving the painting would say what size they wanted, what color they wanted, how big a removal they wanted. The *only* reason I ceased making them was that there was really no way ... One thing an artist can't do: an artist can say that a shop-bought cream soda can is art, but he can't say it's not a shop-bought cream soda can. And I began to realize that I could no longer just say, "This painting is not a unique object," because it was accepted as a unique object. And that eventually just kept building up, and now it's gotten to the point where I'm not terribly interested in the object itself. It becomes an object the minute it's shown. And showing for me could be publishing, could be the physi-

cal piece shown, or it could be hung up, you know, somebody could tack up a notice in a gallery or someplace else. That's all … It's really very simple. [Laughs]

PATRICIA NORVELL: So then you have no specific thing that is the art. The presentation can be the art, or the event can be the art, or? …

LW: No, the event can never be the art. There is no thing about an event that's art. [Pause] The action per se is just something that goes between intents. You could have a double intent, but you can't use the event. I cannot ever see the event or the action becoming art.

PN: So then it's what, the idea or the presentation?

LW: It's the art itself. I don't really like the word "idea." You know I use it because in English there's not really a much better word. But the art is the art itself. There is no difference to me. Same thing as when someone receives a piece of mine, assumes responsibility for the piece, which is either purchased or whatever it is. They assume the responsibility that this is art as well as I assume the responsibility. And I will either transfer the piece to them by, if they choose, building it, which is fine with me. They can have it built. Or we can just discuss it orally, verbally, or they can read it in a book and we shake hands on it. There is never a document that passes that's signed. Quite often, I'll give a piece of paper with the piece written on it, but that's just, you know, my own little quirk in case they forget the exact wording. But it's never signed. It's only got my name in block letters, which is the assumption of responsibility, or it's on a typed piece of paper. No signatures. The only record that someone owns the piece is filed with a lawyer on a typewritten sheet. And filed in one set of books that I have and in another set of books that's in a safe-deposit box. That's the record and complete proof of receivership. The title. [Pause] But, you know, somebody really can't ever own a nonunique piece. What they've really done is they've assumed the responsibility for that particular piece. I can't show it without asking their permission. But basic to my aesthetic is that the reproduction of a piece of mine is as equally valid as art, as the "original." Whereas the wall removal I did in Bern, the *36″ × 36″ Removal of Plaster Lathing from a Wall* …[1] That piece, if somebody walked in and saw it, and got excited by it and went home and did it on their wall, in the physical sense, that piece is just as much art. And it is my art. But it is a reproduction of my art. And it's just as valid aesthetically as the one that was in the museum or the one that was in the gallery or somewhere else. So you run into a very tacky problem with the acceptance of receivership.

PN: Well, you also run into the problem of authenticity, though, because other people might be doing the same thing, artists saying it's their art.

LW: Oh, well, then you run in … That's the standard problem of plagiarism, and in 1969 anyone can copy anything that they want, exactly. You can't really concern yourself with that. You know, if somebody wants to build a piece of mine physi-

cally and say that it's theirs, which has been done to me a few times, that's, you know, that's fine. I know it's my art, the few people who know about the art know it's my art, and that's the end of it. I have nothing but … I can't get upset about plagiarism or people who steal. [Pause] Only because my art is going this way and most of the people who do steal generally, you know, really fuck it up. They don't understand the full intent.

PN: I didn't mean stealing it, necessarily, just that ideas are around and people are doing them, and that's not really plagiarism.

LW: Oh, yeah. That's fine with me. But the pieces that I deal with generally are pretty concrete. You know exactly what I'm talking about. You know *ambiguously* exactly what I'm talking about—which is why I love translations. Because the general piece comes by, and there really is no way it should look. Like *A Shallow Trench from High Water Mark to Low Tide Mark on a North Atlantic Beach:*[2] if we went down twenty yards from where I did build the piece, it would have been all sand. Where I built, it was all rocks. The same beach, same piece … But the beach down there was only, like, two yards wide, and where I built it, the beach was about twelve yards wide.

PN: If it doesn't matter, then, why do you document it with photographs?

LW: Oh, you see, that's an interesting thing. You take photographs sometimes just out of normal—what do you call it?—touristitis: you just take a photo. And the important thing to remember is that this just shows what the piece could look like if it's built. But I don't ever show the photos in a gallery or anything else. They'll be shown occasionally in a catalogue. But generally, when it's shown in a catalogue, that's what the piece could look like. It was built for that show. That's what it did look like for that show. When it's moved from one city to another, of course it looks different. And if there is a confusion about the photographs there, it's not really my fault.

PN: Why?

LW: If there's a confusion that this is the way it should look? Because the work is quite clearly stated. [Pause] It's really quite clearly stated that this is what it could look like when it's built in that city and not what it should look like when it's built in that city. So use the "could and should" thing again. [Pause] You get a misinterpretation of practically anything you put out. And this is the first art, I think, where the information about the art is as important for knowing about the art as the art itself—which may be a lack and may not be because information about anything is necessary. You can't really go in front of a Barnett Newman painting, without knowing a little bit about art, and know what it's all about. So you can't be confronted by a piece of mine without knowing a little bit about the aesthetic. Not that much, really, you don't have to go into it in depth. It's really quite simple. [Silence]

PN: Are you actually making the pieces now that you state in the catalogues?

LW: It depends upon the institution or the individual. I will be doing a series of pieces that I will be building soon. But I am the receiver, the pieces are not for sale; they become part of the estate. And I'm building them for myself. And I may even document them or photograph them, so I'm not quite sure. But it's immaterial. And when an institution invites me to participate in an exhibition, I give them the choice. Would you like the piece built? Would you like me to build it? Or don't you like it built at all? When somebody buys a piece of mine, they get the choice, the same exact choice, the three choices, and the price of the piece is exactly the same no matter what the choices are. And if it costs as much money as they pay for the piece for me to build it, that's the way it is. [Pause] You know, there's no difference in [the] range of prices: a piece that's built for the Antarctic is exactly the same price as a piece that's built for Westchester County.

PN: And you're assuming the cost?

LW: Every piece is the same price. Every piece has the same price.

PN: Not...

LW: Yeah, every single piece I build is exactly...

PN: Every, no matter which one, has a standard price.

LW: It doesn't matter. It has a standard price. Every piece is the same price. Anything I make is the same price. Because I don't believe in drawings and things like that. [Silence]

PN: How did you come to the price?

LW: I just arbitrarily figured out a median price based on what my paintings were selling for. A median price of what anybody could afford but they had to think about before they purchased. [Pause] I want the art to be accessible. So what it is really ... See, the price becomes almost unimportant because all the art's given away when you think about it. I go through a lot of trouble to get things published all the time. So the pieces are published, the information is public, anybody that really is excited can make a reproduction. So in fact, the art is all freehold. But for the people who really like to own something, once a month I build a piece that's freehold. I make proper notification, and for the period that the piece is exhibited, anybody who wants it asks for it and is given a piece of typed paper like anybody else, and their names get listed in the records—if they choose to. [Silence]

PN: You've done work with Seth. How do you feel about showing in given conditions such as the "Xerox Book"?

LW: When the condition was as good as the "Xerox Book" condition, it's perfect for me. That for me was a piece. And the exciting thing about the "Xerox Book" project was that there were twenty-five sheets and it was the same exact piece [see figure 22].[3] And that helped to show that the removal, as long as it was in proportion, could have been twenty-five different removals. There was no seeing

whether the removal was the art or what was left was the art. And yet it was exactly the same piece. So you had twenty-five of exactly the same piece that could look twenty-five different ways. So for me it was a perfect piece. And that to me is a public freehold piece. Anybody who purchased the "Xerox Book" owned the piece. It's called public freehold for me, and then there's private freehold, which is where the only people that can own the piece are the people who ask for it when it's freehold. And then there are other pieces.

PN: In the public freehold, then, it's not documented who owns it?

LW: No. The cratering pieces in California were public freehold, the grid piece at Windham [Vermont] was a public freehold, and then there are about four private freehold pieces where people who wanted them, interested parties, asked for it. But they have to ask; otherwise I feel it's an impositional thing. That's why I like the shop idea, you know, galleries. I don't like the structure. But the idea of nobody being forced into these things, even by the prestige of art institutions, still troubles me. These are things that people hear about, they will go to them, and there's nobody shitting on the street, drawing them in or anything else. I'm very against impositional art. [Pause] I think all directional art, meaning, I'd almost say, choreographic art—art that gives directions to people to do, art that imposes things on people in a nonconventional aspect, like utilizing the newspaper but not putting it in the advertisement section—is an imposition that art never has the right to do. That becomes aesthetic fascism.

PN: How?

LW: Oh, street works are a good example. You build a piece on the street. That's public property. Whatever your piece is, forget about the aesthetic; that has nothing to do with me. You cannot impose your piece on anybody. It has to be done in such a manner that the piece can conveniently be ignored, or else you're making an absolute imposition upon the "public," an imposition that the artist would never stand for if the public made it on him. And making art does not give you the right to make this imposition. The same as I don't approve of art that you cannot supposedly experience unless you do prescribed things, because that's choreography and, to me, really and truly is aesthetic fascism. [Silence]

PN: How do you feel that you're eliminating that? Well, someone can make the choice to own one of your pieces, to read it, but once they've done that, they are still dealing with choices.

LW: Oh, there are choices to make but there are no directions. All of the pieces, if you read carefully, are stated facts. [Pause] It's already a complete work. It's put in a book that's priced low, but it's priced. You have to go to the bookstore and want it enough to read it. Now, whatever is in a book that's for sale is never, never an imposition, because nobody's forcing you to get it. It doesn't come as a flier in the mail; any of the announcements from the galleries only come to people who want

to be on this mailing list. They're interested parties. So that's, you know, stretching it, but there is no impositional quality there either. Yeah, I don't want to make too big a thing out of the impositional thing.

PN: I'm still not clear on the art and the presentation in your situation. I think a lot of people, other artists, are not concerned with the presentation at all. They're leaving those decisions up to someone else, and people like Seth are stepping in and making decisions that used to be artists' decisions.

LW: Not really. He presents a situation, and you're free to either utilize it or not utilize it. No, I'm not at all that interested in the presentation, but I refuse to make any definite … either giving up, relinquishing of, power or assumption of power in the presentation … because then it would become an art decision. But if I accept all of the variables of presentation, then it's not an art decision, because it has nothing to do with the art. The art is as validly communicated orally, verbally, or physically. It's all the same. So I can't make a decision one way or the other without lending weight to it. It also takes the expressionism out of the work for me. The simplest thing is you wake up one morning and it's a beautiful day out and you've been stuck in the studio for three weeks and you're supposed to build a piece today, or somebody's going to have a piece today and you want to go out in the air. So all of a sudden, that day you go out and you build the piece. Another day it's a freezing cold, snowy day, and you really don't want to go out, so you say, oh, the piece doesn't have to be built. That to me would become expressionism, where my emotional state would be interfering with the art. And this takes it out of that, this leaves it in the hands of whoever is receiving it, the interested party. And they can do with it as they choose. And that way, no matter how I feel in the morning, I can't let that have anything to do with the art. It's again quite simple. [Silence]

PN: What kind of choices do you think you're making in your art now? The choices have changed from previous object art, the formal concerns and manipulations. And you're not dealing with those issues.

LW: Well, I'll only deal at this point with things that are naturally used. [Pause] See, I would never, when I was doing the spray pieces, spray paint on a wall, because it's an unnatural act. It's just not naturally done. It becomes a contrivance. It becomes man over material again. But if you've ever watched a car stripper, they spray on the floor constantly. That's how you clean out your nozzle; that's how you check the color and everything else. It's always sprayed down, so that was fine. The paint is legitimately always poured on the floor. [Pause] And any of the trench pieces, and any of the outdoor pieces, are all done as naturally and unobtrusively as possible. Rubber balls have been thrown in Niagara Falls for the last fifty years. Floatable objects are thrown in canals all the time. And the only thing that might lead to confusion is I attempt to use what we could call natural re-

sources, such as Germany itself—the entire entity of Germany—as an art material. So I will use Germany and France as an art material, and I will use a piece of rope also as an art material. It's just the acceptance of more things as valid art materials. The falls and the manufactured object which is the rubber ball are equal to me as art materials. One is not better or worse than the other. They're all just art materials. The only thing I feel that you can't make art out of is people. [Pause] And that's where I will cut the line. People cannot be used to make art out of. [Silence]

PN: Are you limiting your artistic activity or your art by natural materials, only limited then by people?

LW: Yes. In utilization of just "natural materials," standard process materials and standard natural resources, I can help eliminate the unique object. I can even eliminate the unique artist. [Pause] And all they're dealing with is my way of dealing with art, which of course is unique in that sense. But the art itself—the "object"—is never unique. The whole thing has to lay on what my aesthetic is. If my aesthetic is valid for you, the art becomes valid.

PN: Well, how would you define your aesthetic?

LW: The making of art. [Silence]

PN: What is your feeling about language?

LW: I like language very much because it's ambiguous. The ambiguity of language attracts me much more. Say a photograph is static, and any time there is a photo, it's always accompanied with language. When you read the language, or when you translate the language from one language to another language to another language, which is part of the new work I've been doing, you add to the ambiguity of the piece ... And yet the general piece is there. But when you say a rubber ball, in German it's like a *Gummiball,* which looks completely different than our Spalding pink ball. But its function is the same; it's still a rubber ball. When you say a shallow trench, a shallow trench in fifteen different countries means fifteen different things. And yet it's still a shallow trench. And you can go on and on and on. You know, white paint in France looks completely different than white paint in Germany. They use different pigments, different bases, but it's still white paint. So the language, really, in my eyes, helps to get away from this thing of what something should look like and just deals with it as a general thing.

PN: In *Statements,* everything is done as a block typeface. Did you design the format?

LW: Oh, that was ... I was confronted with a problem. They said, "How do you want it put in the thing?" And so what I did was I took a standard typewriter and locked it on both sides and just started typing. And when I couldn't get my finger down anymore, I put it to the next space. So there was no designing. Every line is made of the same amount of integers from a standard typewriter. It was a convenience. And that's all it was, I just didn't want to be confronted with any kind of typo-

graphical, you know, decisions. So I just set up the typewriter, and the typesetter did the best they could to fit it in, and that was how the book was done. I think the next book that's coming out, *Terminal Boundaries*, which will be in French, German, and English, one book, and will probably be typeset and laid out by the typesetters themselves. I'll just let them do it. That's all. You know, when you're dealing with these things, it's the same thing when you want to show a structure poem ... you've got to make the same decision of whether you want to get a fourteen-dollar-ninety-five-cent frame, a twelve-ninety-five frame, or what I prefer is a dollar-and-twenty-nine-cent frame from Woolworth's. But there's not a real importance attached to it. I just prefer dollar-and-twenty-nine-cent frames.

PN: Now, the thing is that a lot of documentation is distracting.

LW: Documentation can be distracting, which is why I prefer for the work originally to be seen just in language. And then, afterwards, what happens if it's reshown or rebuilt or seen again or sent out? Then each one becomes its own decision. I don't take photographs. All the photographs I ever have are taken by somebody else. I don't even know how to take photographs. [Silence]

PN: What do you feel is the aim of your art?

LW: To make more art. I'm not being cryptic. What is the aim of art? It's to make art. [Pause] It has no other aim. It has no social redemption qualities. It has, you know, no saving grace, nothing for society, really, other than maybe the excitement of art. So it has no function. Its only function would be the making of more art.

PN: Well, how are you then deciding what is art?

LW: Oh, that's simple enough. The nice thing about art is ... You know, there's an old story, if you're one-eighty-second Indian, you can claim that you're an Indian. Once you claim it, you're stuck with it; you are an Indian. Now anybody that's fool enough to want to be an Indian or an artist, let them. [Laughter]

PN: Before, though, we had given limits of what was art.

LW: Did we?

PN: Within a specific time I think we do. It's always changing, and that's what art is doing. But people were dealing within a range for quite a while, and it seems that in this past couple of years we've been very actively breaking out of what are so-called formal concerns or objects.

LW: There's nothing more asinine than the old Abstract Expressionist statement "It works": "A painting is good if it works." I've never yet heard anybody explain how it works. Except in the context of "Well, there's a white mass here, and a red mass here, and a black mass here." But that doesn't work if you change it from one country's aesthetics to another. It was just that that's the absolute pretension of the expressionistic artist ... that it works. Art doesn't work. [Pause] Some art is more interesting than other art. Not better or worse, just more interesting. So I don't really see it at all as that much of an enormous problem. Art is not chang-

ing that much. That's some fiction that the critics and the institutions have set up to try to keep people interested in art. It really is a fiction. Art has not changed that much. When you walk in …

PN: It's altered its presentation or its actual form.

LW: It hasn't changed that much even in its actual form. Its intent has changed, but its actual form hasn't changed.

PN: Now, maybe we're meaning different things. What do you mean by form and intent?

LW: The intent of the art, at least for myself, has changed. Previously, a very old piece of mine, the one that Siegelaub owns, *A 1' × 1' Removal with a Gallon of White Paint Poured into It* … Previously, people, when they would build a piece like that, would attach formal considerations and aesthetic considerations to the physical piece itself. For myself, the physical piece is just supplementary information. Again, it shows what it could look like. But the idea of a removal and an intrusion is much more exciting to me than the physical thing itself. The physical thing is still a hole, you know, and a hole by any other name is still a hole. The idea of making art out of a hole is exciting. But the hole is never terribly exciting. The same thing as a canvas. You know, [Ad] Reinhardt spent his life trying to prove that. The idea of a Reinhardt is always more exciting than a Reinhardt. [Silence]

PN: I agree then, it's a shift from intent to emphasis. But often people are eliminating the physical object. In that shift, it's getting eliminated.

LW: You have to change a little bit your idea of what a physical object is. Everything is a physical object. We're living in a time when now they know … if you're thinking of tying your shoelace, that sends off a certain amount of electrical power. It sets up something in space; it occupies space for a given time … Therefore it's an object. [Pause] So everything is an object. It's just the idea of realizing and accepting the fact that one object is not necessarily better than another.

PN: How do you feel your new work has changed the basis of criticism, or has it? People have complained that they can't judge this new art. What are they given to judge with? Barbara Rose talks about an idealist or pragmatic approach to it. How do you feel you've …

LW: I haven't done anything. The art may have presented more difficulties to the critic, so the critic can no longer rely only upon an art-historical precedent. So it takes out the value of those intensive art history courses that they took for years. But I think that a rational and intelligent critic is quite capable of dealing with the art. They can see the difference in art. If they can't, then they don't deserve the term "critic," which is not a terribly, you know, exalted term anyhow. Critics basically are parasites—with a few exceptions. America has one or two people who are involved in criticism, in an attempt to keep criticism vital. Lucy Lippard is one of them. Lucy Lippard seems to be quite capable of dealing with the art.

PN: I think there are going to be more, younger people who will deal with it ...

LW: Oh, hopefully, hopefully there will be more. [Silence]

PN: Are you involved at all with the Museum [of Modern Art] issue?

LW: No. You mean the Art Workers' Coalition? I will give support, but I don't really see a gripe with the Museum of Modern Art—at all. It's none of my business. I very rarely go to the museum myself. When I do go, it's to see old paintings. I don't really want much from the museum at all, so I can't see wasting my energies attacking the museum. But that's a personal thing. Again the impositional thing. If they want to show a certain kind of art, then let them show it. It's their business. It's not their function to show another kind of art. And the majority of people seem to be trying to turn the Art Workers' Coalition into a success-oriented thing. They're just trying to get a piece of the action. And people will have to realize that perhaps art has changed so much that there will be very little action. You know, I'm hoping the age of the superstar is over—absolutely over—that there will be, because of the population expansion, there'll be fifteen or twenty, at any given time, superstars, maybe a hundred or two hundred superstars, all doing their own art. That would be exciting. And all the museum is, is a repository. It lends satisfaction; it gives people from the Midwest a place to tell their mother they're in. I've never shown in an American museum.

PN: Out of choice?

LW: No. It just never happened! I've shown in European museums, but I've never shown in an American museum.

PN: Well, Europe is much more receptive to a lot of what's going on at this point. But, how do you resolve then—I don't think you have to—the idea of a superstar and the idea of someone plagiarizing your idea?

LW: It's not my idea; it's my work.

PN: Your work.

LW: You see, the only reason that I would say ... anonymous art is a lot of dribble—it's tommyrot. Because if you're going to make art, one of the few things that the artist does is assume responsibility for things. The only way you can assume responsibility is by attaching your name to it. Therefore, if somebody says that's damn fool shit, they can say, you know, so-and-so, you know, makes damn fool shit. But when there is no attachment of name, you get into this thing of anonymous art, which negates for me one of the central qualities of being an artist, which is the assumption of responsibility that this thing is art. That's the only aesthetic I will ever make. That you assume the responsibility and that's it. It doesn't matter what it looks like, what it is ... it's a matter of designation. If you designate the title "art" to something, it's art. Nobody forces you to. You can go through your whole life and say, I'm doing my thing, and nobody has the right to say anything. If you designate it art, then it can be attacked as art. It's the Califor-

nia thing, the custom car makers. For years the custom car makers said, we're custom car makers … and all of these idiots were not content with this. They said, "You're an artist, but you don't know it." And they began to call the custom car makers artists, but the custom car makers called themselves custom car makers. A man is not an artist and what he makes isn't art unless he tells you it's art. [Silence]

So there is no real difficulty to resolve as far as the plagiarism thing goes. If somebody steals something, they steal it. That's the end of it. But what they make, if they steal it correctly, is just as good as mine. [Laughs] If they steal it correctly in its entirety or lift it in its entirety, the reproduction again is as good as the "original." [Pause] A Barnett Newman painted by John Doe is still a good painting if it was a good Barnett Newman. It just doesn't happen to be John Doe's art, but the painting itself is just as good. [Silence]

PN: What about time in your work?

LW: The element of time, designation of time? It's just a designation of quantity, as one would designate a kilo of white paint, a quart of white paint, two minutes of spray. It's just a designation of quantity. Well, it leaves out … it accepts "plonk" in a quantum, but it accepts "plonk" on a very elemental level. In a sense of just all … The only thing you can do with time is use it to designate it, you know, an amount of something. And the words "amount of" and "approximately" and "arbitrary" have become very important to me. They become repetitious, and yet they're a necessity. When you say an amount of something, you can substitute anything and it's still the same thing—a quantity of something, a time elapsure. By the time I start saying something to you, there's a time elapsure. So, we're dealing then with a time elapsure, just as a quantitative thing. That's all.

NOTES

1. The title of the work is *A 36″ × 36″ Removal to the Lathing or Support Wall of Plaster or Wallboard from a Wall*.

2. The full correct title is *A Shallow Trench from High Water Mark to Low Water Mark upon a North Atlantic Beach*.

3. All twenty-five pages that made up Weiner's contribution to the "Xerox Book" were identical. The following statement was handwritten in capital letters toward the bottom right side of each of the 8 ½ × 11–inch sheets of graph paper: "A rectangular removal from a xeroxed graph sheet in proportion to the overall dimensions of the sheet."

7

SOL LeWITT
JUNE 12, 1969

PATRICIA NORVELL: First, could you talk about what you're doing now?

SOL LeWITT: Well, now, I'm working on wall-drawings and drawings on paper and drawings on three-dimensional pieces. How did I start to do them? Well, it's kind of the end of a process which ... I was doing and I still do three-dimensional things. And ... well, it started this way: I did a serial kind of system of three-dimensional cubes. And after I did them, I wanted to do a set of drawings concerning them which would become a book—which has become a book. And in order to do these drawings I had to devise a method to show that some boxes were open and some boxes were closed. So I used parallel lines as, in this case, a description of three-dimensional form on two dimensions.

Then someone proposed the project of a "Xerox Book"—it was Seth Siegelaub—and he said he wanted twenty-five pages. Well, since I had already been thinking about drawing, because that was the last thing that I'd been doing, I decided that I would do a series of drawings [see figure 24]. And what I did I took— since there were twenty-five pages—I took the number twenty-four and there's twenty-four ways of expressing the numbers one, two, three, four. And I assigned one kind of line to one, one to two, one to three, and one to four. One was a vertical line, two was a horizontal line, three was diagonal left to right, and four was

diagonal right to left. These are the basic kind of directions that lines can take ...
the absolute ways that lines can be drawn. And I drew these things as parallel
lines very close to one another in boxes. And then there was a system of changing
them so that within twenty-four pages there were different arrangements of actu-
ally sixteen squares, four sets of four. Everything was based on four. So this was
kind of a ... more of a ... less of a rational ... I mean, it gets into the whole idea of
methodology. I wanted everything to be based on four, just as in the other project
everything was based on three, and in the project before that everything was
based on nine, or the divisibility of nine, and things of that sort, which are ...
Well, I wouldn't go so far as to say that they're mystic, but they're not rational. I
mean, they're just decisions, basic decisions. Well, anyway, this was based on
four.

Then I took the same kind of system and made a different method. The one
remained the same; that was a vertical line. Two was one plus two, in other
words, vertical lines with horizontal lines superimposed. Three was the left-to-
right diagonal line on top of those two, and four was all four of them superim-
posed on one another. And that way I sort of discovered a method of doing a
thing with sort of an absolute control, which was mechanistic enough so that I
wouldn't have to decide each time what tonality to make a thing because starting
with the kinds of systems that I was using—and I used four different systems, so
everything still came down to four at the end—everything was decided ahead of
time. All I had to do was to do it, which took me about a year. But the first set was
for Seth's book, which was the flat method—that is, not the superimposed
method. And then when I wanted to finish the series, I did the superimposed
method—God, this must be really boring—and in that way I sort of discovered a
way of making tonality, and now I'm just doing things, oh ... Then I decided to
do them on the wall. [Pause]

Well, I started as a painter. Even at the time when I was doing three-dimen-
sional things, I usually did them on a two-dimensional grid, so I've always been
interested in doing something two-dimensional. And I don't think that painting
is quite the way I want to do a two-dimensional thing. I think that painting in-
volves a kind of tradition that, ah ... a field that I've given up, because it wasn't
valid to me. But I did want to do something two-dimensional. But really two di-
mensional in that there wouldn't be an intervening structure at all, either canvas
or paper or anything. And the only possible way to do that would be to do it di-
rectly on the wall.

Well, I had this method, which I had been doing for this serial system book of
drawings. So the first time I did it, I did one of the series, which is out in Califor-
nia on a wall [see figure 25].[1] It was twenty-four drawings. But then when I had
other shows, I decided to free myself from that system and just do the thing as it

pertained to the specific wall that I had to work on. So that it became … I wanted it to become part of the wall. Therefore I did it with a very hard pencil. Even though I did a … say, kind of number four tonality, the darkest tonality, yet I wanted to keep it light enough so that it wouldn't visually destroy the surface of the wall and would remain as a part of the wall. The whole drawing would really be part of the wall. I wanted it to kind of sink into the wall, rather than pop out of it.

And then I decided that I would do three-dimensional forms with the same series on it that I did in the past year in books. So I have two of them … One is the parallel-line method, and the other is the superimposed method, and each of them would have ninety-six drawings, twenty-four on each side. Twenty-four would be a complete set. Then these boxes would be the whole system, the book would be the whole system, and the system could be done as drawings on the wall. But actually for the wall drawings I don't think I want to use that four-square or sixteen-square system anymore. It was just a way … a way of discovering how to do the thing. That's what I'm doing now.

PN: What are your reasons for wanting to go back to a three-dimensional object?

SL: Well, it's not a matter of going back. I feel that as an artist I can use two dimensions or three dimensions. They're equally valid and equally interesting. What I don't want to do is to repeat old ideas. Ah, there's no point in that. But I think that if you assume the idea of a surface, which I do assume as a wall is a surface, then the wall of a three-dimensional form is also a wall and can be used as a vehicle for drawing. I had nothing against the object. I have nothing against three-dimensional forms. I have nothing for three-dimension[al forms] … They just happen to be the result of the method that I use. Even before. In fact, one time I was asked to write something about the cube, and what I wrote was that the reason I used the cube was that it's really a pretty uninteresting form. It doesn't have any action involved in it—it has complete stasis—and therefore it's the kind of thing that can be easily manipulated. So that the cubes that I used were the result of the method that I used … It wasn't that I was designing a cube; it's been around for a long time. But that would be a kind of formalist approach—to look at the result of the thing and see what it seems to be visually, rather than to look at the content of the thing. And I think that's to a great degree what's happening today in art. There's a whole group of people that are much more formalist oriented. Now there are a lot of people that are as close to being content oriented as possible. [Pause]

PN: What kind of choices are you making in your work?

SL: Well, I think that basically what my art is about is not making choices. It's in making an initial choice of, say, a system, and letting the system do the work. Only when there's a contradiction or an impasse of some sort do I have to decide one thing or another. For instance, I have to make a decision on color. Well, I de-

cided white because it was the least color I could think of. The other possibility would be black. But black is so positive and it has other meanings. White has unfortunate connotations too. People think of purity. But it just worked, I think, better than black. But I just try, have always tried, to let the content of the piece decide the form of the piece.

PN: And the content would be the system?

SL: Yeah. Or, the … better, let's say, method. Because the system is just another kind of method. And also I think people, ah … Today a big kind of groovy word is "process." But process is another kind of method. But people that use "process," I think, use it in terms of physical process, rather than mental process. But I use the word "method" because I think that it takes in both, and I think both are important.

PN: Both physical and mental?

SL: Well, there's no escaping either. And I think that you can't be too parochial about this.

PN: Why did you decide that painting was invalid for you?

SL: Well, I think that in the history of modern art, I think that the Cubists did as much with painting as, ah … The Cubists were the last painters. I think painting is kind of a Renaissance art and I think that to pick up the paraphernalia of painting today is an anachronism. The idea of what abstract painting would be would be to put paint on a surface, and once the surface is violated with … well, with illusion, the surface is destroyed. It's impossible, I think, to do anything to avoid illusion. Illusion is a function of perception. Everyone has their own perception. For instance, the Abstract Expressionists, as important as they were, were rather behind the Cubists at painting. I think the Cubists were actually more advanced in their thinking in terms of painting. But I think that what the Cubists finally did was to end painting. I don't think any painting can really be done. The only possible exception would be something like Frank Stella doing the shaped canvas. But that already came to be thought of as object, rather than as painting. And I think that the painters of today are not doing anything more interesting than the Cubists. And as a matter of fact, they're following the Cubist format quite a lot, or an Abstract Expressionist format.

PN: But do you feel that the same … your concern with content can't be applied to painting?

SL: Well, it can be applied. Yeah, it could be. But I'm just saying that painting, the word "painting," first of all, implies the whole history of painting. And it implies the whole paraphernalia of painting, and all of the … I can see a painter like Bob Ryman—he's the only painter today who, I think, really is involved with the idea of painting as it can be done today. I think that he really understands what painting is. It's just putting paint on something. But I can't understand other painters,

you know, painting monstrous paintings because they're paintings. The only reason is that they're painters and they're painting paintings. It just seems ... they're not dealing with what painting is. [Pause] And that's why I prefer not to use the word "painting." I prefer to use the words "two-dimensional" and "three-dimensional" art. I think there's a tremendous possibility for two-dimensional art. That's why I'm doing it. But I couldn't see myself taking out my little paint set to do it. If I could use color, that would be another possibility. I think that color is a real possibility to be used. Right now it's difficult to imagine using more than one color on a surface because then you start to get this kind of illusionistic process again. Not only illusionism, but you get composition. You get back to the whole Renaissance idea of what painting is. Well, we're not involved in that.

PN: Don't you feel that a lot of that is what the observer brings to what they're seeing, and if the emphasis were placed elsewhere that could be forgotten? I mean, they could bring those same formal concerns to looking at your drawing on the wall and ...

SL: Well, I can't concern myself with what people think they see. I think that the artist destroys his art if he tries to be both the observer and the artist at the same time. The only thing that the artist can do is to do his thing. And then his perception controls what he does next. He sees what he does and says, "Well, I should have done it this way instead of that way, and I'll do it the next time." But if you say, "Well, if I do it this way, then it'll seem too much this or too much that," it's possible that it's true, but it's possible that it's not true. [Pause] I'm sure that given a specific work of art and twenty people, you'll get twenty different responses. You know, you can't really go by that.

PN: Within the method that you're using now, with the lines, these can be drawn in more than one place ... I mean, I could go and draw one in my house.

SL: If you knew how, yeah. But there are people that I've worked with that, ah, will not know what I want. But anyone could, sure. [Pause]

PN: What about the uniqueness of the work? That work has no preciousness to it or location attached to it.

SL: Well, location is part of it. It can't be moved without being destroyed.

PN: But it can't just be done on one wall? And that's that? Like if you had it on your wall here, that wouldn't be the only place it could be ...

SL: Well, the "it" you are talking about couldn't be moved without the wall being moved. [Laughter]. What you're saying is that the same work could be done at several locations.

PN: The content would be the same ...

SL: It's possible that that could be done, although I think that it's not necessary ... Sometimes I do it one way, and sometimes I do it the other way. I haven't really figured out, you know, quite to my satisfaction ... whether to make it an absolute

relationship to the wall—the surface. Because it implies that it's part of the wall, and if it implies it's part of the wall, then the wall is the important entity and the drawing is the thing that can take up the whole wall. Or to be the length of the wall, or to be something to do with the particular or specific kind of architecture that the wall has … or whether it's to be done as a thing in and of itself, as an end in itself, and just use the wall as a place to put it … Theoretically, I think that if I'm involved with the wall, I should use the wall completely. But then again I think of the thing as an end in itself too.

PN: Are you doing the same piece depending on the wall or are you changing the …

SL: No, it changes. [Pause] What I do is in order to keep it nonrelational, I keep it all the same tonality, even though I break it up. And in a lot of … In most cases it has to be broken up because I use a triangle, a large triangle, and there's only so large a triangle that you can use, depending upon how long a stroke a person can draw with one line. So that the triangle I use is forty inches. And say there's a little on each end left over, say there's thirty-six inches, the drawing can only be thirty-six inches high but I can make it double-high, triple-high or quadruple-high. And in many cases I make it modular to three feet. But when I stopped doing the other thing I was talking about, the four-square-by-four-square kind of thing, where each square within the four was different. Then there was this kind of relational thing, which was the end product of the method. So I didn't mind it in that case. But if I'm going to do a thing on the wall, I'd rather have it as a single thing rather than a thing with parts, if possible. So I can do it with one line, either one of the four lines or combinations of the four lines, but a single line or a double line—that is, one set of lines superimposed on another—or triple or quadruple. To do a triple, there are a number of combinations of ways that can be done and still keep the same tonality. As a matter of fact, there are a couple of drawings on the wall up there where I use triple lines but they have the same grayness, the ones on the gray paper. [Talking and explaining in the background while looking at the drawings on the wall]

PN: How important is what you've been told recently [inaudible] … How do you view documentation?

SL: I don't know what you mean—how important.

PN: How important is it that I know this is one, and this is two, and this is three?

SL: Oh, it isn't important at all! It's only important to me. All you do is see it. But then … Well, with any kind of art that involves this kind of method there are several levels. You can look at it purely visually but then you can either figure out the method or have the method figured out in some other documentation, in some other way, either with words or drawings or somehow. That's why I did the drawings as kind of documentation, to clarify the system, because this particular system seemed to be very difficult for people to glom on to. There were just too

many things involved all at one time, and people are trained mostly to look at things visually, just to see what they see. And if you see just what you see, it looked either chaotic, haphazard, or it was just too much information given at one point. And I could really understand why, you know, people were turned off by it. But then I thought that by doing a set of drawings pertaining to it, the method would become clear.

It's the same thing, if you like, if you hear some kind of music and it sounds like just a mess of sound. If you were interested enough in it, you could read the score, and the score may be much more clear than the sound. [Pause]

There's a quote of Charles Ives. He said: "Who said music had anything to do with sound?" And then there's an example of Bach. He had to write a piece of music for a music society, and he wrote the most complicated thing he could possibly write. Actually, when you listen to it, it doesn't sound that way, but it wasn't meant to be listened to. It was variations on some sort of hymn and he didn't even bother to state the main, you know, music. He just started … But then he did all of these gymnastics with the thing. It came out to be a fairly simple-sounding thing, but that isn't why he did it. You know, he did it to make it the most complex experience possible because he knew all these people were very learned people. And the same thing … I think an artist doesn't do things for the general public. He does things for a certain group of people who would understand what he's doing. So that possibly I overestimated the audience for this particular kind of piece and thought that they would understand what was being done. But unfortunately, I think that most people, critics especially, or critics of my generation especially, who are most of the critics that you read, are tremendously formalist oriented. And there was the whole kind of thing they were taught, and that's exactly how they see things. So … what was the question? [Laughs]

PN: How important documentation, explanations are.

SL: Oh yeah, everybody cringes at the idea of explanation, but I think that any part of the art process, from the inception of the idea in the artist's mind to the inception of the idea in the viewer's mind, all parts are important, and I'd even say of equal importance. I don't think that a three-dimensional structure is more important than a doodled drawing in which the idea is first put down on paper, or a finished drawing or a photograph of the thing. [Pause] And, again, I think the formalist idea that an object is more important than a drawing, you know, comes out. One critic wrote: "Why does he do these objects when the drawings are so interesting and the three-dimensional things are not?" Well, he assumes that one is more important than the other. I don't.

PN: But how much do you show of the doodling?

SL: I try to show everything. In that show that I was talking about, there were two rooms. In the larger room was the finished system, forty-seven pieces. In the

small room were the same forty-seven pieces in reduced scale. They were a foot high. The other ones were four feet high. Plus all of the working drawings, plus … That's all I had at the time, working drawings. Afterwards, there were the finished drawings, which I did after the show, and then photographs. But that to me … all of that was the work. The four-foot-high pieces were only part of the work. But I try to show as much as possible. In other words, I wasn't showing a formal sculpture. I was showing a thought process.

PN: Have you always worked within these kinds of combinations and permutations?

SL: I did things in the late fifties that were involved with that. And then I didn't use them again; then I used them once in a while; then I started using them fairly [recently,] well, around 1965. But I have things from fifty-nine that were based on this kind of permutation. One of my favorite artists has always been [Eadweard] Muybridge, the photographer, who was involved in permutations. I tried to do a lot of things at one time that never worked out which were involved in, sort of, permutations, but it wasn't until fairly lately that I did it. But I'm not … I don't intend to keep doing it. It's just another method. I think that what I did with drawings really isn't involved too much with permutations. The series that I did was, but the wall things I am doing aren't. Except when they use the four different lines. But that's not really … My idea of permutation is to do everything that's implied in the thing—not just do a few things. And to keep it so simple that everything can be done. [Pause] It's not necessary to do that, for me, all the time. I mean, I really don't know what I'd be doing next. Probably wouldn't be that.

PN: How did you get interested in that? As a closed system? As a system within which to work, or because of the theoretical aspects of the mathematics of it?

SL: Well, I don't know *anything* about mathematics. This thing really doesn't have anything to do with mathematics. But it has to do with the way my mind works, I think. [Pause] And … it's just a way, I think, of making some sort of order, but making a kind of order where everything is equal, nothing is superior and nothing is inferior. So that I'd have to make all of the parts of these things because I wouldn't say that one is more beautiful than the other. I can say that after it's done, but I can't say that before it's done because I don't know what it's like until it's done. So I have to do them all. Then I can choose one as better than the other. But in order to do it … I like to separate the functions into conception and perception. Perception is after the fact and conception is before the fact. And I think that the way my mind works, it just … I had to do something that made sense to me, and this made sense to me. [Pause]

PN: Have you read Jack Burnham's book *Beyond Modern Sculpture*?

SL: I didn't read it. I've seen it.

PN: He makes the argument that we're changing from an object-oriented world to a systems-oriented world, and that art is involved in doing that right now.

SL: Well, I think that … I didn't read the article and I'm not prepared to discuss it, but I think that that's just not true. I think that a lot of people are doing things with objects. They're doing some very interesting things. But it's really impossible to make such sweeping statements, you know, and expect them to be even a little bit true. I don't think that that's necessarily true at all. And I think that people that do objects, in many cases, do them with a system in mind. But they're still doing objects and they're still doing systems. I don't think that one is necessarily going to replace the other.

PN: I think it's an emphasis. I mean, the emphasis of where the artist is placing the importance, rather than …

SL: Well, I think that some artists place the emphasis on the material, in the matter. Now is this object or system? [Pause] I'm thinking of Carl Andre specifically. I think that he has, you know, a system worked out to use material. And he doesn't deviate very much from it … The form changes, but he's not interested in form particularly. Sometimes, you know, he uses the same thing over and over again, the same form. So he's not interested in that. He could have it laid out this way or that way. But it's always involved with the systematic use of materials. So the emphasis is slightly more on the material part. But then, how does the material get there? What material is it? How is it decided? These are all part of the system or systematic way of … When he gets through the whole table of elements, then his system will be finished.

PN: [Laughs] I asked him that.

SL: [Laughs] You asked him that?

PN: If he were going to go through them all.

SL: What'd he say?

PN: Said he didn't know! [Laughter] He wasn't telling. [Pause]
 Well, now, another question I've been asking is whether the aim of your art dictates how you present it, which you've been talking about a bit with the wall pieces.

SL: The aim of …

PN: Whether what you're aiming at in your art dictates how you execute it, how you present the final … with the ones you were talking about on the wall, you know, how they are in proportion to the wall. That would be a question there.

SL: Yeah, yeah. That was the question I was indecisive about. Also, I did these things as a book because I thought that a book was a good way of presenting this kind of system.

PN: Is this a different book, or is this the sec[ond] … ?

SL: This is the second book. The second book is all of these square kind of things, it's a one-nine-two … the ones that are going on the boxes also. Yeah. It does have something to do with it. [Pause]

PN: But you are still, in those cases, making choices.

SL: Well, I don't know what you mean.

PN: You're making the choice of what relationship you want it to have with the wall or what role you want the wall to be playing. Your aim hasn't decided that already.

SL: Yeah. Well, the thing is that when you've got everything figured out, then it's time to do something else. Because really, I think, it has a lot to do with figuring things out. Not that one person's work really is that different. The things that I did ten years ago are not essentially different. They look a lot different but essentially they're not different. I've done several kinds of things which are similar and dissimilar. But similarities, I think, go through everyone's work all through their lives. And it's just that there's no point in just rehashing things for the umpteenth time. Just do something else. And when you can work that out to your satisfaction, then there's no sense in pursuing it. [Pause] Sometimes you can return to some of these things because you have further ideas about them, I mean, after a couple of years you can go back to something that you did several years ago and take off on a different tangent.

But I want to clear up the use of the word "ideas." I don't think of art as being something particularly rational. For instance, these methods are really pretty absurd. There's this girl, Hanne Darboven—do you know her work?—she's a German girl, but she's had some work around here. Well, she did a whole series of things based on adding up the day, month, and year—you know, like two, seventeen, sixty-nine—and she adds it up and it comes out to some number ... Which is really silly—it works out to be a rather, you know, beautiful kind of thing when she gets the whole thing done. And it's the same thing with my work, you know. Like, to put three boxes together is a really silly kind of thing when you think of it. I mean, the world is really going to hell in a toboggan, and I'm putting these boxes together. It's really silly. But, you know, that's not the point. The point is that you're exercising a kind of ... Well, the idea in the first place is generally a pretty simple idea with no importance. If it had importance at all, it wouldn't be any good; it wouldn't be usable. And then it's followed absolutely to its conclusion, which is mechanistic. It has no validity as anything except a process in itself. It has nothing to do with the world at all.

You know, people talk about mathematics and things like that. Well, to a mathematician this would really be a laugh because it really has nothing to do with anything but—you know, like totaling up shopping lists. That would be the extent of that. So the ideas, I think, are not intellectual ideas. They're irrational ideas. And this kind of art that I'm doing, I don't think of it as being rational at all. Rather, I think of it as being more irrational. The kind of formalist art where the artist decides and makes decisions all the way down the line, that's a very rational way of thinking about art. But I don't think mine is at all. And I don't think

that it's intellectual, either. I don't think it's mathematical; I don't think it's sci-entific. You know, it's just a method. Really, you can't accept this kind of rational thing—you know, like I put this here, I put that there, I put this there, and isn't that beautiful. You know, to me, if you put them all in a row, they'd still be beauti-ful. It really doesn't make sense to make art that way. To make all-one-color paint-ings is the opposite of that. It's just to make no ... there's no, you know ... Like, take them all off and they have nothing. [Pause] But I think that the kind of for-mal way of making art in a rational manner is really gone and past. And that's where painters who are painting are painting that sort of thing, because painting and that kind of thing can go hand in hand. What I'm really interested in is in a way of making art where you're not involved in this kind of rational type of deci-sion making. That's really what I'm interested in—and it's the whole thing of my art. But it's so often misunderstood as being all the things that it isn't. I mean, it's understood as being the opposite of what it is. And no wonder it's not under-stood. Because if I thought of it ... Like, the worst offense is somebody calling [my work] Minimal art, because actually [my work] is more complex than Abstract Expressionism. Abstract Expressionism was really the most simpleminded kind of art imaginable. It's just art that had a lot of paint thrown into it. But what I'm doing is much more complex. And it's much more irrational than Abstract Ex-pressionism ever was. [Silence]

PN: A lot of your work can still be shown in the gallery situation as it exists ...

SL: Oh, it's made for that situation. The gallery situation is, I think, a very good situa-tion in that it's an optimum way of showing things. [Pause] A lot of my things are designed specifically for that particular space. Some galleries are better for show-ing art and some are worse. But I think that for a certain kind of art a gallery is pretty good.

PN: What do you think about the conditions that Seth [Siegelaub] is opening up for people, for instance the book ...

SL: Oh, I think it's terrific, because, first of all, he's taking away from New York the kind of hub of the universe. Because if you travel a lot, you see that a lot of artists around the world have similar ideas and are doing interesting things and can be grouped together much easier than just people that happen to live in New York. And to do the show as a catalogue is a terrific idea because it involves one very, very important aspect of the work, which you call the documentation. Which is, from my point of view, as important as whatever is done. In some cases it's more important in some artists' viewpoint. I've been involved in a lot of his projects. But what I do can be done with these things just as easily as anything else. It doesn't necessarily need this kind of thing while other people's art does. Some people's art only exists in the documentation. Well, the wall things of mine are a good example because once a show is over, they're destroyed. The only thing that

remains is a photograph of the wall, a drawing of the drawing, and maybe a verbal description of how to draw it. But the thing itself is gone. So that ... That's why I want to be able to use this kind of method that Seth was working on, because that's the only way that these things would be available in his catalogues.

PN: It's not necessary, then, for the drawing on the wall to remain? Or is that a loss for it not to remain?

SL: Well, whether it remains or not doesn't make too much difference. I'd like to see it remain, you know, for a while. But I don't mind it being taken off either. Once I do it, it's done. You know, I've done everything I can for it. And after that it's out of my hands. Whoever ... If it's a gallery or someplace, they can leave it up or take it down, depending on their own discretion. Once it's gone, then the only thing that remains is the documentation.

PN: Also your work is changing the commercial aspect of art. You're not making a salable commodity.

SL: Well, I don't sell the commodity. I sell the idea. If a person comes in and sees the thing in a gallery and says, "That's very nice. I want to buy it," well, of course they can't buy it. But it can be done again. Or it can be done similarly. Nothing is ever the same twice. But a pretty close approximation to it can be made—of course, depending on the texture of the wall, the size of the wall, the kind of architecture, and so on and so forth. Of course, they'd look tremendously different each time because the conditions vary tremendously. I found that out. A wall that looks completely the same top to bottom, the bottom half would be totally different. You just can't see that before you start. [Silence]

PN: Is there anything else you'd like to clarify?

SL: Probably. But I can't think of it. [Laughter]

NOTE

1. LeWitt here refers to his second wall drawing, produced at the Ace Gallery, Los Angeles, in November 1968. LeWitt's first wall drawing was featured in Lucy Lippard's *Art for Peace* exhibition, at Paula Cooper Gallery, New York, in October 1968.

<div style="border-left: 1px solid; padding-left: 1em;">

8

ROBERT SMITHSON

JUNE 20, 1969

</div>

ROBERT SMITHSON: I think, perhaps, an interesting thing to start with would be the whole notion of the object, which I consider to be a mental problem rather than a physical reality. [Pause] An object to me is a product of thought, you know. It doesn't necessarily signify the existence of art. So that I would say that objects are about as real as angels are real. So that I can't accept that as a category. Mainly, you're confronted with art, and my view of art springs from a dialectical position that deals with, I guess, whether or not something exists or doesn't exist. Those two areas, those two paths—the existent and the nonexistent.

The pieces that I did in the Yucatán were nine mirror displacements [see figures 27–35]. What I did was I took twelve mirrors down to the Yucatán with me. We flew to Mérida and rented a car and then drove down the peninsula. And along the way I selected various sites. I'm more interested in the terrain dictating the condition of the art rather than having the art just plunked down on the ground. So that the actual contours of the ground determine the placement of the twelve mirrors. For instance, the first site was a burned-out field that consisted of ashes and small heaps of earth and charred stumps. Then I picked a place, then placed the mirrors directly into the ground. Stuck them in so that the mirrors reflected the sky. I was dealing, in a sense, with actual color as opposed to paint.

Paint to me is matter, and more of a covering rather than color itself. Or color is light inflected with certain degrees of matter. So that I was interested in capturing the actual light on each spot … bringing it down to the ground, so to speak. So that the mirrors are placed horizontal to the ground surface. And this I did throughout. In different instances there were different kinds of supports used. Sometimes raw earth, sometimes tree limbs or other materials that happened to exist right on the site. Then each piece was dismantled after they were photographed.

I just wrote an article about that trip. It's really a piece that involves travel. A lot of my pieces come out of an idea of covering distances. Distance has a lot to do with the scale between the pieces. It's a succession of pieces that cover large landmasses. So you might say that there's a certain degree of unmaking in the pieces, rather than making. They're sort of taken apart and then reassembled, and taken apart and then reassembled, so that it's less … It's not so much a matter of creating something as of decreating or denaturalizing or dedifferentiating, decomposing. It seems that's one of the areas that interests me the most. It's not so much the making of an object, a plastic object, that springs from an expressive need, but rather a concern with the making process before something is made or after something is made. So that brings in this whole area of taking apart or dismantling.

The project that I had in mind for the *Art and Industry* show in California was a series of collapses. In other words, the actual site was the medium that interested me more than any finished product that they might have. So I traced the process back to its origins, back to the raw material of the place itself, and I was interested in the possibility of dismantling the place, so that the first project would be the collapse of a cavern inside a mine where they mined limestone for cement. And then the second dismantling would be the demolition of these buildings that they were going to tear down anyway. And then the third collapse would be the dynamiting of a cliff face in order to get deposits of blue calcite. And all these deposits would be taken from the site, all the sites within the confines of the cement company would be marked on a map—all the places that I had taken something from—and a trail would be set up between each removal. Then all these deposits would be transferred to the museum site, and then they would be placed around the museum at various points, not necessarily invisible sectors but spread around the museum. And then a map of the museum grounds would show the various points where these things were distributed. So that you would have a map of the dismantlings of the industrial site and then a map of the deposits on the museum site. And you can see right away that you get into an area of one site mirroring another site. And this comes out of my earlier work, which has to do with site and nonsite.

I first got interested, I guess, in places by taking these trips and just confronting the raw materials of particular sectors and considering the raw materials of the place before it was refined into any kind of steel or paint or anything else. So that my interest in the site was really a return to the origins of material. A sort of dematerialization of refined matter was one of my interests. Like if you took a tube of paint and followed that back to its original sources, you'd find that it was in a rather raw condition. So my interest was in juxtaposing, let's say, the refinement of painted steel against the particles and rawness of matter itself. Ah, also I think that it sets up a dialogue between interior exhibition space and exterior sites. In other words, there's a confrontation with an unlimited sector outside. In other words, you're not contained by the walls of a room. But then, once you get out on these fringes, you see, you hit a limit or you hit the outer edge. Suddenly you find yourself back in an interior again. So I thought that it would be fascinating to show the distance between the raw material and the center point of refinement—namely, the painted steel in contrast to the origins of the material. Let me stop there.

PATRICIA NORVELL: How do you go to these outer limits and then find yourself confined within?

RS: Right. Yeah. It seems that no matter how far out you go, you're always thrown back to your point of origin. In other words, I don't see any extension of scale in a lot of work that simply attacks the limit within a room. If you're going to take a lot of material and throw it all around a room, the material is always going to hit up against the wall. So there's no limitation there. The idea is to go outside the wall. That's really where it gets risky, and you're confronted with a kind of extending horizon. And this horizon can extend onward and onward and onward. But then you suddenly find that the horizon is closing in all around you so that you have this kind of dilating effect. In other words, there's no escape from limits. Certain works try to give the impression that they're unlimited in an interior space, say a room, but that's just a promise that doesn't seem to have any validity outside the room itself. So that there's no real extension of scale taking place simply by spreading materials inside a room. So that, in a sense, my nonsites are rooms within rooms. There's a recovery from the outer fringes that brings one back to a central point. But the correspondence between that outer point and the inner point is very essential to the idea of scale. The scale between indoors and outdoors, and how the two are in a sense impossible to bridge. In other words, there's a big gap between what's outside and what's inside. And what you're really confronted with in the nonsite is the absence of a site. There's nothing ... there's no positive way that you can deal with a nonsite because its limits are contracted. It's a contraction rather than an expansion of scale. So that it negates any notion of facile, positivistic thinking. In other words, there's no escape, so that

one is confronted with a very ponderous, weighty absence since there's a negation of the site. The site is not there, yet it's there in tonnage. It's a particle, it's a point on a large landmass that suddenly is contracted into an abstract containment.

PN: Are you talking now about once it's taken into a gallery?

RS: Anything that goes into a gallery is confined because of the room. Ah, what I did was to go out to the fringes or out to the horizon, pick a point on that horizon, and collect some raw material. It's a … The making of the piece really involves a collecting. And then the container is the limit that exists within the room after it discovers the outer fringe. [Pause] There's this dialectic between inner and outer, closed and open, central and peripheral. It just goes on, constantly permuting itself into this endless doubling so that you have the nonsite functioning as a mirror and the site functioning as a reflection, so that existence becomes a doubtful thing to capture, so that you're presented with a nonworld—or what I called the nonsite. What it does … it shows the problem; there's nothing solved. It just presents a problem, and the problem can only be approached in terms of its own negation. [Pause] So that leaves you with this very raw material that doesn't seem to exist. That causes all sorts of problems; and that's what fascinates me: the nonexistence of this very solid real material—raw matter—and the impossibility of knowing it. So you're faced with something that's inexplicable. You really are left with nothing but ignorance. And there's no point in expressing this. So there's nothing left to express. Expression means that you have no awareness outside yourself. Once your consciousness takes over, then you can't fall back on your unconscious expressive reservoirs because they're all dried out, and … It's not a … it's no longer an issue.

PN: Will the piece you're making for the *Art and Industry* show in California that you mentioned earlier also be in containers when it comes back to the museum?

RS: It'll be contained by the limits of the museum grounds. In other words, it'll be … I don't even know whether it's going to be built. Ah, well, the … It's contained by the site itself over a series of points. It's not a room-within-a-room. I'm simply using the limits of the existent site in that case. The contraction isn't as great as [it is in] the nonsites. So it'll tend to be sprawling rather than tightly contracted, the way it is in the nonsites.

PN: How will you go about documenting it?

RS: The documentation will be two maps: a map showing the points of removal on the cement company site, and then there'll be a map of the museum grounds.

PN: Will you use photographs?

RS: Yeah. I'll probably document that through photographs. Photographs are perhaps even the most extreme contraction, because they reduce everything to a rectilinear or square, and it shrinks everything down. That fascinates me.

And then there's another kind of work: the work with the mirrors. There are actually three kinds of work that I do. There's the nonsites. And then there's the mirror displacements; [and] then another type of work which I call earth maps or material maps.

The mirrors utilize ... the mirrors are disconnected surfaces—they're not welded together or stuck together in any way. They're supported or held in place by the raw material; so that the pressure of the material against the mirrored surfaces is what gives that its stability. So it's a different kind of ordering. The surfaces are not connected the way they are, let's say, in the nonsites. There [are] no painted surfaces.

And then in the earth maps ... the earth maps are left on the sites. They're a ... For instance, I have a project pending in Texas that will involve a large oval map of the world as it existed in the Cambrian period. So there are no sites existent at all. They're completely lost in time. So that the earth maps point to nonexistent sites, whereas the nonsites point to existent sites but tend to negate them.

The mirror pieces, I guess, fall somewhere in between the two ... two types of work. They're somewhere between the edge and the center. [Pause] But they're, ah ... okay ... question?

PN: Do you feel that your presentation is part of the art, or is it a separate presentation that illustrates the art?

RS: Well, everything is part of the art. It's just certain disconnected parts of the art ... you mean, like the photographics?

PN: The photographs or even the deposits once they're removed and reestablished.

RS: Well, the deposits within the limits of either the metal containers, or the deposits in conjunction with the mirrors, are always shifting. They're never in the same positions. So that the raw material is always relative, but the rigid or painted or mirrored surfaces are, in a sense, absolute. One aspect of the piece is changing and the other aspect is always remaining the same. So that you have, like, a shift within a kind of ongoing abstraction. So that the relative is always there as well as the absolute abstraction.

PN: What about the photographs?

RS: The photograph is in a sense a trace of the site. [Pause] It's a way of focusing on the site. For instance, if you take a trip to the site, then the photograph gives you a clue to what you look for. I think, perhaps ever since the invention of the photograph, we've seen the world through photographs and not the other way around. In other words, we see through cameras rather than around cameras. Ah, say, like, a painting by Manet, where you have this kind of halation effect or bleed, [it] was really the direct result of a photographic process, rather than a direct result of his natural vision. I think we have to realize that ... I don't know. I don't think that artists see too much, anyway. Perhaps the only way ... They have to be kind

of blind. Perception has to, in this sense, decant itself of any kind of naturalism or realism. You just have to deal with the fundamentals of matter and mind, completely devoid of any other anthropomorphic interests. That's also what the work is about. It's about the interaction between mind and matter. In a sense, it's a dualistic idea, which is very primitive. It's even more radical than [René] Descartes's dualism, because there's no connection between the mind and the matter. If you think about, let's say, think of the kick and then have somebody kick you, there's no correspondence: they're two different entities. So that proves that if you think of the kick, you don't feel the kick. So you have to have the kick in one place. They're just in some kind of correspondence to each other. Descartes thought that actually the mind and the body were connected by the pineal gland, but of course they are not. So that's a problem. And then you have facile unitary ideas or gestalt ideas, which I consider part of the expressive fallacy. That's just a hope, that these two things are united. It's sort of a relief. I mean, after the horrors of the duality, this seeming reconciliation seems to offer some kind of relief and promises some kind of hope.

PN: Is it important for people to go see the sites?

RS: Yeah, but that's very unlikely—that they will. It's very strange because I always have people telling me how interested they are in the sites, and yet they never go there. A few people have. And, like, most of them have the experience but miss the meaning. So that there's no way of grasping the site. And part of the idea of the photograph is to pick out instances or moments in time and present those along with the other deposits. It's possible for people to visit the sites. It would be good if they did because then they would be confronted with the intangibility of something that appears to be very tangible. But usually they're offered these two choices but they inevitably pick the thing that they can't really respond to because they don't even attempt to. So that it poses this double path: they can't deal with the site because it's far away, and then the nonsite itself is a very ponderous absence.

Usually, most thinking … most people come to it with some idea of reality. It seems that there's like a … Everybody's convinced that they know what reality is, so that they bring their own concept of reality and start looking at the work in terms of their own reality, which is inevitably wrong. So then they proceed to enlarge their mistakes into all kinds of value judgments, and they never once question or doubt their own sense of reality. So all they can do is really describe the piece, say that it's a container filled with rocks, and it seems to point to a site. So they never contend with the reality that is outside their reality, which might be no reality at all. The reality principle, in a sense, is what keeps everybody from confronting their own fears about the ground they happen to be standing on.

PN: Judgment—judgment of new work and how it presents this problem that you are talking about now. It seems to me that your work, when you do bring it, in the

case of the nonsites, when you brought it into the gallery and put it in boxes, you were presenting an object that looked like it should be considered as a formal art object and judged on those grounds.

RS: Well, the fact is that I don't see any point in taking beautiful materials and trying to make them look ugly the way certain artists do in order, you know, in order to create some kind of form. I'm more interested in taking essentially squalid materials and making them, ah, beautiful, I guess. It's an exquisite preoccupation.

No, you can approach it that way, since most people are conditioned to think that way, but it's not ... there's no object there because there's not even any place there. And the whole idea of object is something that I find a pernicious myth. It's like the belief in fairies or something, you know. They just don't exist. The mind is so conditioned and it needs the certainty of the mental construct of an object, but there is no object, any more than you can say that a painting by [Kazimir] Malevich is an object. It explicitly tells you that it's a non-object. But here there's not even any place left. The place has been abolished through the very density of the material. But the insistence on something being an object seems to be based on a need to find a positive answer. And there's no answer there, you see. It's just a question.

PN: What kind of choices are you making in your pieces?

RS: Choices? Ah ... Well, I guess you go through a whole chain of choices. Through your whole development you're gradually relinquishing or extinguishing choices till you get down to the bedrock or the final limits of the mind or the origins of matter. The choices take place within the mind and within matter; so that the choices tend to exclude any ... They're sort of self-canceling choices, they just sort of ... Each choice seems to negate itself. I don't know the right ... You get to a point where, you know, you're just up against a particular limit that brings on its own choice. I really don't know exactly what you mean.

PN: For instance, in the case of the nonsites, what size or shape box you're going to put them in?

RS: Oh, that's true.

PN: How were you making those choices?

RS: Each limit in a sense is determined by the site. The particular site dictates the abstract limits of the nonsite so that it's a matter of the terrain ... each particular place dictating its own peculiar limit. I can never preconceive or conceive of a limit until I'm confronted with a particular site. The choices of the sites are ... they mainly take place in an area of time. The sites show the effects of time, sort of a sinking into timelessness. When I get to a site that strikes that timeless chord, then I decide that maybe this is a good one to use, so that I suppose the site selection is subjective. There's no objective choice. It's just sort of a running down until finally you have to pick something. And then you take it down to a

site, let's say, at the zero degree that appeals to me. A condition of … a site where the material strikes the mind, where absences become apparent, where the disintegration of space and time seems very apparent … [Pause] Sort of an end.

PN: Then it's all very self-contained, once the site is selected? Like a self-contained system …

RS: Yeah, I would say that it is. That's why I say that … really it's like a treadmill. [Pause] I mean, there's no hope for logic. If you try to come up with a logical reason, then you might as well forget it, because it's not dealing with any kind of nameable, measurable situation. All dimension seems to lose itself in the process. In other words, you're really going from someplace to no place and back to no place and back to someplace. And then to locate between those two points gives you a position of elsewhere, so that there's no focus. This outer edge and this center constantly subvert each other, cancel each other out, so that you really have no destinations. There's a suspension of destination.

PN: What is your [reaction] towards given showing conditions, such as those that Seth [Siegelaub] has done with his "Xerox Book"?

RS: I think that Conceptual art that depends completely on written data is only half the story. You not only have to deal with the mind; you have to deal with material. [Pause] And sometimes it can get to be nothing more than a gesture of the mind if you accept just a purely conceptual orientation. My work isn't pure so that I don't have … It's clogged with matter. It's weighty. I'm for a weighty, ponderous art. I find a lot of that work fascinating. I do a lot of it myself. But that's part … that's only one side of the work. [Pause] There's no escape from matter. I mean, there's no escape from the physical. Nor is there any escape from the mind. The two are, I guess, on a constant collision course. So that you might say that my work is like an artistic disaster. It's just going from one disaster to another. There's seemingly no … I mean, there's no explosion or anything that would suggest noisy behavior. It's a kind of quiet catastrophe of mind and matter.

PN: How does your theory of entropy fit into this?

RS: Well, that seems to be significant in the sense that entropy seems to be a word that conceals absences. Science utilizes the word in terms of existence. I think art utilizes it in terms of nonexistence. Science is always fighting against entropy, and artists seem to accept entropy.

There's another term that Anton Ehrenzweig uses—"de-differentiation"—which means that you can't differentiate anything. In other words, one discrete thing is always more or less ending up in another discrete thing. Two things are always in some kind of correspondence to each other, but not in any kind of rational correspondence. The juxtapositions tend to evade any kind of reasoned proof.

So that entropy is interesting in that it deals with things breaking down and falling apart, but in a very limited way. There's almost a kind of deterministic

control that this breakdown has. Chance and randomness seem to be fixed ... sort of like constellations in the sky. The constellations seem scattered throughout the sky, yet they're fixed and they have their coordinates. But these coordinates don't seem to relate to any kind of rational certainty. So this is the subversion of all the rational hopes about reality. Reality, I think, is a suppressive mechanism anyway. I don't know who knows what it is. Critics generally speak from the point of view of reality. They all assume or presume that they know what reality is. There's never any doubt in their mind that what they might be perceiving happens to be wrong. It would be very interesting if they would deal with the possibility of their own role in perception ... the mistakes. And I'm not talking, either, about any kind of nihilism. I don't think nihilism is possible, any more than anarchy is possible. So in that respect, you know, like, I would appear to be rather optimistic, to have a rather happy view of things because ... It's just impossible, you know, to take that kind of position. [Pause] Sort of like an artist, you know, could be said to be like a criminal who doesn't commit any crimes.

PN: Do you think that you're redefining the limits of art? That doesn't fit in with no reality ... or breaking the reality that people have.

RS: Well, it's just that reality doesn't seem to be knowable. It seems unnameable. If you do name something, as soon as you name something, then you destroy its reality. So that as soon as you're, like, named at birth, you're already, like, wiped out. [Laughter] I think that's why a lot of artists are afraid of naming their works, because they're afraid that they'll lose their existence. Which is true. And even if they only call their works "Untitled," they're still not approaching anything or saving the reality of their work. The reality is always doubtful. In other words, I'm just saying that reality is in a sense unknowable. So that to presume that you know what reality is, is just a conceit. Or it's an illusion to help you to get along, you know, to help you take your course.

PN: What about the limits of art? What is considered artistic activity?

RS: Well, all legitimate art deals with limits. Fraudulent art feels it has no limits. See, the trick is to locate those elusive limits. You're always running against those limits, but somehow the limits never show themselves. So that's why I say that measure and dimension seem to break down at a certain point.

In other words, there's, like, the right world of the bourgeois middle class, and then you have this other world. They're sort of like the rational numbers, you know, people that live according to the social reality, they're rational numbers. And then you have these oddities, like tramps, clowns, and things like that, and they seem to be the irrational numbers. They exist too, as much as the rational numbers exist. I think I'm more interested in those irrational sectors. It becomes a kind of parody to a certain extent. [Pause] It becomes more interesting to see what a clown does with tightrope walking rather than what the tightrope walker

does. You can always expect what a tightrope walker will do—it's a mechanical process. But you can never expect what the clown will do. So I guess it's that unexpected aspect that's always turning up and turning against itself. The limits are always against themselves. As soon as you think you have the limits established they're there; but then again they're not there.

PN: Jack Burnham feels that we are going from an object-oriented society to a systems-oriented society.

RS: Well, that's pretty good since I don't see any trace of a system anywhere. That's a convenient word. It's like "object." It's another abstract entity that doesn't exist. I mean, there are all these things … there are things like structures, objects, systems. But, then again, where are they? I think art tends to relieve itself of those hopes. Like, last year we were in an object world and this year we're in a system world. Well, Jack Burnham is very interested in going beyond and that's a kind of utopian view. The future doesn't exist, or if it does exist, it's the obsolete in reverse. The future is always going backwards. We're never … Our future tends to be prehistoric. I see no point in utilizing technology or industry as an end in itself or as an affirmation of anything. That has nothing to do with art. They're just tools.

So if you make a system, you can be sure the system is bound to evade itself. So I see no point in pinning your hopes on a system. It's just an expansive object, and eventually that all contracts back to points. Within a system there are lots of objects, points. If I saw a system, or if I saw an object, then I might be interested. But to me there are only manifestations of thought that end up in language. It's a language problem rather than anything else. It all comes down to that. What you call something yesterday and what you call it today really results in nothing but verbalization of mental constructs. So you have to build something upon which to convince yourself that you're still around. So if a raft of systems will do, if that makes him happy …

PN: Is there any more you'd like to say about your own work? [Silence]

RS: Anything in particular? Have any questions? [Pause] Impasse. Discuss impasse?

PN: Sure. [Laughter]

RS: Well, I guess that's what we all want to arrive at: impasse. It seems to be very fertile, you know, in that you're constantly canceling out all these things and getting closer to a condition of incapacity to make something. There's still a hope that things can be made.

I see the possibility of an art of unmaking. As long as art is thought of as creation, then it will be the same old story. Here we go again, I don't know, creating objects, creating systems, building a better tomorrow. So the thing to do, I guess, is to posit that there is no tomorrow: nothing but a gap. A yawning gap. Then out of that, you see, comes a … It seems sort of tragic in a way … You see, what im-

mediately relieves it is an irony of sorts that gives you a kind of a sense of humor. That's why I say the element of parody comes into it. [Pause] It's that cosmic sense of humor, I think, that makes it all tolerable. It's not a depressing impasse. It sort of just vanishes—you know, receding. The sites are receding into the nonsites and the nonsites are receding back into the sites. It's a two-way street. It's not a one-way street anyway, you know. It's always back and forth, to and fro, discovering places of origin for the first time and then not knowing them. And it gives you a certain exhilaration, I guess.

Then there's also an art of incapability. You know, incapable ... inabilities, actually. It would be nice ... Actually, what I find most interesting—I would like to write an article about the value of Michael Fried's failures because that seems to be what's really necessary. You know, that somebody like that can go on making all these mistakes, and somehow this becomes a very fertile area because it prompts all these other disasters to take place, and they all seem to excite one's interest. So it's actually the wrong things that we do that result in something rather than the other way around. There's no point in trying to come up with the right answer because it's inevitably wrong. Every philosophy will turn against itself, you know. It will always be refuted. The object or the system will always crush the originator—eventually. It will be overthrown and replaced by another series of lies. It's sort of like going from one happy lie to another happy lie, you know, with a cheerful sense about everything. [Pause] An art against itself, I think, is a good possibility. An art that always returns to essential skepticism. I'm sick of positivist views, ontological hopes, and that sort of thing. Or ontological despairs. Both are impossible. [Silence] So that takes care of my mental wreckage for the day.

ROBERT SMITHSON

DOUGLAS HUEBLER

DOUGLAS HUEBLER: Just in terms of where I started from—I started rather convention-ally, as a drawer, painter, and so forth. The reason I go into that is because the painting, at a certain point, like six or seven or eight years ago, moved toward what became known as hard-edge or reductive painting. And when I reached that point with my own painting, I think it was about seven years ago, I painted the stripes around the edge of the canvas, about three or four colored stripes, just to restate the edge, which is something that, you know, you've seen since that time. At that point, rather than make a style or an issue out of that aspect of reductive-ness, it occurred to me that the painting had become in itself an object. And, again, a lot of this is quite familiar in the sense of recent art—I mean, quite fa-miliar. I'm not saying that I invented or discovered these things, but they were discoveries to me at that time. And I'm just sort of recapitulating. The next sense that that object seemed to make for me was to jump right off the wall. In other words, objects that are reduced to that level become as valid three-dimensionally as they are two-dimensionally. And so I became involved with the whole form that got to be very reductive sculpture, and I made forms that were called, had been called, are called Minimal or Primary Structures, and so forth and so forth, that whole genre.

And the things I made were out of plywood. They became essentially architectural, or architectonic in structure. And they were meant to have a multipositioned aspect. That is, that they were made in such a way like a cube, in the simplest way … a cube you could turn in any direction and it's saying the same kind of thing. And the forms that I made were more complex than a cube, but at the same time were meant to be multifunctional in that way, so that they had no privileged, pictorial aspect, you know. I also covered them with Formica, which was to sort of eliminate any sense of texture and any sense of color application. That is, I used very mild colors like grays or whites that are virtually no color anyway, and then the color was already built into the material itself, so that they were not meant to have a color aspect. They were not meant to have a visual aspect from the point of view of a more interesting place to view the thing. So that they became as neutral as possible.

And then again—consistent with ideas that I think [Robert] Morris and [Donald] Judd have expressed perfectly well, but I'll have to talk about them because they were my concerns—what did become of interest in the work then was where it was located in relationship to the viewer … being off the pedestal, that kind of thing, but also, as I say, the fact that it had this multipositioning aspect to it as well. It turned out I didn't really … That was an idea, but I didn't really do that that often. As I found out, the Formica could not take the piece being turned over and over and over again. So although my purpose was to always make it from that logic, the Formica wasn't that tough. It would scratch, and so I just didn't pursue that that way.

Anyway, obviously those concerns come from gestalt, you know: where something is in relationship to you, in relationship to the rest of the world, and so forth. Two or three years ago I was being interviewed in Boston and [was] trying to explain what my work was about, and the guy, Arthur Hohner,[1] up there said, "Okay, so when you see the piece and it's neutral and it's in relationship to you and so forth and so forth, what do you have left?" In other words, where's the art? He didn't say that, but that's what he meant. And I said, "The rest of the world," which is just what the work was about. Now I say all of this … The work was meant as a springboard from your location, its location, and then the rest of the world, rather than as a thing upon which one focused for a final experience. It was kind of an intermediary experience, the idea, of course, being that the rest of the world is always there anyway and that the work, having its visual aspects removed—its anecdotal aspects removed and so forth—was meant to be an equivalent object in the world, rather than a special object in the world.

This is the sort of thing I did for a while. Most of the works were small enough in scale that they functioned in a room. But once they began to get larger in scale, let's say larger than four by eight feet, which is what I wanted to do with them,

the architectural aspect of the piece would seem to, rather than locate the room, would almost eliminate it, smother it.

And I began to think about putting these works outside so that they would have an ongoing aspect in actual nature, rather than working with the environment in an interior situation where they worked with the wall and the ceiling, which is what the gestalt things most often did when they were in museum presentations. You know, you were bouncing off the next piece and against the wall. And so that was the direction I was going to take my work about a year and a half ago. And I did a piece that I meant to go outside, and I took it outside, and I did another piece deliberately for an outdoor sculpture show that was more of a mock-up. And in both cases, I was absolutely destroyed to see how puny they looked outside. Enormous inside, too big for a room, too big for a normal room, not too big for a museum room. I wasn't making the work for museums anyway. I wasn't trying to say: The world is about the space in which museums exist and/or in which huge public buildings exist. I mean, the rest of the world … that makes that a privileged situation too, that the work has to be in that kind of context. And in any normal room, any undifferentiated room, and so forth, the works just knocked it out. So then back to the point when I put the work outside. Wham! You know, there was the rest of the world, and trees were more interesting than the sculpture, and the sky was—and so forth. Unless—and this was the thing that really hit me—unless you framed the environment in which the sculpture existed outside, or made it huge. Now at that time, I had heard … well, I can name some of the artists who were thinking in terms of wanting to make monuments as large as the Empire State Building. Ah, I won't name them—there are a number of them, and that really turned me off because it just seems to me that the world is full of junk, anyway. The world is full of too much stuff to walk around, anyway, and so forth. And I consider the attempt to make art attract attention by making it huge in scale something I didn't want to do. It seems to me a bit arrogant, I'll say that. But it seems to me something at least that I didn't want to do at all. I don't feel that the art has to be that assertive. That is like, for me, the gesturing in Abstract Expressionism, for instance, or any number of romantic postures where you're going to get attention by hook or by crook. You can cast the thing in bronze and polish it up or paint it [in] Day-Glo or do any number of things to make sure that the world knows it's there. But that wasn't the purpose of my work. This is why I'm going through this other stuff, you know. That wasn't the purpose of my work. It was not to be an attention-getting object. It was sort of … to create this sort of ongoing thing.

So at any rate, as I say, the alternative was to frame the environment. That is, a sculpture garden, you know, put a hedge around it, or have it define in the same way that a room defines a certain space, have the sculpture exist in a space out-

side where it is also defined in a slightly larger context. But what really happened to me was that I began to realize that there were different ... that there was a whole convention about how we frame our location anyway, and that convention was essentially a conceptual one. And that is, once you begin to push through these artificial structures that are hedges or walls or man-made things, nature itself goes on and on and on in an altogether undifferentiated way. And the way we deal with the world, if we locate ourselves, really is a matter in the head. It's a matter of terms or, as I said, conventions. Anyway, that's where I stopped making objects and began to think about what there was about location, where you are, that can be determined, experienced, or used without making objects, still using the central concern of location and so forth. [Phone rings]

The reason I know where I am is because I'm kind of bored with what I've been saying, which is kind of like art-historical BS, you know. I'm really just trying to get at where I came from, in a way, which may or may not be interesting to anyone else. It is to me, that's all. What I began to be concerned about, as I was sort of saying, is that it occurred to me that our way of dealing with the world was based on all of these conventions. And almost any convention is workable. It's just the purpose to which you want something to work. And I became very interested in the sense of your feeling about a place, where you are in relationship to any larger context. Now, when you've got a piece of sculpture to help define the space in which you exist, and you are there, that becomes like an immediate spatial situation. But I'm rather interested in where we are if we can measure this place in relationship to another place and make these jumps, which we do anyway. You know, just as the telephone just rang, you make a spatial jump to sort of face or experience the person with whom you were talking. In other words, all the conventions that had to do with addresses or time or maps—and the map in particular ...

I want people to see, you know, where the world's at and where they are at within it. Maybe the simplest thing to do is what I did at that time, which was to draw up a series of trips, absolutely random trips, the way the AAA draws up your chart for you if you want to go from here to Cleveland. And I made a series of round trips that I just did absolutely without knowledge of where I would be sending people. And the trip itself was the art, and that was all. I did about, oh, four or five of those last year, or whenever it was, um ... as the first things I did. Anyway, I began to work with the idea of the map and the language that you use to tell people where they are. The map is only a chart, you know. It isn't really a real thing, and yet we begin to assume it is a real thing. Most people experience maps or clocks or charts and so forth as very real life-defining phenomena, or whatever. [Pause]

DOUGLAS HUEBLER

Then I jumped from those map trips to defining spaces by points or markers located in huge areas of space. I made a piece which was an exchange of a shape between New York and Boston, and so forth, and it exists only as an idea. I can define the same dimension, the same apparent amount of physical space, laying markers down just to sort of locate it, and make photographic documents of where it was located. The photographs were not really meant to be good photographs of an interesting place. They just happened to be where the place was that I'd already located on a map before I went in the first place. And what I was doing was to set up a system or a structure or an idea which would direct me to do the things that were demanded in order to complete it: that meant to go to places. Of course, by making a dot on a map, you really are covering perhaps twenty or forty square feet, or circular feet. And there's no proof that when you get there you're pointing your camera or putting that marker on the exact spot, which is of course part of the point too. It doesn't matter, you see; it doesn't matter. It could have been three feet over, or you could have miscalculated just because your pencil was too thick, you know. Any number of things. So what it finally comes back to is the idea of these locations, the idea of the system, and that demands language. I began to get into the whole notion of language, the convention of language as a way by which we read our experience—really read our experience or conceptualize our experience. And how … as many years as I had had teaching art or art history, how much we use language and then try to cover it up. How art history has always said, "But you really have to look" or, particularly more recent art history, "You['ve] really got to learn how to look." Well, what does this mean? Well, it means that we give you twice as much language, and we tell you what Impressionism is, and we tell you how volume and space is restructured in Cubism. Or even with primary forms, we have to tell you what gestalt is about so that you know what you're looking at. And all of this language is built right into the experience.

And so I began to do drawings and I began to make art in which, rather than try to put the language off the art, I tried to put it right on the art—in the art or as part of the object or whatever it was. A document, you see. So this is something that I haven't begun to fully explore even now. I've made some works that have been directed absolutely towards the use of language and have made works where I've used the photograph as a document, but not, I hope, as an ornament. In other words, I have to be very careful. For instance, I'll tell you about a couple of works which will make it maybe more clear. I set up a system that was to shoot the snow on the side of the highway [see figure 37]—this was up in Massachusetts and New Hampshire in the middle of the winter, February—to shoot straight down at the snow, so there's no pictorial aspect. Shooting straight down

at the snow, every five miles, as registered on the car. Actually, it was a forty-five degree angle to the snow, but essentially not pictorial. And it could have been, and maybe it was, every five yards, or maybe it was every five feet, or maybe it was every five miles, you see. At any rate, the pictures and that quality, the system, or the either/or system … that I throw in as a possibility here too—and I won't say which it was, really, because it doesn't matter, you see—but the pictorial aspect … The photographs in this case are absolute documents because they don't show anything pictorially interesting. But they have to exist as part of this either/or documentation. Now, that's one kind of piece where the photographs are essential to knowing the idea of the piece. And the language of the piece as I've described it is usually typewritten on another, you know, eight-and-one-half-by-eleven-inch piece of paper. So that exists as one document—language or the idea—and then the photographs reinforce or are a part of the structure of the idea.

Now sometimes I'm not so sure about the photographs. And I had a recent example where I finally canned the photograph as being too much. And this particular piece is lyrical or romantic enough that one more aspect of ornamentation or romanticism, or sentiment, or whatever, could be too much. Because I don't know … That line is a very hard one to be certain about. I don't want the works to be clever, romantic, sentimental, you know, or nice or anything like that.

But I did one piece where I used the actual location where I existed; that was in this girls' college, Bradford Junior College, which we talked about before. And I sent a memorandum … You see, here's a kind of a system. The visual world is always there. And then there are systems in the world that are always there, like the post office. I've done pieces where I've dipped into the post office and brought something back out using that system. Well, in the case of Bradford, I used the system which is that memoranda are always being sent out, right? I made up a memorandum to all students, four hundred girls, and had it put in every mailbox. I said I wanted to use a secret of theirs for a project on which I was working, and I wanted them to write it out. Well, though I wanted their most important secret, I really didn't expect that anyone was going to give it to me. But then of course the option was, or as a matter of fact the direction was, that they were to write the secret out and then burn the secret in an ashtray and place the ashes in an envelope and put the envelope in my mailbox. And when I had them all in, then I would mix all of the ashes together. You know, that's kind of like a ritualistic or romantic little gesture and so forth, but the idea was really meant as putting something out into the world, you know—a request like that—based on a kind of system, based on some things that are going on anyway, secrets, you know. And remove the load from the secret by having it burned, and then, of course, mixing them all together, and then the final act here was to scatter them throughout the campus. So that the whole piece was made in that location at

Bradford, and it was finished there. And the whole piece is really brought off by the language which I'm using right now. Well, I had, actually, as a piece of real romance, a bunch of faculty children take that box full of ashes—I got sixty-three secrets and I ripped them all open and mixed all those ashes together and all those secrets together and so forth—and then I had a bunch of faculty children actually scatter the secrets, about six or eight kids with their little hands running around the campus just throwing the ashes around. And I took some photographs of that. All I'm saying is that those photographs on a personal level are interesting, but for the piece absolutely unnecessary, so I canned them. And I'm just bringing this up to say that sometimes the photographs are absolute documents when they are what the piece is about, and sometimes they could be ornamentation. And I have to, as I say, be careful about that.

And in those two examples, I sort of thought a lot of what the work is about because it's about dipping into things that are going on, pulling back just enough, without changing anything. In other words, I'm not trying to put anything out into the world like a big or small object, you see ... I've stopped making objects, so I'm not putting anything out like that, and I'm not trying to take anything away from the world. Nor am I trying to restructure the world. I'm not trying to tell the world anything, really. I'm not trying to tell the world that it could be better by being this or that. I'm just, you know, touching the world by doing these things and leaving it pretty much as it is. And all of these things are based on a system. In other words, ultimately a structure, a conceptual structure. And I've done this with the post office a couple of times where I have used a certain amount of what they do, dipped in and defined space and time by sending documents around that [get] touched, that get returned, that are actually in contact with locations that are elsewhere, and so forth.

I'll stop talking for a minute ... I'd like you to, you know ... You jotted down some things ... I'd like you to ask me some things.

PATRICIA NORVELL: What is the aim of your art if it's not to produce objects or to point things out to people or move people or transcend the event or the system? What is the aim?

DH: If I were trying to point things out in the world in a traditional sense, I would be picking something that I found specially moving, and, say, I'll look at that and I'll paint it like an Impressionist, like an Expressionist, like a Romantic, or like a Cubist. I'll do it my way and show you how we might see that appearance, which you may have overlooked. We'll see that specially. And so I'd intrude my style on it. Well, that, I think, is a traditional way of pointing at the world. I am pointing, I suppose, at the world by saying that how we deal with the world, how each individual does, how each person chooses ... whatever structure, whatever system he sets up, can make the world more or less interesting. But the world itself does not

change. The world itself is always there. The systems in it are always there, pretty much as they are … Time is, you know, whatever. Things are going on all the time. And that, we can reach out—and we do, of course, reach out and have a certain aspect of the world—in the way that we choose to do it, and we can choose to do it in any number of ways, but that choice is pretty arbitrary. Just as I say one can document one hour of time or one day of time in a certain location and take everything that's going on there … It's a completely arbitrary choice. It could have been elsewhere or elsewhere or elsewhere. And what I'm doing, frankly … I mean if I can say I'm trying to do something … I was trying to avoid saying I was trying to do something [laughs], but I am. I've got to be honest … I am trying to do something. I am trying to say that, yeah, the world is always there and maybe … I'm not saying everything's the same, either, you know. And I do not say anything is art. [Pause] I don't think anything is art. I think that no thing is art. I think that this is really what I'm against, the notion that things can be art. I don't think things are art at all. They are only things. What we do, and what we put together using the available things maybe—what we can call art, or whatever we choose to call it—maybe the whole idea of what we call art is a redundancy, or maybe it's useless now.

But in particular, by making these choices of what is documented through photography, making that a part of the work, and to make it occur randomly, is to take the load off appearance that I think art has built into the expectation of appearance. If there's anything that I really can say is part of my work, at least, it's to take the notion that appearance itself carries aesthetic value, or art value, I should say … I'm not talking about real experience—I mean real visual experience, where I might choose to look at one kind of thing over another kind of thing in the world just because my responses are that way. I'm talking about art using appearance— using certain color structures, certain notions of composition and so forth. All the art jargon has been built into how the eyes see the world. [Pause] And I don't object to the eyes seeing the world in privileged and less privileged ways. But I guess I object to the fact that art has been predicated, since Impressionism at least, on our experience with the world being located in the eyes, you see. I don't know what this means. I don't know if I'm trying to … I'm not trying to revolutionize art. I'm not trying to negate anything. I'm not consciously trying to do that. But I am certain that art is not limited to being something that's located at the end of your eyeballs, you know. And so that's what this work is about. It's not pointing to the world and saying it's better than we are or anything like that. It's kind of like saying, art is not necessarily a visual experience.

PN: In your trip pieces, for instance, how important is it for people to take the trip?

DH: Not at all. I've never taken one myself. [Laughs]. I gave those away. Those are the first ones I made, and I don't know if anyone has taken the trip either.

PN: But in the piece that you just did in Bradford, where you scattered the secrets, how important was it to you that they got scattered?

DH: Not at all.

PN: But you did do it?

DH: Yeah, yeah. [Pause] I did do it just because, actually, a good many of the students expected that it would be done. I would have been completely happy to have created the idea and perhaps never actually performed it, you know. I mean, even to the point of putting it in the girls' mailboxes. It could have been just as an idea, and perhaps maybe just as interesting.

A lot of these things I honestly haven't figured out completely yet. A lot of these things have to be done. You know, it's like painting the picture. You paint it to see what it's going to look like, and then you decide if you want to do another one like that, or if that wasn't worth doing that way, and so forth. I'm perfectly happy to have done that secrets thing that way, but I also know from having done it that it probably didn't have to be done that way. Maybe another piece will be done another way. [Pause]

PN: Like, [Lawrence] Weiner is just publishing ideas and not even necessarily executing any of them.

DH: Right. He sometimes does, as you know, and he doesn't feel that they have to be done. And I think this is, you know, perfectly true. I think that the truth of this work is not literal truth.

PN: That's the next question I was going to ask—about judgment. Do you think that this new work has a whole new system or grounds for judgment? [Phone rings]

DH: As a matter of fact, the question is maybe what the work is about. While you were talking on the phone, I was thinking about the question, and I can say this: judgment itself is going to develop as the work develops. I'm still in the process of trying to develop a judgment about my own work, as I said, as I work it out. And the same thing is true about knowing about Larry [Weiner]'s work or Joseph [Kosuth]'s work, or anyone else. I'd known about what these guys had been up to for a year or so, and I'm still forming values by which I can know their work better. They may have known how to describe it to me better. This is why, even talking about the work this way is likely to lead you into saying things that you might not have wanted to say, or have given examples, like the secret thing I just brought up, to juxtapose it against how I use photographs as documents ... But it doesn't really tell everything about the work. And what I suppose I'm after in saying that is that the work really tells about the work. As a whole body of the work, it's not very easy for one person just to pop in, as has been done, and to make works that seem to be similar and have that continuity, that sense that at least interests me to figure out—how one can make art without locating it in the visual aspect. If it's possible to do that ... Maybe it does require calling art something other than it

has been. It's usually called either art or the visual arts. Art forms or expressive forms that have used language have been called poetry or literature, and have not been allowed to be about the visual arts at all. Maybe all of these categories are a bit stuffy and archaic at this point. And maybe there are experiences that we can have where we shift from those normal expectations. It's in challenging these expectations that I am the most interested, and I think the other guys are too.

You have to form a judgment about a guy who says the work may or may not be made. You know. Or when you have to decide at the end of the work whether or not you're going to put it together this way or that way. You start the work and you have a system—in my case, a system—and then I look at the work, and then when it's finished ... I mean, this is still like making art, you know.

PN: And do you think that you're still working within a pure medium?

DH: No, no, no. As a matter of fact, again, it's an attempt to try to make what I would call art—creating new judgments about what art may be called—but what I would call art by straddling previous limitations on media, that is, as I said earlier, by deliberately bringing language in and recognizing the role of language. Now I didn't really explain some of the works I made where I have used language, but I will say that in terms of straddling ... I have used things that can go on a wall, like going back to making a drawing or a painting and the whole visual experience. And then I called back on the visual experience and mitigated the visual experience by putting the language right on the picture plane, putting more language there than anything else to look at.

I have, for instance, made a drawing where I put a point in the middle of a big sheet of white paper. It can be, you know, eleven by eleven inches, or eleven by eleven feet—the size doesn't matter. That interests me too, you see ... that by using language I can mitigate any expectation of size. And that also can be on the wall or it can be held in your hand, and the experience of it visually, conceptually, can be the same. And I've made dots where I said, for instance, "On this point are located all the other points in this room." You know. Well, what does that mean? Well, the world, the room is full of points. Points begin to define and measure things, but it's altogether visual. Some of these points may be invisible, and some of them may be visual. And they may be measured and so forth. But there you've got something to look at. Or let's say, another piece that says, "Ahead of this surface"—and it's a blank piece of paper—"ahead of this surface is located an infinite amount of three-dimensional space." It's a true statement. And I have also worked to define large aspects of natural space, outdoor space, by locating points that may be thousands of miles apart, and giving similar language utterances to those locations or those forms, if you will.

Well, sculpture has located distances from point to point. And so has painting in a way, you know. In other words, all of these things that had been visual have

put the demand on you to have that visual experience through competence that you develop by knowing, as I said, from Impressionism to Cubism and so forth—how you learned to see. But how you learn to see that way may be just in terms of the conventions that were decided for the rules of those games. Right?

PN: Right. You're redefining them?

DH: I'm only saying, I'm only saying … that I'll play another game, that's all. I'll say that those visual … I'll play on those visual experiences. I'll play on where points are located and use language. But as I say, the language is part of the work. The language is not out here where you're told it so that you can walk up to that Impressionist or Cubist painting or optical painting and have your experience by having that language located in the back of your head, but it's invisible. I make it visible, that's all. So in this way I am really straddling conventional experience or conventional media. That is, I'm putting something on the wall, but I'm also putting the language right there, you see, and I'm suspending the other kinds of experience with it by doing that. And some of these things I say are altogether true. And yet they suspend normal truth too.

PN: Do you feel there's any historical precedence in art for what you're doing? For instance, [Marcel] Duchamp or [John] Cage?

DH: Well, you know, this is something very interesting. I've become much more interested in Duchamp and Cage in the last couple of years because of what I'm doing. [Pause] And I have to admit that I guess very often I'm not very smart because I didn't quite understand what Duchamp was up to. Some of the things, I did very well. But the little Green Box, or whatever it is—boy, I still don't understand what he was up to! I think I'm coming closer, though. I certainly understand Cage much more. I sort of liked Cage for years, but I don't think I quite knew him very well. As a matter of fact, a lot of his work wasn't really published. You know, he was sort of known by word of mouth, really, more than by this recent book, that rather plush paperbound book that's out now. Is that called *Silence?* Yeah. Well, I've been reading that and I really like it.[2] And I really know a lot more about Cage. I really feel as if we're soul mates that way. And I'm learning more about Cage. So I could say, "Gee, these guys were probably interested in the same kind of territory." Or I could say that, you know, frankly, Zen Buddhists were … or any number of places where people have experienced the world in ways that I would now look at and say, "Wow, you know, that's kind of what they were doing; I like that." Only I didn't know about it, you know. I knew about a lot of things. I've been interested in Zen Buddhism for years, but I don't pretend to be one. I'm not a mystic. I drive an automobile; I swear at people that do the wrong things, you know, when I'm driving; therefore I know I'm not serene. I haven't reached satori, and so on and so forth. But I still dig very much ideas which are based in these kinds of views. Eastern thought, with its notion that things do become undifferen-

tiated, that we're all part of a universal or undifferentiated manifold, or, you know, whatever. I dig these ideas, but I don't practice them. I know kids that do now, very, very militantly, you know ... who will insist to you that there is truth in ... I don't believe it's true. I don't believe that the oyster I was about to eat two weeks ago in front of a young mystic has a soul, you know! I just do not believe it. I sort of teased him. I said something about it and he was really rather uptight about it. But I do believe the idea of it, you see. I don't believe that everything is undifferentiated, but I like the idea of it as something to work by.

So anyway, I think that reaching out into Cage or Duchamp or certain philosophical notions ... I'm trying to learn more about phenomenology. I don't really quite understand that the way I would like to think I could understand [it]. Maybe some day I will. But actually, I don't know, if you can call art anything, you can call it a way whereby you can try to figure out what things are all about. And that's what I'm doing now. And sort of, I guess I sort of felt that I'd figured out certain things [about] what painting was about, and what sculpture was about. Not a matter of being great or not great ... just a way of figuring out how you're alive in the world. And I'm doing other things to figure out interesting ways to deal with the world. And I guess I will call that art, you know ... to try to figure out how to be significantly alive in the world. I will call that art. Even if you don't know exactly what it means while you're doing it, that's what you're doing.

PN: What kind of choices are you making in what you choose to deal with, or in how you choose to execute it? And do you feel the choices are very different from choices you were making in your original object?

DH: No, no, no. I would say there's a lot of similarity there. I was trying to make very reductive art at a certain point. I didn't even go back far enough before. I will say that I've been around long enough [so] that ten years ago, twelve years ago, I was an Abstract Expressionist painter. I was using cement and slapping it on the canvas and throwing paint on it and letting it roll around, taking a very natural course. I did a few rather decent paintings that way. But I got uptight about the heroic gesture involved. When I began to understand Abstract Expressionism, I understood that it was about an existential stage ... a heroic stage for the artist. I began to feel a little uptight about that. It was that long ago that I began to be more interested in a reduced way of being alive, instead of shouting at the world, you know, as I felt Abstract Expressionism did. Well, since that time—it's been ten years or so—I've been interested in a more reduced way, a less noisy way, of being alive and of making art. And so the choices that I make now are very similar. I'm trying to do the most with very little, you see. When I reduced down to Formica, I was trying to do a lot with the idea basic to the work and less with the sensuous aspect. And I'm still concerned with that now. I will say again that the

most loaded piece I've ever done was that secrets thing, and Seth Siegelaub doesn't really like it so much. [Laughs] [Phone rings]

I'd answer that another way by just saying that I've done much more reductive or simple works where I've ... I just have to describe what I've done, you see, I think to make the point a little better. I'll do it as quickly as I can. I set up a system of a simple doubling of the numbers system, as old as man, where I've taken a photograph of the nearest surface—just taken a walk in New York—the nearest surface to my camera, or the nearest appearance, you see. After one minute and another two minutes and then four minutes; and then eight, you know, on and on and on until finally the last photograph is about five hours after the first one. And then I've put those together without putting the order down because the order doesn't matter, you see. It's again the either/or kind of thing. Well, that's ... I told you of the either/or with the snow piece. I had taken photographs of the escalator at the Port Authority Bus Terminal, which I took every minute on the minute for eight of the photographs. And then I took one in another fifteen minutes, then I took one in another hour or something like that. Then I took one the next day, and of course they all look the same, and of course I wouldn't put those in sequence, but I could. Again, it doesn't matter.

It's like, I set up a system, and the system can catch a part of what is happening—what's going on in the world—an appearance in the world, and suspend that appearance itself at any given instant from being important, you know, being what the work is about. The work is about the system. The system is not proof of anything either, except that you can set up almost any series, you see, and reach into anything that's going on, as I say, from post offices to escalators moving or to just plain blank surfaces, or maybe not blank surfaces. But it's all out there at once, and the most removed, least intrusive role is just to use the most dumbbell possible kind of system and bring back enough from the world, you know, to illustrate the system. But again, at the same time, to suspend anything that is brought back from having more importance, or having that visual importance, that pictorial importance, all those things that it once had, you see. So it's like reaching into the world and then bringing back and suspending what you brought back from its normal role, and having it serve art—the art being the thing that comes into your head—and not being about a visual thing. You see, by using the visual thing and then suspending it, then the art has to be located in the idea and away from the visual appearance, you see. When I say, "Do you see?" I'm also saying to myself, Do you see? [Laughs]

PN: Then you have priorities in your art?

DH: Yeah.

PN: The systems taking top priority?

DH: Trying to show that the system, or the idea, the thing that you've set up as the structure within which you will work, is what the art's about.

PN: But then you say that it doesn't matter whether the pictures were taken every minute or every five days?

DH: That's right.

PN: So then you're destroying your system, or you're ignoring it?

DH: Right, right, right. That's right because, as I said, these systems do not prove anything either. They're dumbbell systems. Very simple dumbbell systems. In other words ...

PN: Yes, but then what do you leave the observer or the receiver with?

DH: You leave him with the notion that he can have an experience that is just that experience. It could be that one or the next one or the next one. In other words, they are all based on the convention that the system sets up. But it could be any system, you know. And the visual experience gets knocked out.

PN: But that's the idea that you're leaving them with. What are you physically actually leaving them with to let them know that?

DH: Just the idea.

PN: But the presentation is what?

DH: Documents. Yes. The documents are composed. I see, you know, if you want to get at that. It's the documents that carry the idea. And the documents have to exist, of course, to carry the idea—usually one sheet on which words that express the work are laid out, typewritten and formalized, dated and all that. And then other documents: maybe maps, maybe photographs, you know, whatever else is necessary, but all rather of the same size and presented normally as paper, not framed. In other words, to leave presentation out of it almost as much as possible, you know. You could think of having twenty photographs showing what happened to that escalator, all lined up on the wall, and read it the way you would a piece of a movie film. If you did that, without the language, looking at that escalator would be like looking at a chunk of movie film. But that isn't what the work's about. It's about the language, you see. And the pictures support it. I don't care if someone had the piece on the wall, if they had the language up on the wall with it or not, as long as they knew what the idea of it was about. In other words, it can be on the wall, it can be looked at in a notebook, it can be looked at just as you'd look at playing cards, a deck of playing cards. Any way that it comes into your experience is all right. And it's neither meant to be like an art experience [n]or not like an art experience. In other words, I don't care if it goes on a wall or not on a wall. And I don't put them on the walls myself. Some people have. And some people leave them in a notebook situation. I think it's important to keep them, you know, sort of together as a little package.

PN: So your choices are mainly centered around clarifying the presentation of the idea?

DH: Right, right, right. And that, I found, is extraordinarily difficult, because so much is dependent on the language. I try to be as economical and as clear as I can with the language. I try to synthesize the whole idea in about three sentences. That puts very real demands on me, because I am not a trained writer. I'm not really trained at words any more than anyone else. And I rewrite these things. I rewrite these three or four sentences sometimes for two weeks! I say that with passion because it's very frustrating. I don't like to do that. I want the idea to be clearer. But I don't like to spend the time writing and rewriting as if I were a writer, because I'm not about that, you know.

PN: Would you prefer to talk about it rather than write it?

DH: No, I like the idea that I can finally get it down to a form that I hope is as crystal clear as possible. And I can tell you, for instance, of another piece, a very complicated piece, which I have reduced to about four or five sentences. Well, one, for instance, has to do with money. I have taken the serial number of one hundred one-dollar bills—Federal Reserve notes, as they call it in the language—taken the serial numbers, made a list of a hundred serial numbers, and then I put my initials down in the lower right-hand corner, and then I put the money back out into circulation by spending it—for the most part, except that I sent off a dollar to someone I know in Canada, another one to someone in Mexico, another one to someone in Germany, England, Spain, France, Switzerland, Greece, and so forth, so that it's an international piece. That money's been recirculated. The final piece is composed of a statement and one hundred documents, which the one hundred dollars are. Now, that's the start of the piece. The piece is a duration piece. It's going to be twenty-five years long. And at the end of twenty-five years—whoever owns the piece—as a condition for the piece to be completed, the owner has to complete it. And the owner has to complete it by putting an announcement in an international art magazine listing all of those serial numbers again, and offering—and this is built into the condition of owning the piece—to redeem any of those that are brought forth for a thousand dollars. Theoretically, there is a hundred thousand dollars' worth of documentation out on that piece. Now, I've put down as a final condition: if the owner does not fulfill that responsibility, then the piece will no longer exist as of 1995—at the end of the twenty-five years.[3] Now, all right, to get that all down—I've told you this, you know, in, like, five minutes, in a rather random manner—but to get that down and to get it down very clearly, without making a long story out of it, without this and that, was very difficult. That is a piece that does not use photography. It uses something that's going on in the world anyway—dollar bills being circulated and accumulating value, perhaps. Art accumulating value and so forth and so forth. Systems being completed. Maybe I take ten photographs in ten minutes, or maybe this piece takes twenty-five years to be completed. Maybe it opens up for the owner, or it does

open up for the owner to have a responsibility in seeing it through, and so forth. What will finally happen to it, I have no idea. It doesn't matter to me. I won't say anymore, because there are some conditions about this piece that are sort of explicit rather than implicit. I'd prefer to leave it now, you know.

PN: Jack Burnham has said that we're going from an object-oriented society to a systems-oriented society. Do you feel that's true?

DH: Yeah, well, I don't know about the whole society. I know Jack, and I like what he's saying. I think that what interests me about him ... I didn't know he was saying these things until ... You know, it's like finding out that people are saying things that interest you. I found after I started this whole systems approach that I'm not very smart, that I can't set up very elaborate systems. My systems are ... Well, I mean them to be dumbbell. But I don't understand computers. And I don't understand a systematized society. And I'm not trying to direct myself towards that possibility. As a matter of fact, it probably is dehumanizing. But maybe there are ways in which we can [sigh] learn to bear that too; I don't know. I'm not trying to make that happen in my work. Because I think that has sociological implications, and it's sort of open to any number of things happening with it. But I do very much like the way Jack has analyzed some of the things that have been done with systems. I just couldn't say that it has much to do with any deliberate didactic intent that I might have. I'm interested, as I said before, and I think I can put it this way again ... in trying to put together other ways of making what I would call art ... in some ways, drawing on what has been art and drawing on things that are going on anyway. And changing the burden on them, particularly the visual burden on things.

PN: Has the landing on the moon changed your thinking at all?

DH: No, no, no. I would avoid very much trying to get very much involved with ... Well, I've located points here and there, you know. And the idea of my locating a point on the moon just as a great heroic gesture, you know, is too much. I still would prefer to deal with extremely mundane things, like a hundred dollar bills or an escalator moving up and down.

PN: But in terms of people's orientation or concept of place, it's going to have to change.

DH: Okay. All right. Exactly. I was thinking about that today, as a matter of fact. I did a piece in Seth's summer show in which I located a point, where it's located on that latitude ... And I had to find this out through expert help ... You see, this is why I say I'm not very smart; I always have to call someone who has this kind of information ... I found out that at that placement in Los Angeles the point would rotate around the axis of the earth twenty thousand six hundred and forty-three miles, I think it was, each day. And for the period of time that that point was on exhibition ... in other words, between the beginning and end of the exhibition,

ninety-two days, the work would go, the piece ... It's a point; it's the most reduced thing you could imagine. The idea involves, finally, that that point has moved one million eight hundred ninety-nine thousand miles during the course of the exhibition, you know, like kinetic sculpture, if you will. Well, it's perfectly obvious that everything else is moving at once too, right?

Now the next piece I'd like to do where I use that kind of information, and I found out ... The guy who gave this information to me is the head physicist at Lincoln Labs, and he admitted that the other piece of information I wanted, that is, how much at one ... in one position a point would move in the relationship to the rotation around the earth's axis and the rotation of the earth in orbit around the sun and the rotation of the whole galaxy ... This involves mathematics far beyond my competence ... But he said he could handle it, though it would take time to figure out. Well, the idea, of course, is one point is like everything else, right? That one point is only, you know, like a metaphor for this.

The idea that I could make a piece that would say to you—and you know this, anyway; again, this is the dumbbell part of it—you know, we're moving in space at a high velocity. I think it's perhaps more interesting to think about that when we know about the movement to the moon than it might have been about a hundred years ago, when you located a little landscape and the implication of nature in relationship to the developing industrial civilization with the urbanization and so forth. In other words, a lot of things in the nineteenth century had to do with that. And I think that maybe our view is getting much more cosmic. And I'm interested in some of those kinds of things. I'm a little bit put off or a little bit afraid to jump in headfirst because I just ... I wish I had the training that scientists, physicists, and so forth have today just to reach in and pull out some of the things that I think are available to make extremely interesting ideas. Extremely ordinary ideas too. One and the other.

Now, I think that most physicists would think that these uses are completely stupid. The use that I would ... that they could not possibly take seriously that I've located a point in Los Angeles that's doing this, this, and this. That's so obvious and so ridiculous that they couldn't be bothered with that kind of thing. I think that I would like to see scientists and physicists and so forth be a little bit more playful too. There's a little bit ... something playful about that idea—and I mean that too. [Pause] I think this is the best thing that art can do for those kinds of people. I talked with a lot of them up around Boston and they're really very, very unwilling to think in the rather strange ways that art ... to take things seriously the way artists take some of these things seriously [and] that are serious too. At the same time they're playful.

PN: Do you think that the people who are hired by industry to just think and let their fancy go are doing a very different activity than you are as an artist?

DH: I don't know. I don't know what they're thinking about. [Pause] I suppose they're given the opportunity to think without worrying about practical applications. Is that what you're saying? Is that what they do?

PN: That is their purpose ... just to think. And not be limited by the present structure or uses.

DH: I don't know what they're doing. I mean, I would like to think that what they're doing is like what I'm doing. And maybe better, maybe more confident. I'd like to think that that's what they're about. I don't know. I don't know who they are, and I don't know what they've done. Do you? We sort of know they are doing that ... I sort of know that too ... but I don't know what it's produced.

As a matter of fact, I would think that it would be very strange just to sit around and do that. I think it would be kind of interesting, as I have suggested to some of these guys who are physicists up around Boston, that ... Some of the very bright ones are really very interested in the way artists do think, and they would like to tap into that, as we would like to tap into them in a way. And I have suggested, I guess, something similar to what you're talking about with the think guys, that I'd just as soon sit around and never produce anything and just talk with them because I like to talk with them. Because I like to find out, you know. The really bright ones are very interesting to talk with. I don't know what it means. And as long as you can talk and talk and talk without ever worrying about finally producing an art show, which is what often happens around groups like E.A.T. [Experiments in Art and Technology] and Pulsa and so forth. They finally look for something practical to result. And once you begin to do that—and every time they've done it, every time they've started to say, well, what can we do now in three months—you know, as soon as that happens, wow! You know, everything begins to tighten up and closes off. And the real imagination, I think, stops as soon as they begin to center in on making an object or an exhibition or something like that. I think these guys are fascinating to talk with, you know ... If they could get turned on ... a lot of them who are extremely bright, if they could get turned on to some of ...

PN: I think it's probably whether they get turned on to calling it art.

DH: Yeah, that's what we were talking about all along, in a way. If you can begin to suspend the notion that art is about museums and about all of the things that art has been about, if you could put that aside and open it up for more people, like these very bright guys with special talents, that is, not just for people with a special talent for painting color ...

PN: But there's something that makes you an artist, that you're doing and you want to do, that I don't think has been clarified. They aren't interested in that. They are not making art. They are not involved in that. And there's a difference.

DH: I think they're not involved because they still see art the way I feel virtually every-one sees art.

PN: But is it your interest to dissolve those limits?

DH: Yes, that's right. That's right. And when you asked before about new systems of judgment or whatever about art, yeah, very much so. I think that this is what a number of people are up to, not just me—but I'm only speaking for myself now—very much challenging the way that art has cornered itself more and more.

PN: But you still want to call yourself an artist?

DH: Oh yeah. Yes. Because that's the best thing I could be, I guess. I can't start all over again as something else. But I would stay that way anyway, you know—even if I could be a physicist or something that's ... that I can really respect. You know, I can respect using the world in the rather elegant and beautiful ways that they can. I'd still want to be what I call an artist, what you call an artist. And we're ... Well, I have been fifteen years at this kind of thing, or I should say all my life—since I was a little boy I wanted to be an artist. So I just like to call what I do art. [Laughs]

I do think that what is going on with a number of people right now is extraor-dinarily important. I don't think that we can articulate it in a special way yet. I think that this will come as more ... I think more people have to know that we're doing what we're doing. And more people come in from more objective situa-tions, the kinds of people that you might conventionally call critics, if you will, or philosophers or other artists. Anyway, people that look and try to figure out and talk about what we're up to as well. I mean, it has to be a larger dialogue, and I want to hear it myself, just so I can sort of expand, you know, where I'm at.

PN: Is there anything else you'd like to cover?

DH: Nope, nope. I've talked more than I've talked for a long time.

NOTES

1. Editors' note: We have been unable to identify Arthur Hohner.
2. See John Cage, *Silence: Lectures and Writings* (Cambridge, Mass.: MIT Press, 1966).
3. Huebler refers to *Duration Piece #13, North America–Western Europe,* 1969. For a list of the serial numbers of the one hundred one-dollar bills, see Frédéric Paul, *Douglas Huebler,* exh. cat. (Limousin, France: F.R.A.C., 1993), n.p.

Barry, Robert *(continued)*
 temporality, 91, 98; texts written by, 7;
 on theory of art, 87, 92, 97–99; on
 unconscious, 86–87, 95; on Weiner's
 work, 89
———, works by: *Inert Gas Series,* 33, 89,
 99n1; *When Attitudes Become Form,*
 95, 100n4
Baxter, Iain, 53, 55n6, 84, 85
Bellamy, Dick, 32
Benjamin, Walter, 4
Broodthaers, Marcel, 7
Buddhism, 145
Buren, Daniel, 7, 53, 55n2
Burnham, Jack, 21, 28, 52, 65, 97,
 119–20, 133

Cage, John, 145, 146
Calder, Alexander, 99
Castelli, Leo, 51, 66
Catalogues, 6, 11, 18; LeWitt on, 122–23;
 Siegelaub on, 14n10, 15n17
Chance, 62, 132
Commodity: and catalogues, 11; and gal-
 leries, 11, 12, 18, 61, 94; and idea, 1;
 LeWitt on, 1, 123; Morris on, 61, 64;
 and object, 94; and photography, 12
Communication: Barry on, 2, 96; Morris
 on, 61; Siegelaub on, 15n17, 53; Weiner
 on, 106
Concept. *See* Idea
Conceptual art: and documentation, 3, 5,
 6–7, 9, 13; and galleries, 11, 12;
 Norvell's interviews as, 3, 4, 13; and
 photography, 9, 12; and physicality, 10;
 Smithson on, 131
Contingency, 62
Costa, Eduardo, 14n10
Cubism, 115

Darboven, Hanne, 121
Debord, Guy, 15n17
Derrida, Jacques, 6
Descartes, René, 129
Dibbets, Jan, 55n2

Documentation: and abstraction, 23, 24;
 Barry on, 7, 8, 9, 15n18, 90–91, 96;
 and catalogues, 6, 11, 14n10, 15n17,
 122–23; and commodification, 12; and
 Conceptual art, 3, 5, 6–7, 9, 13; and
 history of art, 5, 6; Huebler on, 7–8,
 9, 10, 139–40, 141, 142, 143, 148, 149;
 and idea, 17, 148; Kosuth on, 10; and
 language, 6–7, 90–91, 139, 140, 141;
 LeWitt on, 8, 10–11, 94, 117–18,
 122–23; and magazines, 6–7, 12,
 15n17; Morris on, 9, 15n15, 59, 61; and
 Norvell's interviews, 3, 13, 14n7, 18, 54;
 Oppenheim on, 7, 23, 24; and photog-
 raphy, 6–12, 15nn17–18, 17, 33, 91, 94,
 103, 127, 139–40, 141, 142, 143, 148;
 and physicality, 18; Siegelaub on, 10,
 15n17, 33–34; Smithson on, 8, 127;
 and text, 6–7, 15n17, 17, 18, 34–35;
 and video art, 9–10; Weiner on, 6, 8,
 14n9, 102, 103, 104, 108
Drawing, 112–14, 117, 118, 139
Dubuffet, Jean, 47
Duchamp, Marcel, 78, 83, 145, 146
Dwan, Virginia, 35

E.A.T. (Experiments in Art and Tech-
 nology) group, 152
Ehrenzweig, Anton, 131
Entropy, 131
Escari, Raul, 14n12
Exhibitions: of Andre's work, 13n5, 14n10,
 32–33, 39, 54–55nn1–2; of Asher's
 work, 13n5; of Barry's work, 14n10,
 32–33, 39, 54–55nn1–2, 89, 91,
 94–95, 99–100nn1–4; of Flavin's
 work, 13n5; of Huebler's work, 14n10,
 33, 39, 54–55nn1–2, 89, 150; of
 Kaltenbach's work, 84, 85n1; of
 Kawara's work, 13n5; of Kosuth's work,
 14n10, 33, 39, 54–55nn1–2, 89; of Le-
 Witt's work, 13n5, 14n10, 39,
 54–55nn1–2, 122, 123n1; of Morris's
 work, 3, 13n4, 14n10, 33, 54–55n1,
 56–57, 65–66, 69nn1–2; of Nau-
 man's work, 13n5; of Ruscha's work,

Kaltenbach, Stephen (*continued*)
Duchamp's work, 78, 83; exhibitions of work by, 53, 84, 85n1; Goldin on, 54; on history of art, 77; on idea, 81–82; on influence, 75, 80–82; on information, 79, 83; on Klein's work, 78, 83; on Lippard's work, 82; on magazines, 77; on marijuana, 72, 74, 77; on market, 75; on materials, 71, 72, 76; on Nauman's work, 75–77; on object, 79, 83; on Oppenheim's work, 83; on practice of art, 70–77, 79–81; on presentation, 72, 73; on reception of art, 2, 77–78; on Rodia's work, 78; on sculpture, 71, 72, 76; on Serra's work, 78; Siegelaub on, 53; on Siegelaub's work, 5, 82–83; on teaching, 80, 83; texts written by, 6–7, 79, 83; on theory of art, 76–78, 83
———, works by, "Time Capsules," 4, 5–6, 14n8, 74–76
Kawara, On, 7, 13n5
Klein, Yves, 78, 83
Kosuth, Joseph, 2, 4, 5, 6, 7, 10, 11, 13, 19, 53, 143; exhibitions of work by, 14n10, 33, 39, 54–55nn1–2, 62, 69n3, 89; Siegelaub on, 7, 32, 33, 36–37, 39, 40, 42, 44, 45, 54

Language: and abstraction, 28; and ambiguity, 107; as art material, 42, 139; Barry on, 87, 90–91; and documentation, 6–7, 90–91, 139, 140, 141; and experience, 139, 145; and history of art, 139; Huebler on, 139, 140, 141, 144, 145, 148, 149; and presentation, 87; and reality, 132; Siegelaub on, 42; Smithson on, 132, 133; Weiner on, 107, 108
Leo Castelli Warehouse, 57, 58, 65, 69nn1–2
LeWitt, Sol: on Abstract Expressionism, 115, 122; on abstraction, 115; on Andre's work, 120; on catalogues, 122–23; on commodity, 1, 123; on Cubism, 115; on Darboven's work, 121; on documentation, 8, 10–11, 117–18, 122–23; on drawing, 112–14, 117, 118; exhibitions of work by, 13n5, 14n10, 39, 54–55nn1–2, 118–19, 122, 123n1; on formalism, 114, 118, 121; on galleries, 11, 122; on history of art, 115; on idea, 1, 118, 121; on illusionism, 115, 116; on materials, 120; on Minimal art, 122; on music, 15n13, 118; on Muybridge's work, 119; on object, 114, 115, 118, 120; on painting, 113, 115–16, 122; on perception, 115; on photography, 119; on practice of art, 2, 112–15, 116–17, 119, 120–21; on presentation, 118–19, 122; on process-oriented art, 115; on reception of art, 116, 117–18; on Renaissance art, 115, 116; on Ryman's work, 115; Siegelaub on, 39; on Stella's work, 115; on system, 2, 113, 114–15, 119, 120; texts written by, 6; on theory of art, 115, 121–22
Lichtenstein, Roy, 43
Lippard, Lucy, 82, 91, 99–100nn2–3, 109, 123n1
Loft art, 27, 28
Long, Richard, 55n2
Lozano, Lee, 7

Magazines, 6–7, 12; Barry on, 15n18; Huebler on, 149; Kaltenbach on, 77; Siegelaub on, 15n17
Malevich, Kazimir, 130
Mallory, Robert, 70
Manet, Edouard, 128
Marcuse, Herbert, 64
Market, 5, 11, 12, 18, 75, 104. *See also* Commodity
Mass culture, 9
Materiality: Siegelaub on, 1, 32; Smithson on, 127, 131. *See also* Physicality
Materials: Huebler on, 135, 136, 146; Kaltenbach on, 71, 72, 76; LeWitt on, 120; Morris on, 60, 62; Oppenheim on, 26–27; Siegelaub on, 32, 36–37, 40, 41–42; Smithson on, 124–25, 126, 127, 128, 130, 131; Weiner on, 107

Weiner, Lawrence: on Abstract Expressionism, 108; on Art Workers' Coalition, 110; on communication, 106; on documentation, 6, 8, 14n9, 102, 103, 104, 108; on event, 9, 102; exhibitions of work by, 14n10, 32–33, 39, 54–55nn1–2, 89, 104–5, 111n3; on galleries, 11; Huebler on, 143; on idea, 102, 109; on information, 103, 109; on language, 107, 108; on market, 104; on materials, 107; on museums, 110; on Newman's work, 103, 111; on object, 101, 107, 109; on ownership of art, 6, 102–3, 104, 105; on painting, 101, 108; on photography, 6, 14n9, 103, 108; on physicality, 109; on plagiarism, 102–3, 110, 111; on practice of art, 101–2, 103, 106–7; on presentation, 101–2, 106; on reception of art, 105–6; on Reinhardt's work, 109; on removal, 101, 102, 104–5, 109; Siegelaub on, 32–33, 36–37, 39, 42; on temporality, 111; texts written by, 7; on theory of art, 108–9, 110–11; on typography, 107–8

———, works by: *A 1' × 1' Removal with a Gallon of White Paint Poured into It*, 109; *A Shallow Trench from High Water Mark to Low Water Mark upon a North Atlantic Beach*, 103, 111n2; *Statements*, 33, 107; *A 36" × 36" Removal to the Lathing or Support Wall of Plaster or Wallboard from a Wall*, 102, 111n1

Whitney Museum, 3, 13n4, 56, 62, 63

"Xerox Book," 33, 35–36, 39, 104, 112, 131

Zen Buddhism, 145

TEXT 9.5/14 Scala

DISPLAY Scala Sans

DESIGN Nicole Hayward

COMPOSITION Impressions Book and Journal Services, Inc.

PRINTING + BINDING Edwards Brothers